# THE
# COTSWOLDS
# AT WAR

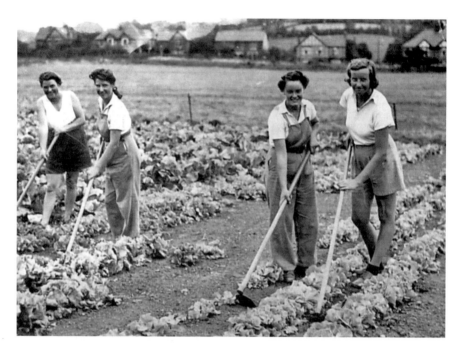

Members of the Women's Land Army at work on Dursley's Recreation Ground during the Second World War. From the left: Olive Meek, Margaret Joyner, Betty Green and Tony Page. The produce, in great quantities, went to Lister's canteen.

# THE
# COTSWOLDS
# AT WAR

## JUNE LEWIS-JONES

AMBERLEY

*For my husband Ralph, with my love*

First published 1992
This revised edition, 2009

Amberley Publishing Plc
Cirencester Road, Chalford,
Stroud, Gloucestershire, GL6 8PE

www.amberley-books.com

Copyright © June Lewis-Jones 2009

The right of June Lewis-Jones to be identified
as the Author of this work has been asserted
in accordance with the Copyrights, Designs
and Patents Act 1988.

ISBN 978 1 84868 362 4

British Library Cataloguing in Publication
Data. A catalogue record for this book is
available from the British Library.

Typeset in 10.5pt on 13.5pt Sabon.

Typesetting and Origination by FonthillMedia.
Printed in the UK.

# Contents

Acknowledgements 7
Introduction 9

1 EVACUATION 13
Evacuees and Exiles 13

2 HOME DEFENCE 37
Local Defence Volunteers (LDV) to Home Guard 37
The Glorious Glosters 45
Air Raid Precautions (ARP), Voluntary Bodies 50
Observer Corps and Special Constabulary 59
Fire-fighting Services 62
Invasion War Books 66

3 AIR RAIDS AND AIRFIELDS 75
Warnings and Precautions 75
Air Raids 85
Airfields 107
The ATA and the Spitfire 118

4 SECRET SERVICE 127
Press and Propaganda 127
Personal Diaries 132
Intelligence and Spies 135
SOE and SAS 143
The British Resistance – Churchill's Secret Army 150

5 WAR EFFORT 157
Production 157
Saving and Salvaging 172
Fund-raising and Entertainment 176
Troops and Refugees 185

6    DIG FOR VICTORY                          201
     Land Use                                201
     Land Army                               210
     Pests                                   218
     The Kitchen Front                       223

     SEVENTY YEARS ON                        239
     Polish Hostels                          242
     Epilogue                                249

     INDEX                                   251

# Acknowledgements

I would like to express my thanks to the many people mentioned in the book for their kindness in helping me collect material for it. In addition to those whose names appear either in the text or in picture credits, my especial thanks go to the following: H.N. (Andy) Andrews, DFM; Derek Archer, editor of *Glo'shire at War*; Jack Archer; Richard Arquati, RIAT; Paul Aston; D.A. Attwood, Aviation Archivist, RAF Hendon; Joan Baxter; Roger Beacham, Cheltenham Library; James Belsey, *Bristol Evening Post*; Jane Bennett, Clerk to Quenington Parish Council; Bingham Library staff; Peggy Bridges; Richard Briley; Bob Browning, author of *ECKO, Malmesbury*; Tim Bryan, GWR Museum, Swindon; Alicja Swiatek Christofides, author of *Fairford Polish Hostel 1947-59*; Jo Clark, Chair — Highworth Historical Society; Gerry Coles; Jenny Collyer; Robert Ely; Mrs Eley and Mrs Haslem, Gloucestershire Records Office; Lilian Foster; Phyllis Glavor; Gloucestershire City Library staff; *Gloucestershire Echo*; Gloucestershire Federation of Women's Institutes; Gerald Green; Major Martin Green, author of *Warwalks, Stop Line Green*; Fred and Joan Haddrell; Alison Hobson, Secretary Fairford History Society; Stella Hoffman; Andrew Hoskins; Imperial War Museum; Cheryl Jones; Joyce Large; H.H. Lawrence; Margaret Lawson; Joy Lofthouse; Don Miles, DSM; Dr Gordon Mitchell; Urszula Wasilkowska; David Mundy; Miss C.A. Muskett, The National Farmers' Union; Paul Newton-Smith, Highworth Historical Society; Cyril Palmer; Peggy Perrin; David J. Poole, Lister Petter of Dursley; Bill Porter; Lt.-Col. H.L.T. Radice, MBE, Gloucestershire Regimental Headquarters; John Rawlins; John Rennison, aviation historian and author of *Wings Over Gloucestershire*; Dorothea Rettie; Brian Routledge, author of *RAF Fairford 1944*; Jessica Scantlebury, Senior Archive Assistant, the Mass Observation Archive; Heather Shuttlewood; Anne Smith; Frank Smith, Wycliffe College; Ralph Smith; Brian Stephens, Smiths Industries, of Cheltenham; David Viner and staff, Corinium Museum; Mary Vizor; Arline Vlietstra; Marian Walecki; Chris Walker, Chairman, Burford History Society; Malcolm Whitaker; Ralph

Wilkins; *Western Daily Press*; *Wilts and Gloucestershire Standard*; Reg Woodford, Steward, Gloucester Cathedral; and finally, but by no means least, my thanks to my publisher, Alan Sutton, for his interest and support in getting this second edition published.

# Introduction

It was proposed by the Chairman, Mr A. Hobbs, and seconded by Mr
Pink, that a resolution be sent to the League of Nations or National
Peace Council stating that we do not want war.

*Quenington Parish Council Minute, 25 July 1935*

An outstanding childhood recollection of the Second World War years was
my grandfather's indignation that despite a Peace Ballot being taken in
the village, and not one of the 300-odd souls of the parish being in favour
of war, war was eventually declared. So often did Grampy Lewis mutter
darkly about it that I believe he took it as a personal affront and insult to
the better judgement of the small Coln Valley village in the heart of the
Cotswolds.

This is not a book about the battles and strategies of warfare; it is about
the folks at home, about how they coped with the efforts to defend their
home patch from threatened invasion; about how resolute and resourceful
they became to carry on living as normally as possible under abnormal
conditions; about their strive to be self-sufficient, how farming and fac-
tories changed the course of production; about how city children came to
double the size of the village school; and of how mothers turned their hand
to munition work and grandmothers sacrificed saucepans for Spitfires, and
every schoolchild became a fruit-and-nut hunter of the hedgerows — all
for the War Effort.

This was the national picture of a country at war. This book looks
at one region, the Cotswolds — the very name of which conjures up a
scene of idyllic peace, some spots hardly touched by events of a thousand
years. It is a vignette of that period 'during the war', as national policy
was interpreted on a local level and became part of the fabric of ordi-
nary everyday life. Austerity as well as necessity became the mother of
all inventions: conkers turned into munitions, corsets to parachutes and
camouflage created a culture all of its own as kerbs were whitened and
windows blackened.

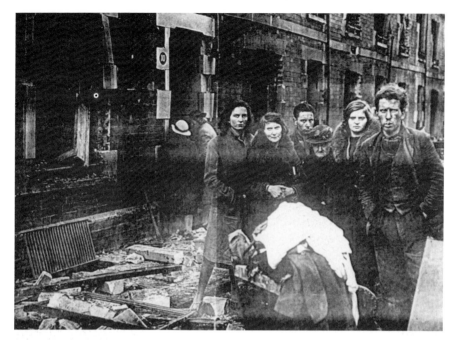

A family gathers together what little is left of their belongings after a bombing raid in Cheltenham. (Left to right) Mrs Green, Amy Hanks (née Peart — Annie's daughter), Leslie Hanks (Amy's son), Annie Peart (Amy's mother), Eunice Hanks (Jim's wife), Jim Hanks (Amy's son).

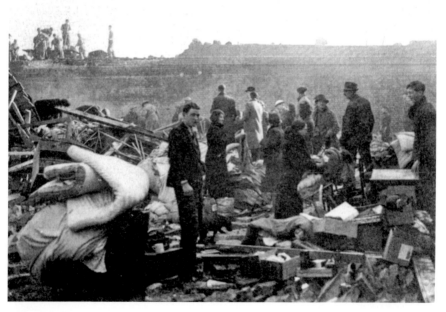

Salvaging what remained of their homes after a blitz on Stoneville Street, Cheltenham (Courtesy, Cheltenham Reference Library).

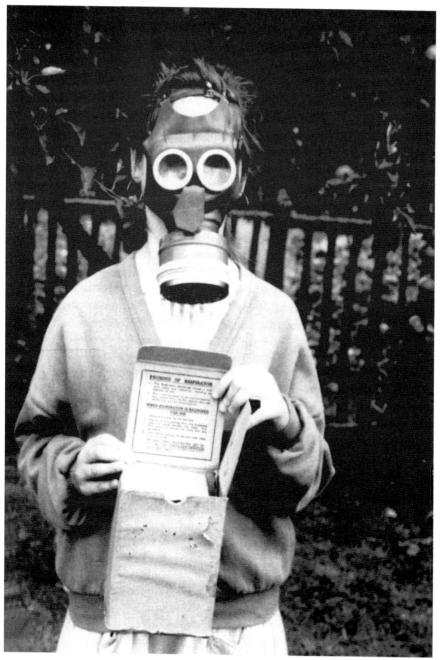

Mickey Mouse gas mask; the floppy nose was to make it more fun for children to wear.

There was unity of purpose, but also instances of discord: fierce parochial pride bred inter-parish rivalry on such issues as to which village should have the pom-pom, or which had made the most jam or salvaged the most scrap. Clubs and funds were formed for pigs and potatoes. Passwords and propaganda became part of a new language; new music with catchy tunes and bold lyrics kept up the spirits while the country worked.

Seven decades later, the Cotswolds still bears a few reminders of the part it played. Tracts of lonely airstrips, draughty hangars, look-out bunkers, and fading initials scored in tree-trunks cataloguing many a lovers' trysting place on the periphery of deserted camp-sites bear witness, and war memorials have become part of every town and village. Much of the landscape, changed for those war years, remains at it was then although, inevitably, industrial and housing developments have been built to meet the demands of a modern society.

It was the social structure, virtually unbroken since feudal times, that was destroyed irrevocably. The pieces picked up after the war did not fuse again into the pre-war pattern of life and this is why that special 'during the war' period is such an important slice of our social history and must be recorded. It belonged to a generation — to a time — and so it seems appropriate to gather up the scraps and snippets and re-kindle fading memories of the Cotswolds at war. In this second edition, I have retained the format and much of the original *The Cotswolds at War*, first published in 1992, and added new material that has come to light giving an even wider picture of just what was happening in these quiet country corners and present them with much pride, a little pathos and, I hope, a liberal sprinkling of humour — lest we forget.

# CHAPTER ONE

# Evacuation

## EVACUEES AND EXILES

Of all the upheavals endured by the people at home during the Second World War, the evacuation scheme must rank as the most profound sociological experience. It was designed primarily for the safety of the youngest members of the nation, but it affected the family life of millions.

Aerial bombing attacks were generally believed to be imminent and this expedited evacuation plans to the Cotswolds as early as April 1939. Tetbury Rural Council was informed that 800 children from London would arrive by train at Kemble Junction on the second day of evacuation, and they were to be taken by road by Western Traffic Commissioners to several parishes. Billeting Officers were appointed by the Rural District Council to each parish, assisted by the Women's Voluntary Service (WVS). Contact with the Assistant Director of Education for London County Council would secure full particulars of the evacuees to enable them to be labelled to their destinations, thus simplifying the work at Kemble.

Cirencester prepared for their anticipated 800 in June, with the railway personnel kitted out with red armlets for the urban area, and white for the rural area. The Corn Hall was designated as the reception centre where refreshments would be given. It was all for nothing. Evacuees did not arrive; 1,000 billets were not used, and a spokesman admitted to the press that he was 'unable to comprehend what has happened'.

The first batch arrived on Friday 1 September: 474 children with 58 teachers and helpers; of which 304 were billeted in the rural district. 'A sorry procession, but surprisingly brave' was how the *Wilts and Gloucestershire Standard* described them. Many clutched teddy bears and dolls in their hands and they looked tired. Swollen eyes told of tears shed at parting with their parents. The children had arrived, but there were no immediate supplies of helmets or respirators for younger children. At Northleach, the story was similar. The evacuees arrived with their own gas masks, but the local village children had none. A vanguard of furniture

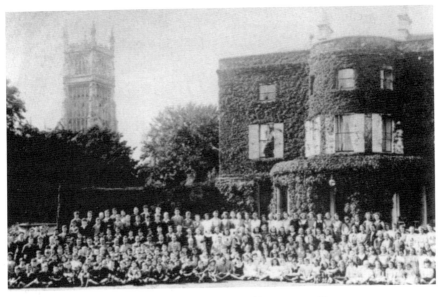

A group of evacuees from Barking in front of the Abbey House, Cirencester.

vans, closely tailed by the owners of the furniture, joined the exodus to the country, vainly hopeful of finding an empty house.

Gloucester received 1,081 children and 163 teachers and helpers on the first day of the official evacuation scheme; all to be billeted and schooled in the city. Some 500 mothers with babies and toddlers followed. A further 4,530 children in officially organized parties came to the county in the westward migration from the Home Counties.

As the initial air bombardment did not materialize there was a gradual drift back to the cities, only to be followed by a further evacuation, mainly from London and the south-east, as the war intensified in Europe the following spring. By July 1940 the figure of evacuees touched 5,000.

The Ministry of Health had issued leaflets to the householders and the evacuees stressing the importance of evacuation and appealing for tolerance and help from both foster and fostered families. Just how this affected those householders and evacuees is better told in their own words. Fifty years later, the evacuees recalled their memories of the evacuation to the Wychwoods and Burford parishes.

The days before evacuation
We were told we were going on holiday for a fortnight... there was much hustle and bustle... my parents pulled a confidence trick... I don't think we knew what it was all about mothers trying to hold back the tears... labels, gas masks and pillow cases, and marching in twos.

Dagenham children went down the Thames on pleasure boats with a battleship escort to join the special trains to the country areas.

On arrival in the reception area
(at Chipping Norton) we were hot, we were thirsty, and we were getting tired. We were given a carrier bag each, in which we had a tin of corned beef, a tin of Nestlé milk, a bar of chocolate and some biscuits. I remember seeing sacks filled with hay and straw and thought that this was where we were going to stay. Then Mr Berridge took us to our billets, but the old Baptist schoolroom was where we had our school, with our own teachers, quite separate from the village school.

As we got into the car, she told us not to kick it, she seemed nasty... a terrible feeling of not being wanted. It was a change, coming from a three-bedroom council house to live in the Old Prebendal... He said he had heard all about Londoners... I cried every night in bed... the foster father swore at us and said we could only go in the house at mealtimes and to go to bed. If it rains you go in the wash-house... It was dark, we did not know that there were fields outside... our lucky star shone on us that night, and it did for the rest of the war.

The foster home
They did their best to be kind... I looked on Mrs B as my second mum... I was an only child, now I had a ready made brother... the family were poor, but I loved it there... we did not know how to call the servants. We were among the few evacuees to have a billet with inside bathroom and toilet... we were given baked potatoes for dinner every day, and always gooseberry jam for tea. My bed was supplied by the billeting authorities, it was canvas stretched over two poles. Any change in our living standard was a change for the better, I had a bed without bugs.

I was only four years old; the youngest to be evacuated with our school. We were told to stick together, which was a good thing as there was a lot of confusion... we were labelled at the school and given our gas masks. We only had a tiny satchel with our little bits and pieces in. We should have gone to the West Country, but it was a bit of a hit and miss where you arrived. At the first house we stayed in, the old lady wouldn't tell us where we were, we were frightened and anxious to write home. Perhaps she thought we were Cockney spies. We then moved to a farm... we had never seen pigs before, then there we were boiling up their feed and using long-handled ladles and carrying coal down country lanes. It's strange how much we all learnt about one another's lives.

I arrived on the evacuee train on 1 September 1939, got out at Witney — and never went back. From the station we were crocodile marched to the Grammar School; as we went down Corn Street the folks came out of their houses and selected us from the line. First of all I was taken in with my two sisters, I used to get kicked out of bed by the other son. After that we were split up and the Buckinghams took us in. They had three daughters.

That was the first time I had ever had a good Christmas present. I was allowed to choose my own box of sweets from a catalogue. I kept it for weeks. Mrs Buckingham worked in the blanket mills, we used to thread her looms for her on our way to school.

I had never seen a cow before and was terrified to go across the field, but at 9 years old I was working on a farm at weekends and holidays. We had a card system by which you could get off school to go potato picking. You also had extra cheese ration if you worked on the farm. You also had extra clothing coupons if you took a size 6 and over in boots. I remember going to school in size 6's, my feet floated about in them they were that big for me — but I was popular with my five older sisters who were delighted with the extra coupons!

Impressions of the Cotswolds
Everyone had cycles and funny accents... That's not a real siereen, that's an 'ooter... sunny Sundays, with planes... I found apples grew on trees... you could see all the way from Idbury to Leafield. The Evenlode, how big it was then. In front of the three cottages opposite ran a small brook, it seemed so idyllic... scenery like a picture book. It was another world, one which we grew to love... we played in the fields instead of the streets.

What evacuees missed away from London
My freedom... Sunday morning tram rides… trips to Southend... the trolleys, trains and shops, and Saturday cinema.

On return to the London area
I felt closed in and found it difficult as I had changed... friends that I had left behind had changed... people were friendlier and more cheerful... after the family had been split up we had difficulty in re-adjusting to one another again.

London was noisy with too many people... we had to queue up for food that was plentiful in the Cotswolds — such as vegetables. Our house was boarded up — It was depressing... there were big open spaces where bombs, mines and rockets had fallen... my mother managed to buy a few pieces of utility furniture and the rehabilitation people gave her a couple

of ex-ARP beds and some blankets. I was resentful at returning to the poverty we had known pre-war.

Comments from the foster homes
The youngsters were billeted on the poor, not the rich... once you had taken them in the billeting people did not want to know... they never called again. I was asked to take them in for the night, they stayed years.

I can't remember where we all slept, we certainly didn't have enough beds... we bought two beds from the Basque refugees when they moved out of St Michael's... when her three evacuee children arrived my mother sat down and cried. It was the daunting prospect of finding enough food for her new children; when the evacuees left we *all* sat down and cried.

They never ate potatoes till they came down to the Cotswolds, they had piccalilli with everything. By going potato picking they earned enough to pay for their boots... clothes had to be laundered on Saturdays so that they were ready to wear clean again on Mondays. They took some time to get used to going to chapel on Sundays.

The evacuee parents pinched the potatoes from the allotments... our evacuee's mother was a snob, she moaned about many things when she came down here to live. She walked to Foxholes to work, but after the bombs dropped at Idbury she went back smartly ''cos it's worse than London'.

Evacuees arriving September, 1939, destined for Shipton and Milton-under-Wychwood.

The invasion of evacuees on small village schools meant many dou-
bled in size overnight. Resources were stretched to their meagre limits.
Accommodation was often as scarce as stationery, and school was often
taken in the village hall, the vicarage and even in a room at the pub.
Shift systems were worked to allow both local and evacuated children a
share of the facilities but, mainly because whole schools were evacuated
as a unit with their own teachers, they worked as separate entities. The
'appointed day' for raising the school leaving age in Britain from fourteen
to fifteen years had been set in the Education Act of 1936 for 1 September
1939. But instead of it being Extended Education Day it became Extensive
Evacuation Day — the school roll in rural areas was raised and not the
school leaving age.

Feeding centres, established for 'necessitated cases', had been introduced
in Gloucestershire in 1934, for not just poor but proven malnutrition in
schoolchildren in an effort to restore the nation's health following a Royal
Commission report on physical deterioration. The service had halved by
the outbreak of war, but quickly became a government issue. Safeguarding
the health of the rising generation, and releasing mothers from the duty
of cooking a midday dinner to enable them to work in factories or on
the farm, were seen as priorities and local education authorities were
urged to set up a school meals and milk service as a matter of urgency.

Heavy camouflaged army lorries became a more familiar sight in the streets of Fairford
than farm wagons as the troops moved into the town. Edna and Eric Jefferies, with
evacuees Doris Halford and Vera Morse.

Feeding centres became 'school canteens'. A cooked meal of 2*d.* worth of meat, half a pound of fresh vegetables and a pudding was provided for 3*d*; with one-third pint of milk for a halfpenny it offered good value, nutrition and a heavily subsidized alternative to the half-a-crown a week which Cirencester WVS had calculated would only just cover costs when they researched the town's potential needs in July 1939. School canteens were entitled to extra points as priority establishments, but only the towns could benefit from the vouchers for dried fruits and scarce imported foods when the school canteen was officially recognized as a central point for communal feeding in an emergency. Where schools had no facilities for cooking on their own premises, local WVS and other volunteers somehow managed to produce hearty cooked dinners at some central point for the evacuees. The old carpenter's workshop in the Walnut Field became The Settlement for Fairford evacuees. Local people gave chairs and tables and a few odd rugs to make it as comfortable as possible, and it was there on portable gas stoves and in gas boilers that Mrs Gantlett, Lady Hirtzel, Mrs Perry, and a handful of other ladies introduced the East Enders to Cotswold country cooking.

The Settlement was open daily from 9 a.m. to 6 p.m., then the families moved to their billets for bed and breakfast. Aided by the WVS, the evacuated mothers started taking over the cooking, but local help was always needed, especially as it became a canteen as well when the Americans came to the park and the RAF to the air base. They, too, appreciated the

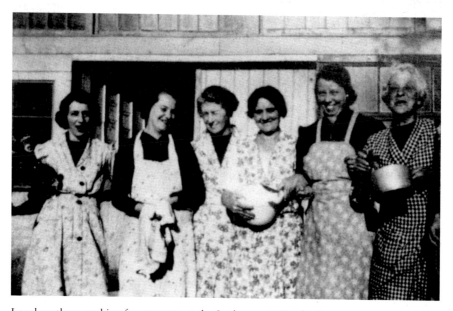

Local mothers cooking for evacuees at the Settlement in Fairford.

'Gloucestershire bag puddings' — mince roly-poly and suet puddings boiled in cloths in the big boilers. Farmor's School garden produced home-grown vegetables and local people donated apples. Mrs Walter Jones supplied gallons of skimmed milk at a penny a pint from Morgan Hall dairy, to supplement the local milkman's quota brought in heavy galvanized churns with brass labels. The vicar's wife and the formidable Miss Keble peeled potatoes and opened tins of pilchards, stirred oceans of custard and scared the children into eating prunes when their eyes turned to the carefully rationed out jam tarts. Mrs Rosemary Gwynne-Jones showed them how to make real bread pudding and Muriel Hoddinott usually beat even the most wily Cockney kid at football. She also introduced the city children to a form of cricket. Field exercises were carried out by the WVS, who were ordered to save fuel and had to construct 'camp kitchens', taking all day to cook a rice pudding in the ovens they had to construct from old bricks with wire netting on top. The old carnival trestles and benches were set up for the communal feasts.

The rehearsal for the Arnhem drop brought its own excitement to the entire district. The troops floated down with coloured parachutes, like poppies, then unfolded tiny bicycles like those ridden by clowns at a circus — and much to the joy and amazement of the evacuees, rode around the Walnut Field on them, then cooked their 'iron rations' on the field stoves. Even the inscrutable Miss Keble is said to have been in awe at the sight of it all — the double tin the troops brought to heat up had meat in the bottom half and a portion of pudding in the top. Lady Hirtzel, sensing the occasion portended something monumental in forthcoming manoeuvres, startled everyone by commanding 'Open all the jam', with the authority of an admiral issuing the order to splice the mainbrace. The big jars of emergency jam were opened and everyone had their fill of jam sandwiches.

The American Red Cross sent great bundles of 'wonderful' clothes. Rosemary Gwynne-Jones recalls laying them out on the trestle tables so that the evacuees could help themselves. The result was that some fancy and quite frivolous hats topped quite old and work-worn outfits. Rosemary Gwynne-Jones was one of the famous contemporary artists working under the official direction of the Ministry of Home Security as a War Artist and used the shed attached to the medieval dovecote in Park Street as her studio, opposite an old barn which served as an air raid shelter. She painted and sketched individual evacuees at The Settlement to become part of the five thousand works in the collection of national war pictures. Ivor Tully remembers how the evacuees bred rabbits to sell to the local butcher and how the timber from the old carnival store was raided for firewood in the desperately cold wintertime.

The state of some of the evacuees was a cultural shock for many Cotswold families and tales are legion of holey navy knickers, wet beds and nits. One cottager pleaded publicly in the local paper: 'Please tell me how to get paid for the board and lodging of the three children I have taken from London. We are beginning to get them house-trained — they are far worse than young puppies and kittens. Who is going to find me new bedding and clean wall papers?' There were numerous complaints that evacuees were sent to the country ill-clad, badly shod and unclean.

The RSPCA made an appeal to the hundreds who brought their pet dogs with them into the countryside to keep them under control, after serious cases of sheep-worrying were reported resulting in loss of valuable food animals.

The Dorcas Society burnished up their Victorian social origins and revived knitting circles: flying needles producing blankets for evacuees alongside woollies for the Navy. Kind ladies from Kemble met weekly at the vicarage to knit socks and warm vests as well as blankets for the children who had been evacuated to the area.

One eight year old point-blank refused to eat his supper because he wasn't given 'his usual beer' with it. And an evacuated school mistress was bound over at Malmesbury after 'feloniously stealing one part of a bottle of brandy of the value of 9s.' Found to be 'in full possession of her senses', the teacher was duly summoned for breaking into the Duke of York Inn at 1 o'clock in the morning, by smashing a window and stealing the brandy — which she promptly started drinking. Hence being charged for only 'one part of a bottle', which she had in her possession when caught.

Minor ailments and casualties were dealt with at the Evacuee Hospital in a room over John Smith's the corn merchants in Cricklade Street. No. 50 Siddington Road housed five children needing special supervision, and the Cirencester WVS earned high praise for its 600 members who did everything from scrubbing floors to cooking meals at the feeding centres, as well as carrying out night duties at the Memorial Hospital when casualties from the Front were brought in, and keeping confidential reports on each evacuee child to monitor its well-being. Stratton had its own section. Nor should the invaluable services of the Girl Guides be overlooked. Mrs Joan Haddrell was involved with the Guides who were given the task of training the WI and WVS how to cook on an open camp fire, and the use of a haybox for cooking — these training sessions were carried out at Kemble. The British Restaurant in Cricklade Street, behind the old Church Hall, was opened by the WVS in October 1940, primarily for evacuees — although anyone could avail themselves of a nourishing hot meal with vegetables, pudding and a cup of tea for 9d.; children 6d., to augment their meagre rations.

Three hundred meals a day were being served at Stroud's wartime canteen at Bedford Street Congregational Church schoolrooms within the first few months of the war. And boy evacuees borrowed tools from the park superintendant to start cultivating half an acre on the site of the new Crypt School at Podsmead to grow food.

Believed to be the first effort by evacuees to mark their appreciation of the kindness and hospitality given them by their Cotswold hosts, twenty-seven pupils and their teachers from the Russell Centre School, West Ham, entertained the villagers at Sapperton at a Christmas concert in 1939. Choral verse speaking, mimes of a boxing match and a girls' singing lesson were followed by Mr Bren Brace the headmaster of the Sapperton Centre, singing songs. A good time was had by all, and £6 was raised for the Village Hall

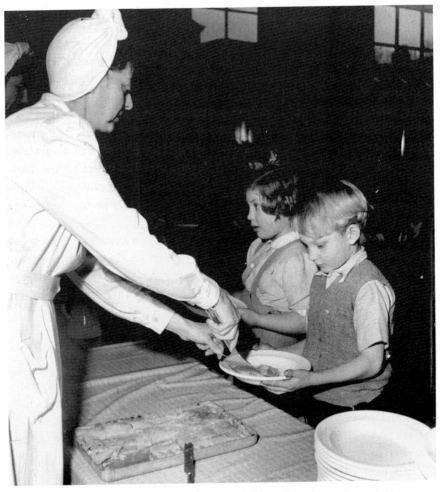

School dinners were introduced during war-time (Courtesy, Ministry of Education).

funds. The kindness of the Salvationists of Tetbury to the young people of the Air Ministry evacuated around Westonbirt was repaid with a performance by Victor Peacock and his talking parrot and toy dog. Such performances had, the press revealed, been previously confined to Eton and Harrow.

The boys evacuated from Russell School, West Ham to Somerford Keynes became the subject of a bitter battle between the villagers and the London County Council five weeks after they had settled happily in their country homes. Mrs Isa Fawcett of Somerford Keynes Manor spoke on behalf of the angry and upset women 'whose kindness to these boys has been thrown back in their faces', and the parish insulted by the heartless manner in which the headmaster had the boys removed to Cirencester. It is about time that the LCC told that schoolmaster that 'the methods of Hitler cannot be allowed in this country.' She added that the boys had been given bicycles to save them walking to school and quoted instances of village families making the boys feel part of them; they were enjoying the country life and were extremely happy and well behaved. Their parents visited frequently and were delighted both with their own reception and welcome in the village and the way in which the boys were being cared for and treated as one of the family. The arbitrary action of removing the boys with very little notice caused bitter resentment as it transpired that the West Ham Authority had decided 'that the boys were better off in the town for educational reasons'. The juniors would have gone to the village school in Kemble and the seniors would have cycled into Cirencester, the same as their village contemporaries. Pleas from the parents, headlines in the press that 'Somerford Keynes Wants Their Boys Back', and the boys' own wishes were ignored. Several boys returned to London and the raids before Christmas.

The proximity of hastily constructed airfields to villages made their mark on many schools, as at Down Ampney which opened early in 1944 under the control of No. 46 Group Transport Command, and played an important role in the Arnhem and D-Day operations as well as the evacuation of some 20,000 wounded servicemen.

The Down Ampney School Log Book records:
**1943** 23 June: The playing field was taken over by the Air Ministry.
30 Aug: The Alex Farm children did not come. Unofficially informed that they are to go to Cricklade School now that the airfield has cut off their road.

At the next village, Kempsford Log Books give a glimpse of disruptions and diversions:
**1938** 29 Sept: Head Teacher was not at school from 10.30–11.30 a.m. for Air Raid Wardens Gas Mask lecture in the Village Hall.

**1940** 18 June: Admitted 28 evacuees, ages ranging from 6 to 14 years. The large age range and lack of accommodation necessitated using the Village Hall.

21 June: One evacuee from Whelford and two from Ampney admitted.

Numbers on roll: Kempsford 80; Evacuees 31.

5 Sept: Owing to disturbed night (Air Raid warning lasted 7 hours) many children tired this morning. Registers closed at 9.30 and 11.30 a.m., the whistle was blown for all children to disperse quickly to nearby houses in view of any future Air Raid warning.

19 Nov: Air Raid warning (Red) received by telephone at the School House at 1.25 p.m. Children were immediately dismissed to nearby houses as arranged, and all were out of school and Village Hall within 2 minutes.

3 Dec: Air Raid warning (Red alert) 2.45 p.m.

6 Dec: Lost another hour for Air Raid warning.

**1941** 14 Feb: 1 ton 10 cwts [1.5 tonne] of coke and 3 cwts [150 kg] coal received. This has to be charged to the Evacuation account.

18 Feb: Air Raid warning 1.15 p.m.

27 Feb: Air Raid warning (Red) at 2.10 p.m. Then a second warning received at 3.15 and children dispersed to their arranged nearby houses. On this occasion the All Clear did not go until 5.20 p.m.

1 Oct: No school today as the Correspondent received notice to close until 6 Oct to allow children to assist in potato gathering.

**1942** 23 Feb: Roller towelling (20 yds [20 m] linen) returned and rough Turkish asked for. The firm was asked why 20 coupons had been asked for.

6 March: Five children sat for the Evacuee Scholarship examination. 17 evacuees on roll.

14 April: As all farmers and others in the district are working to the new time (Double Summer Time) and dinners are at noon, School opened at 9 a.m. as usual, and will continue to do so.

15 May: Monitress, Lilian Witchell, sent to Cirencester this morning by the Head Teacher (Head Warden of ARP) for gas masks which are urgently required.

30 June: Several children away this week haymaking. Employment cards have been issued.

15 Sept: Older children gleaning, and Classes II and III out picking rose hips.

**1943** 28 Feb: Paid £2 5s. for 9 pairs wellingtons, also 33 coupons.

9 June: Mr W.R. Watkin, Secretary for Gloucestershire Education Committee, called this morning. Some of the older boys were sorting

books collected under the special salvage scheme. Mr Watkin inspected the collection and the lavatories.

17 Sept: Some families away this morning reporting that an airman had landed in a tree by parachute. They all returned to Hannington Wick.

20 Sept: I have ascertained that there was no truth in the story told last Friday about the parachutist.

29 Oct: School dismissed at 2.50 p.m to allow Head Teacher to attend Home Guard exercise.

**1944** 1 Nov: Stanley Chesters, last evacuee on roll left, having reached school leaving age, and Norma Wing transferred to Evacuee register.

**1945** 24 May: At 3.40 p.m. the whole school was taken to Kempsford House (Col. A.W. Parsons) for Victory Party.

The plans for secondary education to be centred on Farmor's School at Fairford, serving some thirteen villages, had to be shelved for the duration of the war as the education of evacuated children took priority.

A newly-opened feeding centre which later became a school canteen. (Courtesy, Ministry of Education).

Farmor's School Log Books record:

**1939** 31 Aug: Owing to National Emergency, all teachers returned from holiday today.

1 Sept: 69 children with 4 teachers and 4 helpers evacuated from Princetown Street Council School, Holborn, received this evening.

3 Sept: War declared.

**1940** 14 May: Schools throughout the country ordered by Government to re-assemble owing to war conditions caused by the German invasion of Holland and Belgium.

14 June: Received the second batch of evacuees owing to the increased gravity of the national and international conditions. Admitted 57 official evacuees from Barking, and 3 unofficial. Two teachers are with them in two classes. Our Woodwork classes are now discontinued as the Woodwork room is used as a classroom to accommodate them.

21 June: Mr Robin Tanner, HMI, visited to discuss the evacuees. We now have 97 merged with 137 local children.

**1941** 30 May: A Flight of the Air Training Corps has been formed in connection with the Evening Institute. Thirty lads are receiving pre-entry training before taking up duties with the RAF. This school is used as Headquarters.

**1942** 12 Jan: Rolls Royce Kestrel aeroplane engine installed in Woodwork room for the instruction of ATC cadets. The room is also being adopted for instruction of Flight Mechanics E.

30 June: A branch or company of the Girls Training Corps has been formed with 40 members. Miss A. Smith, LCC evacuated teacher is Commandant.

**1943** 25 June: Miss Biltcliffe, Domestic Science teacher, is removed today temporarily to take charge of a RAF Canteen in Cheltenham Technical College, so Cookery is suspended here pending the arrangements.

**1944** 18 Sept: Miss Biltcliffe absent today and for the rest of the week to be married. Her fiance is on draft from overseas and so the matter is being rushed. I have cancelled Cookery classes for the week.

**1945** 22 March: Women's Land Army class closed this evening. They can take Cookery instead.

Neighbouring Lechlade, with whom Fairford had long been a friendly rival as is the case in small communities of equal size and stature, could lay claim to receiving evacuees a year before hostilities began 'just in case', and the dubious honour of having its school grounds strafed on one occasion.

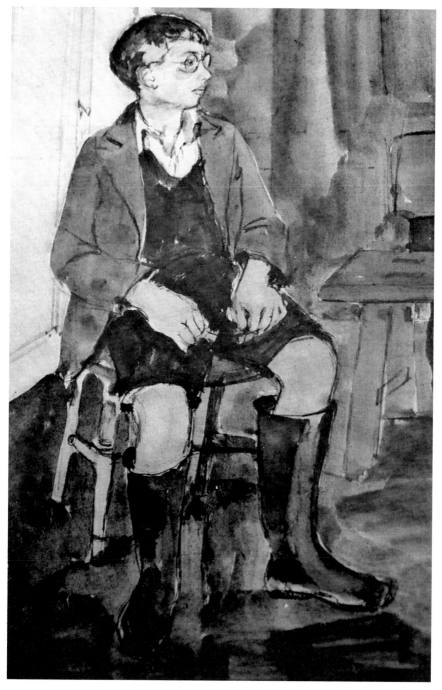

An evacuee at the Settlement, Fairford, painted by Rosemary Gwynne-Jones, for the War Artists' collection.

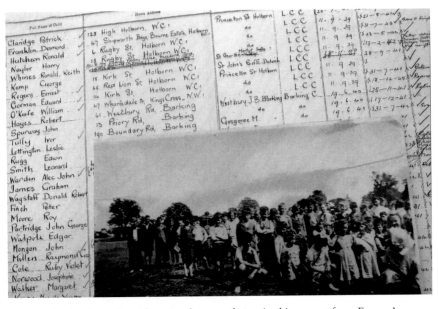

Evacuees had to be registered separately — as shown in this extract from Farmor's School, Fairford.

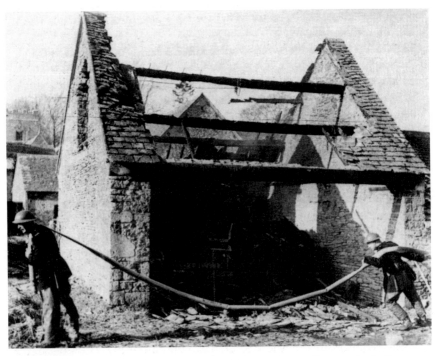

Farm buildings were among many damaged buildings at Upper Slaughter in the last notable raid on the Cotswolds in February 1944. (Courtesy, Cheltenham Reference Library).

Lechlade Log Books record:

1938 3 Oct: Nine children from London, having been evacuated last week on account of the possibility of war. They include 5 girls from Dr Barnado's Village Homes at Barkingside.

1939 18 May: For several weeks work has been seriously interrupted by the noise of aeroplanes.

24 May: The noise made by a Harvard today has been so bad that a complaint has been made to the OC at RAF Station, Brize Norton by the Head Teacher, asking for relief from this noise.

19 Sept: Nurse Twinning inspected the heads of 89 Lechlade children, 31 Government evacuees and 17 privately evacuated children.

15 Dec: No examinations are being held in written work this term, owing to the necessity of conserving paper supplies.

20 Dec: The Christmas Party was held in the Memorial Hall as it became available through the departure of the troops using it.

At North Cerney the outbreak of war appeared as the briefest mention. Coughs, colds, the choir outing to the pantomime, and the bumping into a drainpipe by Kenneth Weaver, warranted longer entries in the Log Book; and German measles certainly caused more concern than German warfare.

However, the invasion of ninety-five evacuees to the small village must have disrupted the rural routine, and perhaps it is a tribute to the stoic nature of school communities to absorb such upheavals that few incidents were deemed worthy of recording for posterity during those long years. Forty of the evacuees were accommodated at Rendcomb and Bagendon, and North Cerney Village Hall became a schoolroom for three years. And yet the traumas and deprivation and the added burden of administration appear as nought beside the enormity of such mischief as Tony Baxter got up to: 'rubbing red chalk on his cheeks and wasting time', and Basil Freeman 'cutting up a shoe-bag' while the Head Teacher's back was turned.

Troops in the north Cotswolds made merry in Temple Guiting School when it was opened up to them for recreation. The Head Teacher recorded: 'They made good use of the piano, but used my blackboard for tap dancing' — and duly reported such goings on to the vicar. The 'good use' of the piano turned out to be a taking over and became the subject of some lengthy correspondence in which it was made clear that 'the Hall has been requisitioned by the War Department and is not available to the Parishioners, but the piano was not taken over in the order. It was certainly not intended for the private use of a Government department'.

Temple Guiting Log Books record:

16 July: M. Morley and Miss Waghorne called to arrange about using the school for wartime cookery classes instead of the Parish Hall, now occupied by soldiers.

2 & 3 July: Lessons taken in the open air owing to risk of infection (scarlet fever). Vaccinations given.

7 Aug: Only 41 present out of a possible 71. Reasons — whooping cough, scarlet fever, evacuee parents visiting and Cutsdean Sunday School outing.

1942 6 Jan: The Monitress, Miss P. Butler, has left to work in a munitions factory.

24 June: New face pieces fitted to gas masks by the Chief Air Warden, Revd R. Butler. 18s. 8d. taken in school for gas masks and boxes. Four sums of 1s. 6d. sent direct to the Vicarage. A letter was sent home to each parent saying that school would be open each morning at 9.30 for 3 weeks during the Harvest Holiday to allow mothers to continue work in canteens and munitions.

1943 31 May: Two weeks without a school cleaner. The children and teachers do what cleaning is done.

Milton-under-Wychwood Log Books record:

1939 12 Sept: 86 evacuated children have been admitted to this school from Upton Cross, West Ham. The Baptist Chapel schoolroom and the British Legion hall have been obtained for use, and the Milton children and London children use them alternately; desk-work being taken at the school, and oral work in the hall.

Shipton-under-Wychwood Log Books record:

15 Sept: Accommodation having been secured at the Red Triangle Hut a single shift was adopted using the Hut for oral lessons and the school for written work.

18 Sept: Application for admission has been sought for Basque refugee children now resident at St Michael's Home. I cannot admit as I am without a Certificated Assistant.

20 Dec: School will be available during Christmas holidays as meeting place for evacuees.

1940 12 July: There is no special arrangements of air raid shelters here, but the school has a Fire Stirrup Pump and two buckets for fire fighting. Ordered wooden battens and wire netting to protect windows against splinters.

13 Nov: Headmaster requested to attend an interview with a view to proceeding on Military Service as a Staff Officer.

6 Dec: This is my last day at school for the duration of the war.

9 Dec: The wooden hut in the playground (formerly the Cookery Centre, but taken over by the Military as a canteen), has been burnt down during the night. The classroom door forced off, and the Stirrup Pump from the Infants Room missing.

14 Dec: Missing pump found in the store-room.

**1941** 30 June: Boy caught in the act of taking chocolate from school supply, same boy in trouble with Police over theft of mole-traps.

2 July: Owing to refusal of petrol rationing; authorities to allow me supplementary ration for travelling to school, I today started the journey by train. The latter was 21 minutes late.

13 Aug: Material for making besoms for fighting possible fires in corn crops (from incendiary bombs) received from RDC. Started some senior boys on making them.

14 Aug: Used up last of brushwood — only enough for 58 brooms.

19 Dec: I have had no teacher for Class II since 10 Dec. The Vicar kindly took boys for football this afternoon.

**1942** 6 Jan: School even colder — 35° (F) in my room. Coal still not delivered. Reported this to the Vicar.

9 July: Mrs Hewlett called regarding Rest Centre, explained that food could not be stored in school because of dampness.

**1943** 9 Sept: News of Italian surrender was marked on this occasion by an extra play taken during Scripture period.

At Cold Aston School some seventy-five evacuees came from many different schools, and experienced action in the countryside. Several planes crashed nearby in November 1939 and all pupils were taken to see one that had crashed in dry ground. The lobby was turned into an air raid shelter, and in February 1941 the school windows were loosened when bombs fell locally. Official reports list the village as Aston Blank — a double name under which it has endured for many years — so, it is as Aston Blank the bombings of 17 January and 15 June 1941 appear; the first included eight high explosive bombs and 'several' incendiaries.

Nether Swell School in the North Cotswolds tells its own wartime stories through its Log Books:

**1939** 21 July: Heard from Gloucester, plans for evacuation and to be ready to receive 51 more children.

13 Sept: I saw Mr Oughton, one of our school managers, to discuss our plans in the event of an air raid. He suggested we took the children who stay for dinner into his cellar. Those that live nearby to be sent home.

**1940** 8 April: Mrs Dugdale sent a parcel of wool for the girls and boys to knit scarves for the soldiers.

1 May: Children brought prettily decorated maypoles to school. They are collecting money to buy wool for the soldiers.

12 July: We are all collecting old aluminium and have already collected 40 sacks of paper. Gave two boys permission to go pea-picking as Mr Izod is short of men.

22 July: Glos Education Office sent a member of their staff to see what provision could be made for air raid shelter. We at once painted over the lobby windows where we shall shelter — with the anti-splinter solution which he brought.

31 July: The men came and blocked up the lobby windows — the lobbies are now prepared as shelters.

**1941** 7 Jan: Very poor attendance owing to several evacuated children staying away because of snow and bad weather. The vicar brought two buckets to be kept full of water in case of fire bombs. Sand is also on order.

28 Feb: Had gas mask drill — wore them for 10 minutes this morning. Sent the pamphlet on pig-keeping to each man in the village who keeps pigs.

24 & 25 March: Scholarship examination held on two mornings this year in case we might be hindered by raids. 11 sitting, including evacuees.

**1942** 2 March: Wrote to the Food Office as we need soap for school cleaning.

26 March: The vicar borrowed our map of the world to use when lecturing to the troops.

16 April: It seems better for the children to have school from 12.45 to 3.15 p.m. The big children can then go to help on the farms.

24 April: No wood can be obtained for lighting the fires in school, so the children are collecting it from the countryside and bringing it to school.

22 May: Received 2 lb [0.9 kg] Cod Liver Oil and Malt for Billy Ferriman.

17 July: We are to remain open for the school holidays. Mothers who wish their children to have milk, must be here at 9.30 each day and attend regularly for it.

9 Oct: Wrote for 8 more sacks for chestnuts. Sent off another parcel of socks, scarves and pullovers of our knitting for the Red Cross to Mrs Bailey.

25 Nov: Permission from Gloucester for children over 12 to use the rest of employment card for potato picking.

**1943** 8 Dec: Have heard that some of the boys were playing with live bullets last night. Have written to parents of the boys to find out if there are any more in their homes.

**1944** 21 Jan: Leslie and Judith have given in their 'Micky' masks and are waiting for new ones.

4 Feb': Have heard that one of the bombs dropped on Upper Slaughter has damaged the school there.

**1945** 5 Feb: 49 bottles of milk were collected by the children from Mrs Oughton. They were paid for by Gerald Clarke, who had the milk book receipted by the Land Girl.

23 March: Received 6 pairs of Wellingtons—a gift from the Queen; no money to pay, only coupons.

11 May: School was closed on Tuesday and Wednesday for Victory in Europe. The children are having a tea and sports on Saturday.

**1948** 6 Feb: A crate of food, a gift from the South Australia Schools Patriotic Fund, arrived today. It contained 12 packages, and in each were 2 camp pies, 1 tin barley sugar, 1 tin jam, 4 jellies, 1 pkt crystallised fruit, 2lb [0.9 kg] sugar and 1 tin of beef dripping. This food will be used in our school canteen and will be served as extras above the ordinary daily menu.

The recollections of evacuees at Bibury by Miss Hearne and Miss Taylor were of one little boy who presented Miss Taylor with a big bunch of dandelions, thinking they were the best flowers he could present her with on a nature walk. Another little boy, called George, was absolutely amazed at the sight of apples hanging on a tree and asked rather awesomely, 'Do 'em leave 'em out all night?'

All was not quiet on the female front, though. There was almost war over nits. The wrath of Cockney mothers against a couple of the country ladies knew no bounds and created such a furore that a special meeting was called to ascertain exactly why two evacuees were whisked away back to London, to 'be disastrous to the scheme'. The Chief Education Officer of Gloucestershire was referred to Earl de la Warr's speech of 19 October 1939 on the dangers of such bad feelings between the village and the city ensuing out of the matter.

At Bibury it was a measure of *noblesse oblige* that the East Enders could not accept or understand. Not unnaturally, when the local schoolmistress found that the two evacuees living in the same house as herself were 'alive', she had words with the village nurse to help with cleaning them. Several children were duly taken to the village hall to be treated as it was not possible nor politic to do so at the school. The nurse took along the required carbolic acid, bowls, disinfectant, paper and solution and her own clip-

pers. She asked 'certain' ladies to assist her as there were quite a number
to be dealt with. The nurse reported in the official enquiry: ' I saw that J's
hair had been cut. Someone had brought some scissors, I knew it would
have to be cut and treated as I have never seen anything like it. It stood out
wide with nits'.

The official complaint from the London County Council legal adviser
was 'that L's head had been shaved and J's cut off'. The evacuated teacher
making the complaint stated that 'things were taken out of our hands and
those of the district nurse by the important ladies of the village. The hair was
cut off by Mrs X and her gardener, but as this was done in the village hall,
they were not actually seen doing it'. Such action, the legal adviser reminded
the Chief Education Officer, was 'unwarrantable, if not unlawful'.

It was not possible for the city folk to comprehend the fact that
countryfolk were quite used to having their hair cut by a self-appointed
village barber — whether he was gardener or groom by trade. It was still
the day of Sunday morning short back and sides and a look at the family
pig, and Mrs X vouched for her gardener's 'skill, as my sister has had her
hair cut by him'. The last Bibury saw of J was that of a bewildered little
girl, shorn of her nit-matted locks 'except for two little wisps in the front',
being bundled with her shaven brother with their battered brown paper
parcels into the back of an equally battered black car and driven off at
great speed to raid-ridden London and back to their bug-bitten beds.

Billeting was not confined to evacuees; soldiers and horses were finding
themselves in unfamiliar surroundings, and the Army Council were seeking
unoccupied houses as the population shifted around in the first weeks of
war. One penny a day for the use of an unfurnished room and 10d. a
day for full board were the rates for the soldiers; stabling with 10 lb (4.5
kg) oats, 12 lb (5.4 kg) hay and 8 lb (3.6 kg) of straw was sought for 2s.
3d. per day per horse. 'Retired' horses were called up from their country
pastures for duty in London streets, and dealers scoured the Cotswolds in
particular for small traps and dogcarts. A pony trap which sold for £5 in
August 1939, fetched £25 in September. Working horses suddenly became
in demand and £50 was the average price paid for one. Feeding stuffs
were rationed just the same as foodstuffs. By 1940 they could not be sold
without a licence. In February 1941 coupons were introduced by the War
Agriculture Committee for agricultural horses, racing and hunting stables.
Heavy draught horses were allowed 18¾ lb (8.4 kg) of oats, beans or bran
and normal heavy farm horses 9lb (4 kg) a day. An appeal for extra for
those in continuous and heavy work could be made. That horses should
be in such demand at a period in history when everything that moved was
measured in horsepower locomotion rather than the power of the animal
seems contradictory.

Nuns and nurses were also among those evacuated to the Cotswolds. Catholic nuns of St Marie Reparatrice from Finchley were accommodated at Rodmarton Manor to continue their teaching; and nuns moved into Piers Court — later the home of the Waugh family. Nurses with their small charges from the Adoption Society of London moved into Temple Guiting House as evacuated guests of Maj. and Mrs Cyril Stacey.

In some cases, Cotswold schools had to be evacuated elsewhere to allow their premises to be used by War Ministry bodies who were evacuated to the country. Wycliffe College at Stonehouse, a public school for boys founded in 1882, was accommodated at St David's College, Lampeter, for the whole period of the war; Wycliffe being requisitioned by the Government as the Meteorological Office. Some Air Ministry finance branches also moved to take over the Haywardsfield and sanatorium; the need for extra offices resulted in a group of wooden huts being erected on the school's playing field — a sacriligious act in any English cricketer's eyes — and, understandably, the school was said to 'be horrified' on its return in 1945. The meteorologists, reminiscing on their wartime 'exile' from South Kensington, reckoned that the staff and pupils of Wycliffe suffered far more inconvenience than they did.

Cheltenham also played involuntary hosts to the American forces. The town was practically taken over for the Forces of Supply. Emergency rations were stored in the Pittville Pump Room and Nissen huts mushroomed all over the Imperial Gardens. The boys of Cheltenham College were despatched as a complete school to Shropshire, but the redoubtable Miss Popham had to be reckoned with when Cheltenham Ladies College was requisitioned. She was a match for General John Lee, Eisenhower's deputy, and was adamant that 'her girls' were not going into exile. On receiving the deadly secret missive in 1938 that the Cheltenham Ladies College would be taken over in the event of war, Miss Popham is immortalized for her battle cry as she stormed the defence of the Office of Works: 'You won't be defending Britain if you break up the public schools'.

Then with skilful strategy devoid of military might, she filled the swimming pool, conveniently forgetting to mention that it was possible to floor it over at a moment's notice. Faced with such an area of water when floor space was at a premium, the Office of Works could do no other than provide her with twenty army huts to create forty classrooms. The wonderful Miss Popham may have accepted being evicted but never exiled, and after six weeks of being hutted she recalled the fact that the swimming pool could be floored over — and offered to exchange the huts for her own school buildings; an offer that was accepted.

# CHAPTER TWO

# Home Defence

## LOCAL DEFENCE VOLUNTEERS (LDV) TO HOME GUARD

When Anthony Eden broadcast an appeal on 14 May 1940 for men between the ages of fifteen and sixty-five to join up as Local Defence Volunteers (LDV), he warned 'you will not be paid, but you will receive uniform and be armed'. The response was phenomenal. Walking, biking and hobbling, the menfolk of Britain turned up at their local police stations to register. Within twenty-four hours the country as a whole had enrolled some 250,000 volunteers, equalling the might of the peacetime regular army.

Initially, there were no uniforms. LDV armlets, made by the Red Cross, Women's Voluntary Service (WVS), the British Legion and students of Cheltenham School of Art, hardly counted as uniform but became a label of recognition. Denim 'fatigues' arrived in June, boots and great coats in September, but it was not until early 1941 that battle dress was issued to the citizen army. Ovid was quoted: 'A negligent dress is becoming to men'; but the denim rather than khaki — of two sizes into which the tall and short, thin and fat and all computations in between fitted — was perhaps not the negligent garb it might at first appear to be. However, the Nazis had proclaimed very early on that they would shoot civilians under arms, so the 'maid-of-all-work' outfits were deceivingly makeshift.

Arms were as ill-fitted: pitchforks, brooms, pikes, rakes, even planks of wood, together with whatever old shotguns the squire and poacher donated for the cause, were mustered to the defence. But they served the purpose for the initial training of drilling and the actual carrying of arms. Many strange weapons, official and unofficial, saw service in the hands of the Cotswold LDV.

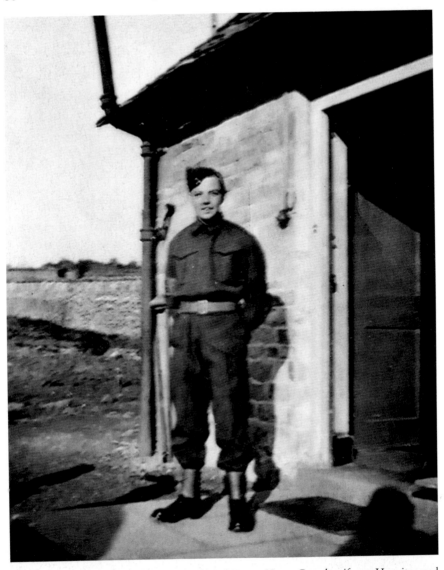

Bill Porter, proudly poses as a 17-year-old in his new Home Guard uniform. He witnessed the bombing of his home village of Swinbrook — the target for which, legend has it, was Unity Mitford, infamous for her friendship of Hitler.

Weston-sub-Edge Home Guard.

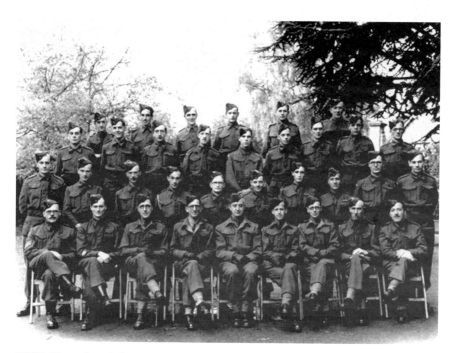

EKCO Home Guard Platoon (Courtesy, Bob Browning).

Tom Basford recalls those early days in the North Cotswolds LDV:

Look, Duck and Vanish, is what we were nicknamed. I was sixteen when
I heard the wireless announcement that a new defence corp was to be
formed. My old Dad and Uncle Bert, who were in the First World War,
had already joined and I remember I was on a horse rake when I decided
to volunteer. I was the youngest to join: I had to report to Hinchwicke
Manor which was the home of Mr Roger Pilkington, to see Mr Firth
the chauffeur. He handed me my uniform: serge uniform, steel helmet,
American rifle and a bayonet, gas mask, overcoat, side hat and the LDV
arm band, a leather belt and two cap badges — one to wear in the front
of the cap and one for the back — being in the Gloucesters. I was told to
parade outside Mrs Turner's shop at Snowshill and I caused quite a stir as
the other fellows were all there in the old denim fatigues. They swarmed
round me and felt my uniform and examined my gun and cap badges
— quite amazed. Frank Turner the sergeant, told them they would all get
a kit like mine eventually. Then we had to slope arms. I managed quite
well and that caused another comment but one fellow kept his elbow up
too high and when we turned gave poor old Nugget (Jack Smith) such a
clout with the broom he had as a rifle, I thought his brother — Squirrel
we called him — would have shot him if his rake would have fired!

In the early days it was all 'Tom, fall in; Bill, go over a bit more', but
as we got more professional we had to address each other by rank no
matter if it was your brother or your uncle. We were from all walks of
life, you'd be standing next to the vicar or the butler or the boss's son.
We practised drilling first of all at John Bottom's; you didn't drill in front
of people's houses when you were rookies. Then we did our guard duty
up on the hill on John Bourne's estate — our guard room was the old
shepherd's hut and we could see the anti-aircraft fire at Oxford from
there and we felt we were really at war.

Then the talk of invasion was on everyone's lips. The Irish came and
put up big poles all over the fields at Springhill; we had been informed
that this was to be a secret dropping zone when the invasion came. We
were certainly all on edge and one night Bob Hodge and I had been
moved to new posts for guard duty. It was a moonlit night and such
a screaming noise was coming along the road. We fixed bayonets and
then remembered we had the old Lewis gun from a First World War air-
craft and a few petrol bombs back in the hut. But we had our duty to
do and had to advance; we then came face to face with two old brocks
fighting. I had forgotten that badgers made that kind of noise, but was
very relieved. There was a general policy to shoot first and ask questions
after.

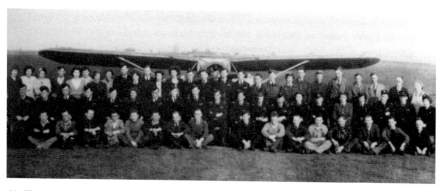

Air Transport Auxiliary, No 9 Ferry Pool, Aston Down against the backdrop of a
Fairchild Argus (Paul Aston via John Rennison).

Legend has it that the LDV holds the unique record of 'the only army in
history to have killed more of its own countrymen than its enemies'. But
they were there ready and waiting. Two bus conductors had a narrow
escape with their lives when the church bells rang at Kings Stanley — the
sign of invasion. The villagers as well as the LDV, armed to the back teeth
with whatever was at the back door at the time, set about the two figures
in dark uniforms chanced upon on a dark night, thinking that uniforms
meant invading troops.

Fear and the heightening threat and talk of invasion stretched tighter the
already taut nerves of a country at war. However much, in retrospect and
the security of seventy years since it all happened, the Home Guard has
become the butt of history's humour as a bungling Dad's Army, it has to
be remembered that duties were carried out after a long day's work, itself
usually carried out in the most difficult circumstances. It is little wonder
that the then dreaded sound of church bells ringing galvanized everyone in
general, and the LDV in particular, into action. Many are the tales told of
false alarms. Local memories recall only one instance of the famous peal
of twelve bells of Cirencester being rung frantically — but it was to draw
attention to someone who had been inadvertently locked in. The reverse
happened at one Stroud valley village: the LDV had been prompted into
action by the report of 'possible parachutists' spotted one evening; the des-
ignated bell-ringer was dispatched to the church to sound the warning of
impending invasion of the parish, but so frightened was he at the prospect
of facing an airborne enemy that he locked himself into the church. When
his braver neighbours had discovered that the airborne drifts were nothing
more sinister than hay blowing off a rick, the Stroud police gave the order
to the local warden to stop the bell-ringing. The warden duly went to the
church and finding it locked, banged on the door. The hammering on the

church door only confirmed the ringer's worst fears — that the invading force had arrived and were seeking him out — so he increased the ringing in fevered fright until he recognized familiar and safe local voices relaying the truth of the situation.

Claiming to be fearless of the definitive foe, the Local Defence Volunteers were well warned that the quiet upriver waters of the Thames could bring invaders by canoe or boat as far as Kempsford. Here the guard doubled up for duty along the river banks — not so much for the human form of the enemy as the ghostly apparition of the Lady Maud who haunted the misty banks.

In the same way, it was the compulsory military service which made the regular army more popular, and stimulated voluntary recruiting: it was reported that the enlistment in June 1939 totalled 4,672 nationally and broke all records. In his broadcast on 14 July 1940, Winston Churchill referred to the body 'behind the Regular Army of more than a million of the LDV or, as they are much better called, the Home Guard'. The new name was born and given its official christening on 23 July. By 3 August the Home Guard units were assigned county titles and military categories of company and platoon; rank style and symbolism followed and their role as part of the British Army was ratified three days later in Army Council Instruction 924. This formalization and disciplined ranking and code of conduct were welcomed by the retired military men who had settled in

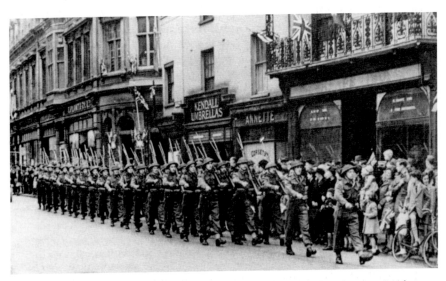

Parading the Promenade in Cheltenham during Salute the Soldier week 1944, Smiths Industries own H Company Battle Platoon of the Gloucestershire Home Guard. The company commander, Major Eric Desmond, leads the parade (Courtesy, Smiths Industries).

the county towns of Cheltenham and Cirencester with only a house full of domestic servants to command, but it came hard to those who had no such background and saw themselves as a body of neighbours banded together for the common weal. Such was the case of Hatherop losing Mr Wise to Eastleach Platoon. As foreman at Dean Farm, Mr Wise had earned respect and a title to his name; when he was admonished at Severalls, the village headquarters, to 'be quiet, Wise,' he transferred his service to that of the neighbouring village.

Reubin Sims recalls how he biked over to Bibury to see the Hatherop village boys go off to war, and then even further afield to Midsomer Norton to greet them when they came back from Dunkirk.

It was the Thursday Football Club, founded in 1934, which formed the nucleus of the Fairford Platoon. Meetings and changing facilities were offered by Sid Tolley at the Bull Hotel Tap and matches were played on the undulating pasture land of Gassons field. The Thursday Club took over the blue and white jerseys from the Fairford Town Football Club and proposed to play on Sundays: Revd Gilman of the Baptist Chapel strongly disapproved and threatened to resign; his resignation was accepted and the Thursday Club played their matches on Sundays. They then took over the Minute Book of the Thursday Football Club for their Home Guard business: they were fortunate in having a fully commissioned army officer interested in the local defence operations so made him chairman. Under the chairmanship of Capt. F. Holford, a committee was formed with Lt. Austin Mervyn Smith as vice-chairman, Sgt. A.E. Ash, Cpl. Des Jones, Sgt. W. Howard and Cpl. G. Morley, with Eric Jefferies co-opted as captain of the team, until he joined the Royal Navy. This mix of Home Guard, football duties and raising funds, for whatever reason, stretched the resources of the Entertainments Fund.

When the platoon's wireless caught fire in November 1942 there was a big debate on how they could possibly afford to have it repaired and send their old members, now serving in the forces, their customary half a crown postal order for Christmas. Sgt. Ash suggested that the set be auctioned in the next draw: 'and this brainwave met with the approval of all present'. The proceeds allowed the postal orders to be increased to five shillings and Sgt. Ash became chairman on the retirement of Capt. Holford.

Tom Basford's memories of fifty years ago are crystal clear:

> The arrival of arms really set the seal on the support role of the Home Guard. Charlie Taylor, the milkman, was the only man strong enough to lift the Browning automatic; quite overcome with the responsibility of it, he pulled the trigger and whirled it round — the rest of the platoon dived for cover. The Sten gun arrived next, in two pieces in a sack. The

Springhill Platoon, all ten of them, were instructed that when the time came for it to be used they were to count the rounds of ammunition they fired then throw it away, preferably in a pond where the enemy couldn't find it — as there was no more ammunition for the north Cotswold detachment, but the enemy might, of course, be advancing with supplies for it. The news that a quantity of First World War Enfields had been found in a cellar, all covered with coal dust, brought the Springfield Platoon to join forces with the Snowshill Platoon under the direction of Capt. Napier from Laverton to fire them off for cleaning at the range of Hinchwicke Warren, in readiness for the regular army. The next day the combined forces had black and blue shoulders and they thought back to the earlier days of cricket bats and broomsticks which only hurt their pride and not their body in practice.

One Sunday we were told not to go far from home. Young Pam Nobles, the gardener's daughter who worked in the big house, was told to run down to tell me to get to Snowshill. Poor kid, it was in the plans to use her as a runner and she would have been treated the same as us had 'Sea Lion' operation gone ahead — but she couldn't be told of course, everything was hush-hush, because everyone expected the invasion to happen. Stow and Springhill were in the plans for headquarters of the invasion force.

It was only the week before that we had been training with the Regular Army the exact plan we were to follow. We had met at Hill Barn, then down to Trafalgar Crossroads to march through Ford. The order was for ten of us to fall out and the 'enemy' was either Guiting or Stanway Home Guards up in the woods. We had to march towards them across a ploughed field and at the first shout we had to lie flat down on the ground. Sgt. Turner called out, 'Private Basford, you will march point', and I thought, 'Oh, heck, someone doesn't like me'; and I prayed that the blokes from Guiting or Stanway hadn't kept any real ammo back, we used to - to shoot rabbits for a hot dinner. The main force was going to go round the hill while the 'enemy' was engaged in fighting our advance. Fortunately, it was all blanks they fired and it was soon over so we marched back to The Plough at Ford with the 'enemy' and had a drink at old Tommy Bowles's. It would have been a different story had it been the old Nazis up in the wood though, and not our mates from the next villages.

Being countryfolk we might have had some advantage. As gamekeeper I got to know the ways of the woods, and when I heard the old cock pheasants start up 'Cock up, cock up, cock up' and the whole area resounding with the call, I knew that there was aircraft approaching. The pheasants could feel the vibrations miles away and gave good warnings

of bombing raids. Not long after the searchlights from Guiting Power, Broadway and Honeybourne would pick out the bombers and pass their lights over to the next batch. We could see Coventry burning that night over the Stratford Vale.

We got to know the different sounds of our own planes: the Wellingtons from Moreton. Whitleys from Honeybourne and Ansons from Rissington. When Hitler tried to fire the cornfields there were incendiaries dropped over Killdowns and burnt some fields between Springhill and Bourton-on-the-Hill by the old jockeys' stables. We collected up the fins from them for the evacuees, they all wanted them as souvenirs — very highly prized amongst the London kids those fins. Later, when radar came, the ground was covered with tinfoil for miles. They dropped it on the south coast to upset the radar, and it would blow right up on to the north Cotswolds.

The Springhill Camp was built for the army, but the asbestos roofs showed up white so it got bombed. It was altered a bit and then used for the prisoners of war. By the end of the war there were no pheasants on the estate, they had poached them all — but I suppose we would have done the same, given the chance.

I came by that old Hill Barn the other day by Ford and stopped to watch an old fox mousing, and I knew it was right what we had done all those years ago. And I wondered for a moment if there ever had been old Nugget who used to scare the girls with his blackened face as Beelzebub in the Snowshill Mummers, and Squirrel and the rest of them in those khaki uniforms creeping along behind those old stone walls ready to defend these hills with our couple of shotguns and pitchforks. But of course there was. It all happened. We *would* have given a good account of ourselves put to the test — and if they had come and got past us, there was still some good blokes at Stanton and Stanway to get over and we knew the area — they're our hills and we wouldn't have let them go cheaply. No, not being Gloucestershire men, we wouldn't. Old Cromwell found that all those years ago, and Hitler would have found we don't change much.

## THE GLORIOUS GLOSTERS

'The Glorious Glosters', of which the Cotswold Home Guard battalions were an integral part of the Home Front Defence, were raised as a regiment from the 28th Foot Battalion in 1694. Stroud Breweries introduced Old Braggs Fine Old Rum — a produce of British Guiana and British West Indies, according to its label — to the Cotswold cellars in honour of Col.

Philip Bragg who commanded the 28th Foot from 1734–1759. At the out-
break of the Second World War, the old 28th were the 1st Battalion; the
old 61st were the 2nd Battalion, and with the 5th Battalion went with
the British Expeditionary Forces to serve in France. A desperate last-ditch
stand at Cassel took a terrible toll on the old 61st, but despite the heavy
losses they reformed and showed the Germans what the Glorious Glosters
were made of in the D-Day assault. The 5th Battalion suffered comparable
losses when their ship struck a mine in the Normandy landings of 1944,
but, like their counterparts in the 2nd, they reformed to add more colours
to the Regiment's thickly emblazoned honours.

The role of the Home Guard was, as in the First World War, as a
defensive force, but the threat was different. Firstly, raiding parties or indi-
viduals, airborne or seaborne, possibly some by submarine, or individual
saboteurs whose task might be to destroy or damage vital points in the
country, had to be anticipated and planned for. Secondly, bodies of troops
parachuted directly to such targets as offensive air bases demanded full-
scale weaponry and manpower to counter-attack. The threat of invasion
was uppermost in the minds of everyone and a competent defence body
against small-scale raids in their own localities was the reason for forming
what became a civilian force totalling over a million men aged eighteen
to eighty, excluding those of call-up age and fitness and the handful of
conscientious objectors.

Some nineteen Home Guard Battalions wore the Gloucestershire
Regiment badges. The figures taken from the regiment's own records give
the strength on 1 November 1944 as 32,727. At times, between its forma-
tion in May 1940 to its final stand down in November 1944, the numbers
were even greater. Categorized in areas, the battalions were numbered:

| | | |
|---|---|---|
| 1st Battalion | Cheltenham, including Winchcombe, Smith's Factory at Bishops Cleeve, Dowty, Bristol Tramways and Tewkesbury | 1,844 |
| 2nd | Campden and North Cotswolds | 1,423 |
| 3rd | Cirencester, Headquarters Abbey House, including two Divisions of the town, Northleach, Kemble, Fairford and Lechlade, Tetbury | 2,389 |
| 4th | Forest of Dean | 2,477 |
| 5th | Gloucester | 1,685 |
| 6th | South Gloucestershire | 2,350 |
| 7th | Stroud | 1,557 |
| 8th | Dursley | 2,239 |
| 9th-19th | Bristol and area | |

The 8th Battalion, which was redesignated the 30th in December 1942, had the honour of providing from its ranks the Badminton Guard. Maj. D.M. Attwood recalled the first day 'a mob of month-old recruits turned out of the transport in a tide of undisciplined khaki' as his worst memory. It was a very different picture they presented two years later when they marched out on the last day, 'very much a Royal Guard'. He spoke of his Company at Badminton in the highest terms: that he 'had never commanded a finer body of men, well-mannered, always beautifully turned out, trustworthy to a degree and crime practically non-existent.'

Their early rough and ready training might have prepared the Home Guard to face their adversaries, but many admitted being more nervous of meeting Queen Mary whom they had been selected to guard. But she took the initiative and walked among them within the first couple of days, and in the two years of their royal duties they were to remember her with more affection than awe. If their first qualms at meeting a queen were quelled immediately, they must have experienced some apprehension at forming a Guard of Honour for a visit by King George VI a mere ten days later. For a local Home Guard to be inspected by a reigning monarch was honour indeed. Royal visits to Badminton included all the Royal Family at some time, King Haakon, King George of the Hellenes, Queen Wilhelmine, Princess Juliana and the Grand Duchess of Luxembourg; visiting states-

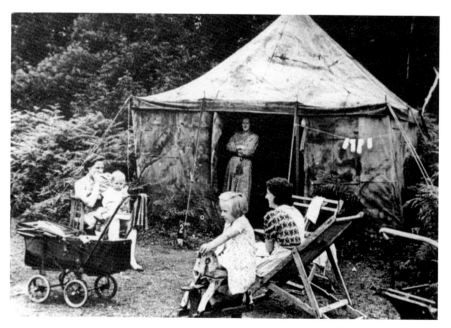

Hinnigar Camp was set up on the Badminton estate to give Bristol families a two-week break from the blitz-wrecked city — *Bristol Evening Post*.

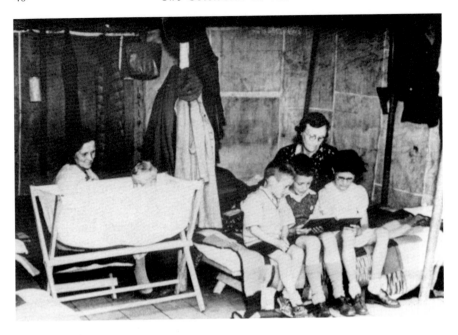

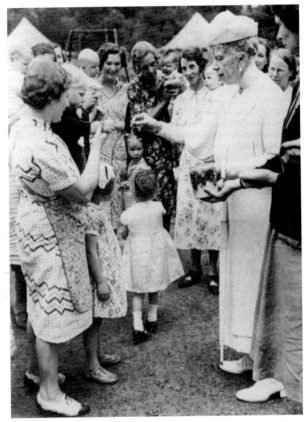

*Above:* Bedtime stories at Hinnegar Camp in the peaceful park at Badminton — *Bristol Evening Post.*

*Left:* Royalty and refugees meet together at Hinnigar Camp on the Badminton Estate, the war-time refuge for Queen Mary — *Bristol Evening Post.*

men included the Churchills and Roosevelts, and many top military figures — all came under the guard of the Cotswold Company.

The Badminton Guard were popular in the community; they gave off-duty help to local farmers, dug old people's gardens and their diverse skills were called upon to deal with all kinds of domestic handymen jobs. In January 1942 the signallers among them ran the Badminton Telephone Exchange — the crossed lines and abrupt terminations were said to be fairly frequent, but patiently endured because the village was grateful for their help. The Guard kept busy. As well as their duties and normal training sessions, there was an unorthodox night 'Poacher stalking' scheme in which the Guard became amphibious; assault boats, rubber dinghies and a kapok bridging kit were kept on the lake — and there was a formidable supply of fire power. It was a force to be reckoned with.

The Duchess of Beaufort managed to produce a hut 'out of thin air when such huts were unobtainable', and served the men their eggs and chips along with the local WVS. The Princess Royal, Duchess of Kent and the Duchess of Gloucester often helped out in the canteen during their stays at Badminton House. Maj. Attwood's men referred to the Duchess of Beaufort privately as 'Grace', following a comment made by a new recruit who had said that he liked the lady in the canteen called Grace. Her Grace gave the Guard every bit of support she could to make their stay at Badminton a memorable one.

Queen Mary's 'wonderful kindness' has been recorded in the Regiment's personal scrapbook by Maj. Attwood. 'Every Friday we were invited to a film show, always a brand new one. She took a very keen interest in our recreational facilities and helped us start a cricket team, form a band, furnish our quiet room and always honoured us by visiting our dances in the village hall.' She helped in arranging many interesting speakers for the ABCA scheme and was so interested in the history of the Regiment, and proudly wore the back badge in the back of her hat on many occasions. She copied the history out in her own hand and gave it to Maj. Attwood to read out to the Guard.

|  |  |
|---|---|
| | October 1st, 1941 |
| *From Mary R* | Badminton |
| | Gloucestershire |

The enclosed account from an RAF Officer, now a prisoner, may interest your men, if you can give it in one of your talks — I also enclose a short account of the Battle of Alexandria March 21st, 1801 in which your Regiment took part, which may also interest the men. I think my four dispatch riders would very much like to be present at some of your talks if you will kindly give them permission to do so. If agreeable to you 12

o'clock would honestly suit me best as I am so often out in the afternoons — and I am very anxious to attend your talks — more especially the current one. I do not pretend to understand War, though I hope I am able to take a fairly intelligent interest in it.

Still in her own hand, Queen Mary attached a copy of the account of how, in consequence of their being ordered to face about during the battle of Alexandria, 21 March 1801, the 28th Foot (later the Gloucesters) were permitted to bear their cap badge 'Fore and Aft'. She gave credit to her source as Sir John Fortescue's *History of the English Army*. And, only too aware of the current situation in which she was placed in the care of the home defence company of the great Gloucesters, she wrote a personal note of congratulations after the success of the 28th at Letpadan.

## AIR RAID PRECAUTIONS (ARP), VOLUNTARY BODIES

Defending the home front was not something new to the Second World War; its roots go back to the start of civilization and the Cotswolds have fine examples of the early settlements' defence systems, revealed in the post holes and ditches by the excavators' spades. All through recorded history communities paid tolls and taxes to their king and manor, and raised constables and wardens who could be called at the sound of the church bell to round up straying cattle, put out fires, form the hue and cry against malefactors and take up such arms and implements as necessary to fend off marauding invaders from attacking their home patch.

What is of interest, in the twentieth century, is the enormous response to a call for voluntary help in home defence. Wellington's soldiers were gathered by ballot, Nelson's Navy by the Press Gang and Kitchener's Army by conscription and conscientious call to duty at the pointing finger. The enormity of the threat from the air increased as war clouds gathered in the Thirties; the prospect of the country being reduced to rubble had been prefaced in the First World War, when some 103 raids had been launched on Britain. As air power increased in size and strength, the realization that war was brought to the people intensified and Air Raid Precautions became a Home Office concern in 1924. Hitler's boast of the new German air force the Luftwaffe, equalling the size of the British RAF in 1935 was graphically demonstrated as to its destructive powers in the Spanish Civil War, and statisticians calculated that the capability of the Luftwaffe was such that the 'knock-out blow', which was seriously expected, could bombard the capital with 3,500 tons of bombs within twenty-four hours. Calculating the cost of this in human terms, both mortal and mental, led

to such horrific forecasts as to the number of casualties requiring how many million square feet of coffin timber, stock-piling tens of thousands of cardboard coffins, and the daunting prospect of dealing with at least four million mentally disturbed survivors. A more rational reasoning resulted in realizing that power of organization, defence and survival would have to be decentralized from the city and devolved to the regions. The Home Office issued a circular to all local authorities on the precautionary measures which would be necessary to safeguard their regions in the event of air attack. From that circular of 9 July 1935, the Air Raid Precautions (ARP) service was sired as the lynchpin of the Civil Defence system.

In 1937, within two years of its formation, the King approved the Royal Crown as a mount to the ARP badge and later above the initials CD in the quartering of the Civil Defence Services flag. In 1938 Gloucestershire had the distinction of being the first authority to have its ARP scheme, described as 'exemplary', approved by the Secretary of State.

At the outbreak of war, the Gloucestershire County Council was expending 6*d.* per head of its population of 340,000 on ARP costs; manpower was still voluntary and unpaid and only one stirrup pump was made available to each of the warden's sectors in each area. Nailsworth complained that one was not adequate for their area, as did Fairford — who were told that there was 'no possibility of more than one trailer pump being supplied for ARP purposes in the rural areas on the principle that the district is regarded as 'non-vulnerable', and that there will be adequate hand appliances to cover rural areas'.

Northleach Rural District covered thirty-one villages with 152 wardens, but in the villages where first aid supplies were not 'allowable expenses', the villagers were paying for their communal kit out of their own pockets. There was also bitterness in the fact that there was an acute shortage of gas masks for the village children even as late as when the first batch of evacuees came to share their homes, parents, beds and schools. Lack of supplies to rural areas for ARP units was still making local news in September 1940. French and Sons of Cirencester reduced their 'ARP heavy orange macintosh sheeting from 4*s.* 11*d.* to 2*s.* 11½*d.* per yard, but that was of little comfort to those who needed buckets and hose and decontamination clothing, anti-gas suits and gloves and boots and eye-shields and curtains, helmets and torches and rattles, whistles and handbells and maps and signs and the rest of the specialized equipment they should have had to deal with the precautions, as laid down in their comprehensive regulations. The issue of the badge seems to have been of greater importance than assisting the means of qualifying for it. Wardens had to have served for one month and showed themselves efficient in one of the seven main services before they were granted a badge — and then

were informed that it was the property of the Government, to whom it was to be returned when the person ceased to fulfil the conditions of its issue. If the badge was accidentally lost, the cost of replacement was two shillings. Any unauthorized person wearing the badge would be committing an offence under the Defence of the Realm Regulations.

The organization of the defence services under which the ARP operated was an admirable example of British attention to detail at its best. Every aspect of what was involved in an air raid was covered from the issue of respirators, evacuation, shelters, black-out, mustering of transport and volunteers, warnings and patrolling, rescue, fire, reports, first aid, repair and restoration of communication and roads, buildings and domestic services to Special Constabulary, Reservists and Observer Corps. By the end of 1939 it was estimated that of the 1,500,000 defence workers, over two-thirds of them were volunteers. The Service was soon regarded as a permanent one and full-time workers were paid at the rate of £3 per week for men and £2 for women. Part-timers were unpaid. Recoverable expenses were limited to postage and travelling; 'expenses for refreshments whilst on training duty are not allowed', but local authorities could approve recreational centres and obtain grants. Compensation for death or disablement, caused as a result of or in the course of duty, differentiated between the sections of the service and women who only received two-thirds of the rates payable to their male counterparts.

South Cerney's 'War' in July 1939, which was the village's first ARP practice, was described in detail in the *Wilts and Gloucestershire Standard*. Carried out in atrocious weather, the personnel 'turned out well and everything went without a hitch'.

The warning whistle at 7.45 found the Wardens alert, with respirators, rattles and handbells, and ready for the 'incidents' which occurred when a squadron of enemy bombers represented by an RAF plane firing Very lights, flew over the village half an hour later. The explosion of bombs was simulated by fireworks and the presence of gas by smoke candles. On arrival, the Wardens found a Boy Scout bearing a placard stating the damage done. Casualties were represented by Cubs labelled to indicate their 'injuries'.

Wardens worked in pairs. While one took the necessary action on the spot, the other reported to the Report Centre at Cirencester and his own post. Fire, ambulance decontamination and rescue parties, represented by labelled cars, were sent out from Cirencester when assistance was summoned. At the warning signal the first-aid post was manned, and here all the casualties were first taken. At the 'all clear', Wardens gathered

Filling sandbags at Barnwood, September 1939.

A street-seller finds a well-protected patch between the sandbags at Gloucester's Guildhall, as illustrated in the *Gloucester Journal* of 9 September 1939.

at the first-aid post with their messages for the umpire to discuss the evening's work. Everything worked smoothly, thanks to the whole-hearted co-operation of everyone concerned, and to the many ladies and gentlemen who lent cars for the occasion. The exercise provided a valuable demonstration of the worth of the ARP services, which, in the event of hostilities, will undoubtedly defeat the principal object of enemy air attack.

Hitler was obviously unimpressed — war broke out six weeks later.

The following year, in September 1940, a member of the *Standard's* staff, Kenneth Bird, married an ARP Warden — her fellow wardens providing

'an archway of steel helmets' at St Peter's Church, Gloucester. Mr Bird was by then serving in the RAF. The initial enthusiasm for volunteering for defence duties had waned; the armed services had taken the major-ity, others were starting to feel the strain of a year at war. After a flush of advertisements calling for vigorous young men to 'do a man's work' in the ARP, appeals got rather more aggressive: 'Are you sure you are pull-ing your weight — have you got a twinge of conscience about the fellow across the way who does his twelve hours in the factory and turns out at night to do his ARP duty?' asked The *Citizen*. The newly-wed Mrs Bird, flanked by her warden colleagues, was obviously one of the 680 in the city of Gloucester — a number which did not reach the recognized estab-lishment for its size and area, let alone attracting a further 25 per cent, prescribed as necessary for reserves. Only 33 of that 680 were full-time paid wardens. Maj. G. Willis, the City ARP Officer, was quoted as agree-ing that the figures were an indictment of quite a large number of people in the city for 'not going to it', so far as ARP was concerned. 'Gone to it' from Cricklade, as he signed himself, gave the teachers of Gloucestershire a verbal trouncing for 'not going to it'. 'Sir', he asked of the editor of the *Wilts and Gloucestershire Standard*, 'Now that so very many of the school teachers are on short shifts, but at full pay, and enjoying a further increase on top of that, how many of them are giving their leisure time to our coun-try? I am one of the many working seventy hours a week. Teachers — go to it — relieve others in great need of a little rest.'

Andoversford admitted to having difficulty in getting men for ARP work, due to other war work commitments. Dowdeswell is said to have complained — but did not specify about what! A government decision that boys under the age of sixteen may no longer be used as messengers in the defence services was made on the outbreak of war, so many Boy Scouts lost their unofficial affiliation to the ARP. Likewise, many Civil Defence personnel were attracted to the military status of the Home Guard and those who had some knowledge of firearms were enrolled in the early stages in both services, with the comforting knowledge that, when faced with the need, they could defend their central posts fully armed, apart from gaining a certain kudos of being part of a fighting force rather than a civil watchdog and rescue worker. Not all sectors agreed to this dual appointment, however, and in the main the two functions were separated as far as possible with a fine degree of jealous preserve on each one's importance.

Before the skills and services of the wardens were called upon in the air raids, the communities which they served did not always look kindly upon them. The workaday blue overalls and tin helmets did not command the respect of brass-buttoned uniform and acceptance ranged from tolerant

amusement to unveiled irritation and hostility. Many people saw them as petty tyrants: Peeping Toms craning to glimpse a pinhole of light escaping between the black-out curtains, and tea-drinking autocrats who decided in the safety of their well-sandbagged citadels how many buckets of sand each premises should have and where.

Training sessions did not always go as smoothly as the one reported for South Cerney. At one, in the Stroud area, an early attempt at getting a course running on treating casualties ended up with a note from one exasperated volunteer 'casualty' pinned to the organizer's desk: 'I've waited long enough, I have bled to death, so now I'm going home.' Another, after reading the rules, regulations and requirements involved, wrote on the application form, 'Yes, I have read and understand what is asked of me and, No, thank you.' One report, from a minority group who did not seem to be bothered whether the country and their fellows were invaded or annihilated, actually laid the blame for the international situation on the 'nasty ARPs', who, the group declared, were hell-bent on causing war. However, true to the British capacity for laughing at itself, the *ARP and AFS Magazine* published this little ditty in 1940:

> Big helmet Wilkie they call me.
> Big helmet Wilkie, that's me.
> Now that they've made me a Warden
> I get my torch batt'ries free!
> Once, at the sound of a warning,
> A blond cried, 'Shelter me, please'.
> Then said, 'That isn't a rattle, Blimey —
> It's your knocking knees'.
> Big helmet Wilkie they call me.
> Wilkie the Warden, that's me.

There was a case in Gloucester of a warden being 'reprimanded' for stealing a drink from a pub during a raid 'to give him courage'.

The ARP warden did not possess the powers of the Special Constabulary, and this sometimes irked when they were reminded that their duty was to assist householders in carrying out the regulations which had been imposed for the safety of the public. An incident at Chalk Hill, near Stow-on-the-Wold, led to a warden being taken to court for acting 'in excess of his duty'. A motor cyclist refused to stop for the warden, who then tackled him and dismounted him and, for good measure, gave the cyclist a bit of a hiding for disobeying an order. The cyclist, in his defence in court, stated that he had not been stopped by either the Home Guard or the Special Constables on duty so was not going to take orders from a mere ARP. The

warden ended up paying a fine for assault and reminded of his restricted powers in the scheme of home defence.

'Hard and ungenerous' allegations made about the ARP receiving wages for their work were denounced by Cirencester Urban District Council in October 1939. Mr G. Winstone let it be known publicly that in many towns there had been a great deal of criticism about the remuneration of officials. He had thought Cirencester free of such talk and was astounded when he was stopped in the street and confronted with the question as to what they were paid for local voluntary work. He pointed out that the town owed the official staff of the Council, who often worked ten to thirteen hours a day, a deep debt of gratitude for their self-sacrifice. And not a single member of the official staff received payment for ARP work. Far from 'clearing the air and closing the mouths of the gossipers' as was intended by this denouncement, the question was raised as to why the public appointment of a Food and Coal Controller had not been publicly advertised.

'Strong feelings' were again voiced in January 1940 regarding ARP allowances. This time it was on the matters of insurance and the mileage rates to be paid to ARP volunteers. At two and a half penny a mile it would cost the County Council £3,000 a year for mileage claims. Adding another halfpenny to the rate would mean an increase in costs of £650. The Gloucestershire Emergency Committee deliberated long and hard over the policy of special insurance — the volunteers' own insurance had to cover their own cars used in the service — and it was decided that the Council's block insurance scheme should only cover 250 cars in the county. At the centre of the 'strong feelings' was the fact that it had been brought to their notice that some people would not normally license their car for a quarter — and it was intimated that by joining the voluntary services it was a means of getting private cars on the road; certificates were favoured as the means of exempting owners from the licence duty provided the car was used only for the transport of ARP personnel and equipment and the officials were satisfied of the need to use the car.

A National ARP for Animals Committee, re-organized in 1941 along lines suggested by the Ministry of Home Security, extended its work by dividing it into two distinct parts. One dealt with farm stock and food animals as a vital source of food; the other concerned itself with domestic pets of all kinds. By the end of June 1941 more than three million animals had been registered as domestic pets and wore a metal registration disc. NARPAC, as it was known, relied on thousands of volunteers to become Animal Guards, whose responsibilities ranged from rescuing and caring for straying and injured animals caught up in air raids, and disposing of the dead. The Committee was recognized by the Government as the authentic

body to deal with ARP for animals and comprised representatives from all the official animal welfare and protection associations — as well as from the Ministry of Food.

The Animal ARP, as it was known in Cirencester, publicized the arrangements for that town. Injured dogs and cats were to be taken to stables in Coxwell Street, then moved after examination to the headquarters at No. 11 Victoria Road. Maj. Duncan offered his premises in Lewis Lane for the shelter of horses. Advice was given on making a splinter-proof shelter for small pets from lying a large sized dustbin on it side. Once in position, the dustbin shelter was heaped over with soil.

The ARP duties, covering everything from a knowledge of high explosive bombs, incendiary and gas bomb control, first aid and the location of all the shelters and medical centres, informing the public of what to do in an air raid and giving clear signals, to remembering to tie up horses to trees in side streets, were embodied in the keynote: courage and presence of mind. As well as the training with its own manuals, there were 20 Home Office circulars, 12 handbooks, 4 Acts and 15 memoranda to digest, with a further dozen or so pamphlets ranging from a penny to a shilling, which the wardens could buy in the first year. More concise information prefaced the ARP diary which contained the essential outlines of duties, lighting up times and how to identify the ARP personnel by the width of the black stripes on their helmets — and a warning that there were heavy penalties for neglect to obey regulations.

Mrs Nancy Cawthorne of Stroud recalls the table tennis and chatting in the Trinity rooms where she spent her duty hours as one of the Rodborough Rangers, 'either as a potential telephonist or as a back up for the Red Cross. Our basic first aid knowledge seemed very limited so fortunately for us and any possible patients we were never called on to use it'. One of her lasting memories she says is of one elderly man who, no matter what time the siren went, appeared with a buttonhole, usually a pansy. Her husband was a messenger attached to the ARP, often turning up for his voluntary duties after 9 o'clock in the evening after a long day's work in an engineering works. They were only too well aware of the part they played as they listened to the planes 'thundering overhead on their way to Birmingham and Coventry — we were very sad to hear the news the next day. We spent many an hour sitting in the stairs, which we thought would be the safest spot in the house'.

Mr A. Tudor was one of the first four volunteers of the Glos 27 division of the British Red Cross to do duty as a driver of the only two ambulances for Cheltenham. After working a twelve-hour shift in the aircraft industry, Mr Tudor found that a major role was conveying

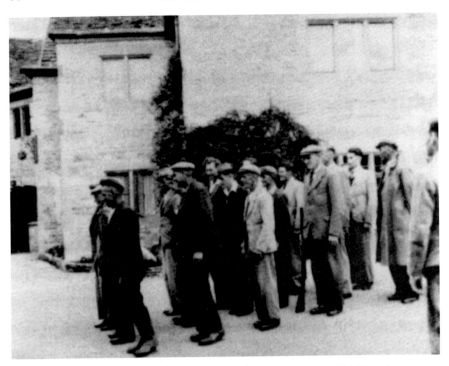

Drilling the Driffield Home Guard. A note on the reverse reads: 'Driffield Local
Defence Volunteers fully armed and ready for action. What chance have the Nazis got?'
(Corinium Museum).

The Northleach section of Special Constabulary during the war years. Back row: Special
Constables J. Sly, L.W. Bunge, P. Greaves, G. Westmacott and E.G. Holland. Middle row:
O. Leach, E.J. Richens, E.G. Jones, W.G. Leach, L. F. Wearing and F. Leach. Seated: C.H.
Gloster and W.V. Blackwell flanking PCs S.T. Smith and H. Elliott, with Special Sergeant
S.T.J. Turner, centre (Corinium Museum).

hundreds of evacuee expectant mothers from Postlip Hall to Sunnyside Nursing Home at Cheltenham — and, I don't know why, but the babies always seemed to arrive at night, just as you thought you could snatch a bit of shut-eye. Our duty hours were from 10 p.m. to 6 a.m. If we could grab a few winks of sleep it was on a stretcher on the hall floor. We were supposed to work one week on and one off. However, no other volunteers were forthcoming and I did an eight week stint before I was relieved for one week, then did a further six weeks without a break: twelve hours work, followed by eight hours night duty on the ambulances; eventually the other auxiliary services were organized and the pressure was eased a bit.

I was in digs at the rear of the Ambulance Headquarters, so was quickly on the scene when the first bombs dropped on Cheltenham. A stick of bombs hit the Sunning End Works, Gas Works and Pilley Bridge. It was a burning inferno at the Works when we arrived and a good landmark for the other bombers coming over. Luckily, the bombing coincided with the half hour break between the day and night shifts otherwise there would have been many more lives lost. One man was killed, we laid him in the porch way of the General Hospital, which had been designated temporary mortuary, and then had to return with the firemen until the fires were out — which took until 2 a.m.

## OBSERVER CORPS AND SPECIAL CONSTABULARY

Gloucester's reception of the news of Britain's declaration of war was marked by the same calm spirit which had been in evidence all through the crisis, The *Citizen* reported on Sunday 3 September. More people had gathered at the Cross than usual at the fateful hour of eleven o'clock, and when *Citizen* sellers raced out with the news, they were immediately surrounded by eager purchasers. 'An electric atmosphere denoted that the occasion was an historic one, but there were no scenes of excitement in the streets and no demonstrations.' Report and control centres at the Guildhall and Shire Hall were fully manned; the Mayor, the Town Clerk and the heads of the services were on duty awaiting the Government's directions. The ARP had been out the previous night calling on householders to check their black-out efficiency, and the police patrolled the streets with a loudspeaker, emphasizing the necessity for the regulations to be observed.

An appeal for sixty men 'urgently needed for full time membership of the Gloucester Observer Corps' was highlighted at the foot of the momentous news story. 'All sorts and conditions of men watching while we sleep', is how the *Wilts and Gloucestershire Standard* described the work of the

A group of the Royal Observer Corps of the Northleach post in 1942. They were
part of 24 Group ROC, with a call sign 'love four'. The wooden building from which
they operated was situated half a mile from the town. On parade here are: back row
— Observers H. Leach, S. Smith, A. Last, Lt Observer W.G. Leishman and Observer W.
Morse. Front row: Observers J. Norman, H. Rangvell, Observer Officer B. Barwell, Chief
Officer H. Hollman and Observer H.C. Cook (Copied from an original photograph
loaned to the Corinium Museum by Mr G. Green).

Observer Corps the following month. The Armada beacon, by which
their forerunners warned the country to prepare to defend itself against
attack, became the badge of their corps under the motto, 'Forewarned is
forearmed'. From all walks of life and profession, the men who watched
and waited, on roofs, in sandbagged trenches, more often than not in the
mud of farmland, spotted and plotted, checked and reported on the course
of approaching aircraft. Everyone's skills were put to the utmost use; the
parson, meticulous in quickly composing terse and accurate messages
on the telephone; the gardener, a handy chap with the spade for digging
trenches; the village blacksmith keeping the heavy gun and mount in
working order, and the retired military volunteers who concentrated on
camouflage — so effective at one spot in the Cotswolds that the observers
couldn't see the sky through it, let alone any aircraft.

Nearly 1,000 'Specials' were on duty in Gloucestershire every night
between 6 p.m. and midnight by January 1940, and 'such is the keenness
of the volunteer force, they have offered their services for the "Dark Hour
Patrols", carried out by the Motor Patrol on certain days between mid-
night and daylight', the Chief Constable Col. W.F. Henn, reported. Prior
to the outbreak of war, the force had 'existed chiefly on paper'. Col. J.L.
Sleeman was appointed as Commandant and re-organization resulted in a

force not intended to be drafted into the ranks of the regular police in an emergency, but to create a separate auxiliary force. The ideal strength of 3,000 seemed adequate for the eleven divisions of the county, bearing in mind that all were volunteers and duty hours were in their spare time on a rota basis. The Mobile Section was 142 strong and 'could be at any point in the county at two hours' notice'. Lectures were given by regular police officers and the Special Constabulary accompanied the regular police on their beats, they also had to take courses in first aid and ARP duties. Within the first four months of their founding on a wartime footing, the Specials carried out 286 prosecutions in Gloucestershire on their own initiative, and assisted the regular officers on many occasions by giving supporting evidence.

At that time there were no paid Special Constables in the whole of the county. A clerical section to cope with the mountain of paperwork was drawn from the Women's Auxiliary Police Corps, who were then attached to the Special Constabulary. Another branch formed the transport section.

Having a father in the 'Specials' created a special stir in a Latin class at Wotton-under-Edge school for Mrs Rosemary Guy when the Latin master jovially announced to the class that Rosemary's father, Mr Eaves, had frightened him to death. Both were Special Constables and met one dark night on the lonely hills above the old town. Challenged by Mr Eaves, the Latin master suddenly forgot the essential password which had been issued to them to recognize fellow constables on duty. On another occasion while on duty on the hill, they spotted what they thought was a light shining from the town; they rushed down the Nip Nap only to find that it was the moon shining on the windows. The black-out caused injury to the local police sergeant when he drove his small 'old-fashioned' car into a crater made by a bomb in the centre of the road at Horsley. Another bomb which fell behind the Masonic Hall blew all the shop windows out.

The Gloucestershire Special Constabulary Commendation was awarded to Special Police Sgt. John Hancock of Berkeley who captured two German airmen after their plane was downed at Woodlands Farm, Clapton on 27 March 1944. The Head Special Constable at Gotherington, who was the local rector, made a heroic attempt to rescue Miss Elizabeth Kearsey from her blazing thatched cottage when it received a direct hit on 19 November 1940.

Locked into local folklore is the tale of the constable who dug out an unexploded anti-aircraft shell from where it had crashed through a house in Painswick on 21 October 1940, carried it through the streets to the police station and deposited it on the guardroom table.

## FIRE-FIGHTING SERVICES

Fire-fighting, although an obvious emergency service to be needed in the wake of air raids, did not get the initial attention it warranted in the preliminary schemes for precautions. Fire Schemes Regulations were issued in 1938, together with an announcement that 'fit men over the age of twenty-five were eligible for the Auxiliary Fire Service (AFS) or the Fire Brigade Reserve. After London lost eight of its Wren churches in the fire blitz of December 1940 the Minister of Home Security broadcast an appeal for fire watchers. Nearly 2,000 volunteers had enrolled in the Stroud and Nailsworth districts within the following few months, and the area became fire conscious to the degree that almost a thousand stirrup pumps had been purchased from the Local Authority by its rate-payers. Fire watchers and fighters then became a part of the ARP organization.

The Fire Guard, regarded as 'the largest civilian army of all times', was officially formed in August 1941; the fear of Hitler burning the English harvest as it stood in the fields by the use of incendiary 'leaves' prompting the action. Farmers were circulated on the dangers and a return of the Stroud and Nailsworth districts showed some 3,708 acres of corn on 220 farms (30 farmers did not reply). A total of 662 volunteers mustered to the cause and got armed with 600 fire-fighting besoms, sold to the farmers by the Defence Committee; the former blaming the latter for the wettest harvest for years.

Fire watching is said to have been one of the most tedious of the voluntary services; each street was eventually to have its own watch — often housewives were co-opted in sitting up all night and checked that they were on duty by either a warden or a 'Special'. Of course, there were always the regulations pertaining to their duty which they could read — digest might have caused a different problem when taking, for example, the Defence (Fire Guard) Regulations of 1943.

> Any directions, notice, return, registration, exemption, release, certificate, application or thing, given, published, served, effected, granted, issued, made or done in the exercise of powers conferred by any provision of either of the said Orders, shall, if in force immediately before the coming into operation of this order, continue in force and be deemed to have been given, published, served, effected, granted, issued, made or done in the exercise of powers conferred by the corresponding provision of this order, and any reference in any document to either of the said orders or to any provision thereof shall be construed as including a reference to this order or to the corresponding provision of this order.

A sentence of 114 words could cause indigestion let alone insomnia! The Regulation contained 50,000 words with the three Orders made thereunder. But an Explanatory Memorandum was issued — containing 64,000 words!

The Fire Guard was established as a separate service in April 1943. In peacetime, Cirencester had twelve 'retained' firemen who received a retaining fee of £3 3s. a year. On the outbreak of war these were augmented by sixty auxiliary firemen, serving both urban and district councils, and received no pay whatsoever. Acting on instructions from the Home Office on the outbreak of war, four 'retained' firemen and three auxiliary firemen were put on a full-time basis, for which they had to give a twenty-four hour service, for a wage of £3 per week. They were the only paid members of the service.

The Rural District Council recommended that some 274 volunteers would be needed, and approved 19 manual pump units, to serve 26 villages; Northleach, Bibury and Chedworth were to receive two each, but in other cases one pump would have to serve more than one village. Mr G. White is reported as saying: 'You find them some beer and you will get plenty of willing hands.' To which Capt. H. Green replied: 'That is quite true, but before the men can pump and have the beer, they must be trained.'

However, no grant could be claimed until the council's scheme was approved by the Home Office, so training costs had to be borne initially by voluntary subscription by the person trained. The meeting then moved on to deal with the uproar over the erection of 'hideous red telephone kiosks'; although 'the County Council had refused to allow kiosks to be painted red'. A protest was sent to the GPO: the red kiosks remained and proliferated over the last fifty years. A deputation of the Chairman, the Clerk and Mr Hugh Busby went to the Home Office in August 1940 to discuss the inadequacies of fire-fighting services in the Fairford district. 'The Home Office expressed the view that, for the duration of the war, at any rate, they would be satisfied if a two-man manual pump was purchased and installed at Fairford. Some £1,000 was approved for the trailer pump and 20 more stirrup pumps for the area.' And, in view of the 'vulnerability of the area and the character of the district from the water supplies aspect, an additional canvas dam was requested, and agreed to, of 500 gallons [2,250 litre] capacity'.

Water supplies came under the restrictions imposed to safeguard as carefully as every other commodity: 'five inches in the bath' became as much a fact as a slogan, for everyone was conscious of the drain on supplies fire-fighting would cause. The influx of evacuees and troops into small rural areas also stretched the basic resources to danger point. Northleach had

The call to save water resulted in the famous line 'Five Inches in the Bath'.

a double, if not ambiguous, problem. A resolution was passed by a parish meeting called in February 1940 to demand action from the Ministry of Transport over the serious flooding the town had experienced in the recent years, causing flooding of houses in the centre and disruption and serious diversion of the heavy through-traffic. At the same time, councillors made strong protests against the use of their Windrush water to supply Evesham, but as the matter had already been introduced into Parliament and approved by the Ministry, the Revd E. Hanson pointed out 'they were flogging a dead horse'. Fears were expressed that opposing the Bill would be an expensive proposition, so they protested to the County Councils of Witney, Oxford and Burford instead.

Control of the AFS was discussed at length by the Rural District Council of Northleach, who felt that it was only logical to amalgamate the fire-fighting service with the water service. It was pointed out that 'stirrup pumps in villages were not recognized in the fire service'. Moreover, in many villages the same men were air raid wardens and members of the fire squad. It was proposed that the local control should be transferred to the senior warden, with the exceptions of Northleach and Bibury, and that the

existing Fire Brigade Committee should continue under sub-control. All quite contrary to the original, and approved scheme. The Rural District Council did not feel happy that such important affairs as the control of the fire squad should be in the hands of local parish councils, many of whom, it was said, had not met in living memory. Then they looked at their equipment and found they had only 300 ft (91 m) of hose, so another half a dozen hydrants, costing £10 each, would have to be bought, and, unless they had storage provided on the roofs, neither Westwoods Grammar School nor the Police Station would be covered in the event of fire. For the half year ending March 1941, the fire brigade service cost £115; the auxiliary fire services, £70. A healthy balance of the Council's budget resulted in a cut of 4*d*. in the next year's rates.

Cheltenham calculated the cost of fire-fighting in November 1939, and bought seventeen cars and two lorries for the AFS 'as they thought the war would last a year and the high rental charges, mounting each week, means they would have paid for them in another ten weeks'.

The actual manpower was still heavily reliant on unstinting voluntary service. In February 1941 'Free tin-hats, sandbags and Injury Compensation' were offered as an inducement to join the AFS. The tin-hats, though, it was emphasized would be on free loan and volunteers would only be assured

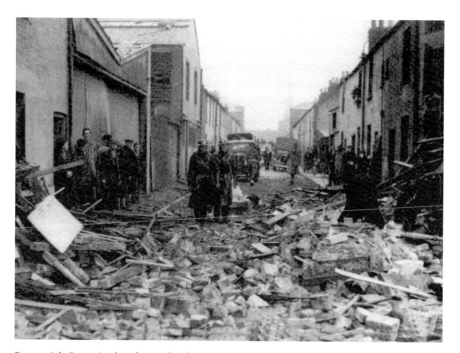

Brunswick Street in the aftermath of a raid, 27 July 1942 (Courtesy, Cheltenham Reference Library).

of one if they pledged not less than forty-eight hours' service a month. Rot-proof sandbags — one per person of the service for fire-fighting, would be replaced as used, but each party 'will be expected to find its own receptacle for water'. Compensation for injury was as for other Civil Defence services. Each stirrup pump party was, ideally, to have two persons watching and 'raid spotting'. Each party of fire watchers, and Boy Scouts were expected to include this as part of their service at the age of fifteen to sixteen years old under a Patrol Leader in their own district, was expected to cover thirty houses in a closely built-up street. Watchers over shops and dwellings were posted on a roof 20 ft (6.1 m) above surrounding roofs to cover a radius of 200 yds (183 m); or a party to cover 16,000 sq ft of roof area.

Mr E. Hart was a 'retained' officer of the north Cotswold Brigade. An engineer bearing the rank of Chief Officer, serving a total of twenty-seven years, he recalls serving with the voluntary brigade at Stow.

> In those early days there were very few boundaries, we used to answer calls to anywhere in the district. Many villages had no fire cover previous to the war, then many of them had a car and towed a pump. As I usually drove the main appliance, we were away first. Our main machine was a Morris Commercial 15.9 HP fire engine, this we had and used until the time that Upper Slaughter was bombed with about 900 incendiaries, then it was scrapped as obsolete.

A great number of fire and rescue services from the western edge of the Cotswolds were called on during the intense raids on Gloucester and Bath so did experience the horror of blitz conditions.

The test for Cirencester's fire engine was to get two jets of water over the church tower, the tallest in the county. A huge water tank was situated opposite the church, with a smaller one opposite the Corn Hall — covered with wire netting after the lively New Zealanders took to dunking each other in it following a night out on the town. The hole their crack shot made in the tail of the weather cock on the church tower for a bet has now been filled in, to be remembered only by the impressionable young local lads of the time like Brian Carter, who had it verified by the commanding officer that the shot was from a Lee Enfield.

## INVASION WAR BOOKS

It is not practical, and space precludes details of the numerous committees that were set up to form a network of schemes to defend this country and deal with the formidable task of anticipated dangers it faced in wartime.

The threat of invasion was as real as the fear of full-scale air attack. As is the interesting way of history, it is perhaps not amiss to note here that it was at Gloucester that William I 'had deep speech' with his councillors to record every householder, his worth, his beasts and each community's facilities to compile the Domesday Book. Nine centuries after, the towns and parishes of the kingdom set out doing exactly the same but in order to defend itself against another conquest.

The Invasion War Books were compiled as a kind of concise ready reference, and made in duplicate. One copy was deposited in a safe and secret place, with a strict undertaking that it was not to fall in enemy hands for obvious reasons. An outline of the problems faced in the event of an invasion is summarized for the Stroud area, known as Area Eight, as follows:

1. Appreciation. In the event of an invasion of England, there would be the possibility of an enemy seaborne landing on the estuary of the River Severn. Any such force would be strongly equipped with tanks and army forage vans, supported by motorised infantry and the Luftwaffe. Simultaneously airborne landings and paratroop raids would in all probability be made in any part of the county of Gloucestershire. Probably the enemy's first object would be to gain control of the important ports of Bristol and Avonmouth. His next objective would be to gain possession and control of airfields—Moreton Valance, Aston Down; factories — Brockworth, Staverton, Rotol, etc. in the Cheltenham and Gloucester area: Daniels, Erinoid, Sperry, etc. in Stroud area; and centres of resistance and communications, such as at Cheltenham, Gloucester and Stroud.

The courses open to our own troops — to look out for any parachutists landing, keep them under observation, report their movements, and prevent them attacking and gaining possession of any of these objectives. If possible to kill them — they are most vulnerable within ten minutes of reaching the ground. To prepare a compact all round defence of centres of resistance and towns — the perimeter consisting of platoon localities, based on road blocks.

2. Warnings. Defence Committees (later Invasion Committees) would be notified by the military authorities by invasion signals: 'Stand To', indicating that the enemy was fully prepared and conditions favourable for him to invade; 'Action Stations' indicated the immediacy of the invasion. The Defence Committee headquarters would be permanently manned, with liaison between them and the Military, the Police and Civil Defence headquarters.

3. Three stages of control in the event of actual fighting in a locality, with a general paragraph on the priorities of saving life and property, but

the over-riding duty to aid the armed forces in driving out the enemy to govern the action of the Civil Defence Services. Communicating messages within the system and denial of resources to the enemy. Personnel were strictly forbidden to act independently of the detailed instructions with which they would be issued and in particular there 'is to be no destruction of ARP stores and equipment'. Withdrawal in the face of the enemy was equally forbidden, unless on the command of the Military Commander, or to retreat to a defence point already prepared, to avoid capture, and there remain with the rest of the civil population. Those in charge of the Centre would do their best to conceal or destroy any papers or maps which might be useful to the enemy. The overall policy to 'Stand Firm' was emphasised both to assist the police in maintaining the stand amongst the public at large, and also to set an example by their own steadfast conduct in the face of the enemy.

*'Area Eight' in the War against Hitlerism* by P.R. Symonds, covering the Civil Defence Services and ARP in Stroud and Nailsworth districts, gives the estimated total population for that area as 48,162 and the number of dwellings as 13,923. The resources available to defend them were:

1,693 Home Guard 51 Regular Police and 212 Specials
819 Civil Defence Wardens with a further 38 in the Rescue Service and 593 in the Casualty Service
121 Messenger Service with over 1,000 in Local Authority
1,035 Fire Guards (volunteers) 3,500 compulsory enrolled and 787 for business premises
5,312 'unattached' volunteers (as a result of Quiz forms)

The percentage of the population provided for by public and communal shelters was: Stroud Urban District 16.5 per cent; Rural District 0.37 per cent and Nailsworth Urban District 4.5 per cent.

A summary of the items the householders offered in the case of emergency was: 7 horses and 4 carts; 9 handcarts and 3 trailers; 97 bicycles, 67 wheelbarrows, 283 spades, 83 picks, 71 ladders, 219 buckets, 20 hurricane lamps, 43 heating lamps and 15 primus stoves.

Firearms available ranged from ten shotguns to two revolvers. Food such as sugar, tea and biscuits would not have gone far for the numbers involved but it was essential to list everything — particularly equipment and utensils needed for casualties. Only 9 tents could be called upon, but some 68 single bedsteads, 28 rugs, 103 blankets, 72 sheets, 75 pillows and 124 hot water bottles; 27 bedpans and 16 urinal bottles, 24 feeding cups, 143 towels and 88 bars of soap with 43 bottles of disinfectant and 62

pairs of large scissors would have helped out the beggarly seven first aid outfits —although it is supposed that the defence services had their own to take to the scene of the emergency.

Factories had their own defence arrangements, but they, too, had to conform to the regulations. Sperry Gyroscope listed twenty-five works and shelter wardens and a total of twenty-two first-aiders. Five parties of three fire guards and spotters were organized to the main vantage points of the factory: the control tower roof, the canal block house, and the lift shaft post. On imminent invasion the factory workers were ordered not to report for work and the Invasion Committee could therefore call upon them if they were not already in the ARP or Home Guard units.

The National Cyclists' Committee, Club and Union, jointly publicized details in the local papers on immobilizing bicycles in the event of invasion, following a ministerial broadcast in June 1941 on the ways in which the public could resist from helping the invaders. The Ministry of Home Security agreed that the most effective way of putting the nation's ten million bicycles out of action would be by removing the pedals, the chain and the nuts of the back wheel — hiding these parts in all cases. But, as the joint Committee, Club and Union pointed out, the nuts were often interchangeable and a bicycle could be ridden with only one nut on each of the front and back wheels — so it would be better to unscrew at least three of them. They also urged the cycle shopkeepers to remove the pedals right away and not wait for the invasion.

Cheltenham Gas Company was regarded as a great support to the Home Guard for it provided the petrol and tar to fill the bottles of that efficiently simple home-made grenade, the Molotov cocktail. The wicks were made by old silk stockings donated by the ladies.

Armed with these petrol bombs, the Home Guard would attack an invading force as it slowed at the road blocks which would have been set in place at vulnerable spots. The idea was that as the enemy soldiers got out of the vehicles to remove the blocks, the armed Guard would open fire until they could capture them. The combined trades and skills of Stanley Grimes, carpenter, and William James, his apprentice, the brothers Andrews, local blacksmiths and a son to provide the transport, built the road blocks in preparation for the expected invasion route at Hillesley Road, Kingswood, Wotton-under-Edge. The blocks were whole tree trunks with cart wheels mounted at each end to allow for speedy wheeling across the road.

The following report was made by Stanley Grimes who served with the LDV at Wotton-under-Edge, later to become known as The Wotton Company, Sudbury Battalion, Home Guard, at the height of the hot summer of 1940. The War Office instructions of 'What To Do and How To Do

Preparing road blocks at Hillesley Road, Kingswood, Wotton-under-Edge. These were intended to slow invading vehicles down so that the LDV (later the Home Guard) could attack with Molotov cocktails and whatever arms they had available at the time.

It If the Invader Comes' were already distributed, the papers were full of warnings and the wireless brought gloomy news into every home of yet more raids 'somewhere in the south-west'.

## Wotton-under-Edge Local Defence Volunteers

24 June 1940: Parachutists reported to have landed in the Tresham area. Called out at 3 o'clock in the afternoon. Went by car to Alderley, Hillesley, Hawkesbury, crossed road at Dunkirk, could find no confirmation of reports. Ascended the Monument with glasses, could see nothing. Came back to Hillesley, stopping all cars for identification cards till 9 p.m.

1 July: Thirty parachutists reported to be dropped in a line from Watsome to Wortley Hill. Called out at 3 o'clock in the afternoon. Proceeded by car from the Police Station to Southend, Stumpwell Lane, Swinhay Lane and the Charfield Mill Yard. Met soldiers in Swinhay Lane and the Charfield Mill Yard, they were in extended order across fields towards Ithels Mill. Our party proceeded by car to Huntingford, Wick and North Nibley then to Wotton Police Station.

Went home to have a cup of tea and back to Police Station. Proceeded from there to Wortley with a troop of the 7th Warwicks, who are

stationed at Tytherington. Left transport in lane and beat woods and fields to Slades Barn, all extended order. Three of the party had to walk back to transport while the others proceeded to Newark Park and House. The transport in the meantime proceeded to pick up the men at Newark House. Miss King provided beer, cake and cider and lemonade for us all.

Arrived back in Wotton, reported at the Police Station. Nothing found, Warwicks were dismissed.

Proceeded from Police Station to Wotton Hall to investigate suspicious character, went up Old London Road to the quarry, then to the hill, but could find no trace of suspect, walked back to Station.

To the military archaeologist in particular, and the historian in general, the remarkable defensive line, known as Stop Line Green, is of immense interest as it can still be traced by the number of 'pill boxes', anti tank bollards, tank traps and river bank revetting, to be found in the Cotswolds. Stop Line Green was also known as the Bristol Outer Defences, as it was constructed to protect the port of Bristol and impede the progress of invasion coming by way of the Bristol Channel. Running in a continuous line of some 100 miles in a rough semi-circle east of Bristol from Highbridge to the south to Upper Framilode on the River Severn in the north, Stop Line Green was a vital link in the defensive chain with

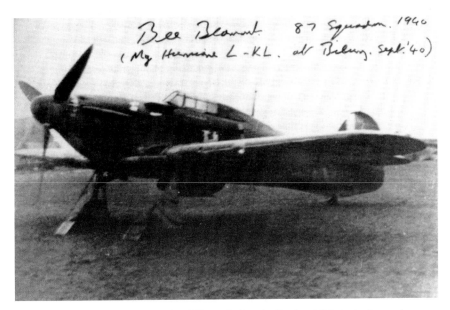

Hawker Hurricane L-KL pictured at Bibury during the Battle of Britain in September 1940 and flown by Pilot Officer Roland Beamont of No 87 Fighter Squadron (R. Beamont collection).

others called Stop Line Blue and Red. Reminders of the defence measures taken still stand, some incongruously like the pill box that sits in the centre of the track of the old Malmesbury branch line.

Despite the volume of paperwork produced for every householder to be aware of signals and warnings and what to do, there were inevitable individual initiatives taken, which often caused more than a little confusion. At Malmesbury, despite the compulsory ban on bell ringing for any other purpose than warning of invasion, the vicar announced in the November 1939 magazine that the ringing of Malmesbury church bells was as a fire warning. He had given permission to the Mayor for their use, 'as the ordinary fire siren is only used as an air raid warning'.

The Revd Claude Tickell, Vicar of Latton-cum-Eysey, was not going to be left out of all this, so he gave his 'Advice in an air raid. Don a gas mask and sit astride a low wall and fall and lie down on the side the bomb is not falling.'

The *Citizen* published a request on 4 September 1939 that 'Boy Scouts should wear their uniform at all times for the duration of the war, as many are occupied with war work'. Little did anyone envisage that the duration would be of six long years; the Boy Scouts did, in fact, do an incredible amount of work from helping evacuee toddlers off overcrowded trains, carrying luggage, delivering messages, helping with recruiting duties to filling sandbags.

Within the first year of the war. the Government had placed an order with Indian Jute Mills Association for 58,317,000 sandbags. Ten thousand had been filled by volunteers; men, women and children at Barnwood during the first weekend for use in the city of Gloucester and the immediate district. A further 24,000 were filled over the following two days. The Guildhall was 'bagged' immediately, and pictures appeared in the papers of hastened weddings because of the crisis — the happy couples posing between columns of sandbags. A street seller at Gloucester took up his pitch in the relatively sheltered spot afforded by the barricade.

It was estimated that to give adequate protection to the great east window of Gloucester Cathedral — thought to be the largest stained glass window in the world at 72 ft (22 m) high — a million sandbags would be needed. It was decided that the alternative course of removing part of it would be more advisable, so eight panels were taken out; the first time that portion had been removed, except for re-leading at a cost of £600, since the window was installed in 1350 as a memorial to the Gloucestershire barons and knights who fought at Crecy and Calais in 1346. Over 60 tons (61 tonne) of sand were used in the sandbags giving the tomb of Edward II protection. The floor underneath had to be propped from the crypt — to

where the wooden effigy of Robert, Duke of Normandy, had found a new resting place — to take the weight.

The task of sandbagging Tewkesbury Abbey was regarded as 'too formidable'; but, it was reported, there was 'restricted lighting in force' by the end of August 1939, and 'two lengths of hose to the Abbey roof, for fire-fighting, were already in place'.

Two hundred thousand sandbags were allocated to the district by the Lord Privy Seal's department. Tewkesbury had applied for 118,000 and was allotted 30,000, which they had to collect from Gloucester. These were for 'vital buildings' only: the hospital, the first aid post at Watson Hall, the Civil Defence Control Centre at the old hospital and the fire station. At Cirencester, the old museum was used for storing the sandbags until work began on filling them at the end of August.

The general feeling that despite preliminary precautions had Hitler invaded, as was expected, the country was inadequately prepared to defend herself, was voiced by Lord Dulverton. His son, the Hon. Robert Wills, recalls being home at Batsford Park in a portion of the house left to the family after it had been taken over by the military and seeing his first bombs of the war in his own garden — three of them. 'I remember sitting at the dinner table with my father and Winston Churchill and my father said, "Tell me, Prime Minister, why Hitler didn't invade after Dunkirk, because he would have surely conquered us then?" Churchill, in his inimitable style replied, "Because my dear Dulverton, Herr Hitler, like myself, makes mistakes."'

CHAPTER THREE

# Air Raids and Airfields

## WARNINGS AND PRECAUTIONS

The threat of air raids was not underestimated in the Second World War. The First World War had given Britain an introduction to the horror and devastation they could inflict. So the warning system was of paramount importance. Cirencester had discovered in 1914–18 that there was insufficient steam for the hooter on the brewery, so the Town Council discussed the idea of employing men to ride round the town on bicycles displaying warning placards, having timed the period between the warning being received at headquarters and the actual arrival of the planes as being half an hour.

Two decades on, although the wailing siren became a national signal, recognized by everyone, there were causes for complaint from some areas who could not hear it. Watermoor residents asked why it was that Chesterton had whistles blown in the street, and they did not, the buzzer at the end of town not always being audible over that distance. The Council approved a steam whistle on Cotswolds Mills to augment the siren and published a notice that the warning tests would be carried out on the first Monday of each month.

The warning 'warbling' of twenty seconds implied Action, followed by a steady note for one minute. A steady note of thirty seconds signalled Raiders Passed.

Tetbury was relying on whistles in the first year of the war when their siren had been out of action for such a long time that residents wrote angry letters complaining about the inadequate warning method. It was only those people who happened to be out in the street and saw the Air Raid Precaution (ARP) warden using a whistle who were aware of a warning at all.

Small villages relied on the initiative and direction of their local ARP. Such as at Eastleach, where the vicar, Mr Squire, biked round swinging a large wood rattle — and that would set off the inter-village controversy

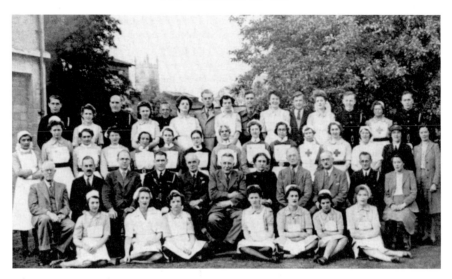

The organisation in charge of Cirencester Memorial Hospital for Air Raids.

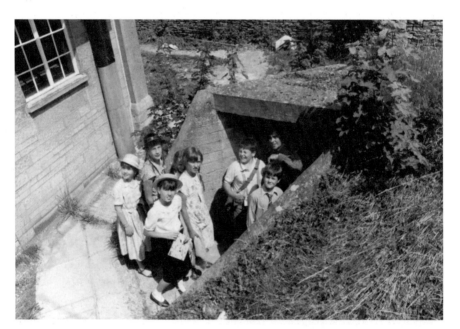

Peter Grace, a Trustee of the Living Memory Historical Association, leading a school party dressed in wartime clothes, into the air raid shelter of Cirencester's Memorial Hospital. Exhibitions of wartime memorabilia have been staged in the shelter each year from May to October for the last 20 years.

again as to whether Eastleach or its near neighbour, Southrop, should have the pom-pom with which to defend their air space.

On 4 August 1939 the Government issued an order that respirators were to be distributed to the general public within twenty-one days. Five days later the order was cancelled 'owing to the holidays and the fact that there was no emergency'. The Stroud district had already got one-third of its requirements assembled by May, thanks to the voluntary cooperation of Messrs Holloway Brothers, Copeland Chatterson and Company, and the Stonehouse Paper Bag Company. The remainder were assembled at the rate of one thousand an hour. The City of Gloucester had theirs assembled at Alexander Warehouse, and they were completely distributed by the end of August.

Cheltenham received its first load of 3,570 gas masks in August, and like elsewhere found a mixed reception to their issue: some people happily turned up for fitting and others were downright hostile and accused the ARP of scaremongering. The baby protective helmet, a monstrous looking concoction, met with passive resistance. It took the ARP some time to get an answer to their appeal for the demonstration for 'a baby of any sex, kind or variety, to test out the protective helmet. The baby must not be more than 2 ft long'. The assistance of the aptly named Public Assistance Institution was sought in desperation and matron found nine-month-old Rosemary Jones for them. Rosemary, however, did not take kindly to the LAGC instructor — it was decided — so Col. A.J. Stewart 'retired to a safe distance, and baby Rosemary was coaxed with a bar of chocolate'. The model took the chocolate, demolished it, and continued to kick. Eventually she had to be declared 'unfit for duty', and nine-month-old George Brown was volunteered, 'who took it like a man'.

By October a special curling pin was being sold to 'enable bearded men to wear their gas masks in comfort' — too late, unfortunately for the Cistercian monks who had already shaved off their beards to make their masks fit properly.

Fashion writers were urging women to 'make a drab accessory into a fashionable ensemble by adding a decorative ribbon and bow instead of the string'. The *Cheltenham Chronicle and Gloucestershire Graphic* announced that waterproof haversacks with dressing gown cord were appearing in local shops, and that 'the more ambitious' could make a gas mask bag of the same material as a dress or suit. The quilted air raid suit to be worn over pyjamas for warmth and 'preserving modesty' had also appeared in the high streets of the Cotswolds. A pattern for a smart one-piece siren suit for ladies was offered to readers, who were assured that 'volunteers filling sandbags now wear slacks — which had become the vogue'. Mrs M. Beerling recalls that her young nephew would not

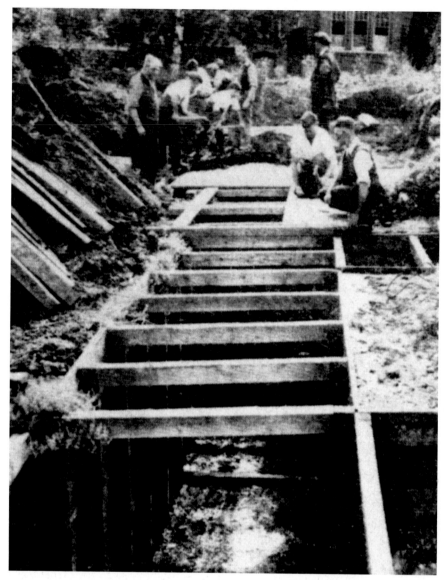

Preparing trenches for air-raid cover, Gloucester 1939.

speak to her for a long time when she first wore slacks, which cost her
5s. — at Marks and Spencer, remarking that 'it is only boys and daddies
who wear trousers'. Long days spent in the huge hangars at Great
Rissington airfield, making camouflage in the bitterly cold winter months,
called for far more protection than the shorter skirts which had become
more of a material saving drive than a fashion fad at the outbreak of
war.

The Government policy for air raid shelter was to initially advise every householder how to protect their own home. The booklet stressed the need for a gas-proof 'Refuge Room' as the first line of defence; gas masks being the second. Full details of how to gas-proof the room were given and 'Things To Do In An Air Raid'. During the first week of the war a number of shelters had been opened in the towns,' but much work had to be undone later when a closer inspection declared that some of the buildings selected during the crisis period leading up to the outbreak of hostilities were unsuitable as public shelters. Lack of technical advice at the time caused a great deal of unnecessary heavy work to sandbag such places as Stroud Parish Church, which the experts later pronounced to be quite unsuitable. The trenches dug across Stratford Park and Cashes Green also came under criticism — and they were later filled in.

The Anderson steel shelter was available to those whose income did not exceed £250 per annum, with an extension of £50 for school age children from the third child upward. The shelter, provided by the Government, remained their property; local authorities had to advise on the site, and the cost of the erection was borne by the householder. Anderson shelters cost from £6 14s. according to size, people with higher incomes were expected to buy their own. Local authorities were empowered to advance money to house owners to provide permanent shelters, the advance attracted interest and had to be repaid within ten years. Underground passages, strengthened basements, brick and concrete 'pillboxes', trenches, cellars, and adapted railway arches provided communal shelters. Grants were made available to firms in industry and commerce to provide the statutory shelters as required by law for fifty employees or more. Education authorities had to make their own provision for schools, often the 'shelter' was no more than a couple of sandbags on the door porch or a reinforced lobby. Many schools exercised a 'safe house' policy — of sending children to designated houses at the start of the air raid warning and to remain there until the All Clear. Gloucestershire Education Authority spent some £11,000 'on trenches and other forms of protection' — but that was for elementary schools only, and often amounted to not much more than brown paper strips for the windows — while £2,800 was spent on the initial stock of stationery for the evacuated children. A circular issued to schools advising that the children should be told to lie down in the classroom during a raid 'and sing songs', was generally ignored as being impracticable and often, because of the bulging classes due to the evacuee influx, highly dangerous. 'There was little room to stand shoulder to shoulder in the classroom let alone stretch out on the floor, they would have had to lie on top of one another and risk suffocation let alone having a sing song', one teacher said.

Rural areas of the Cotswolds, categorized as 'non-vulnerable' did not have the offer of the Government shelters; many enterprising householders made their own provision. Even so, the cost of producing a bolt hole big enough to sleep, cook and worry away the long hours of a raid, with sufficient ventilation to avoid a build up of fumes, smoke and condensation and allow some input of fresh air while making it gas-proof, was often beyond the pocket of poorly paid everyday folk. Often several families pooled their resources and manpower to provide a shelter between them: one such consortium engaged a couple of local grave diggers to dig out the foundations 'because they were used to the work'. There was, however, a natural fear of going underground and being trapped, 'if the bombs didn't blow you out of existence, then pneumonia from the dug-out would carry you off' was the pessimistic view of some.

'My wartime grotto', was how one warden described the shelter he had constructed below ground himself, and covered over so well as to form an attractive rockery. Comfort in the shelter featured in the *Gloucester Journal* — and shelterers were reminded that cleanliness of person was essential when sharing closely confined space with others. The list of things which should be in a shelter, according to the ARP regulations were: roll call of all who should be present, respirators marked with names of owners, plenty of water for drinking, washing and damping door blanket. Emergency food supplies in special food chest. Tin opener and corkscrew, table and chairs, china, cutlery, thermos flasks. Portable handbasin, chemical closet or chamber pots, toilet paper and disinfectant, sand and water for fire-fighting or simple pump. Strong bucket, long-handled scoop and hoe for dealing with incendiary bombs, spare blankets or rugs, mattresses, plenty of warm coverings. Mackintoshes, gum boots or galoshes for use outside. Wireless set, gramophone, books, writing materials, playing cards and toys. First aid outfit, dark lens glasses, and sundries such as torches, spare batteries, candles, matches, hammer, nails, string, thread, needles, knives, scissors and safety pins. A screen for privacy. Most families made do with an old mattress, rugs and an Oxo tin of small bits and pieces with which to amuse the children. The English penchant for flowers often expressed itself in well-used shelters being made more attractive by a pot plant or two — but very few, if any, could have possibly accommodated the extensive range as suggested in the regulations. The Oakhill family devised a very efficient shelter in their Gloucester garden: they simply widened and deepened a ditch and ran an old van into it then covered it with earth. With the seats already inside and floored, the metal shell was an effective lining to keep out the dampness of the soil.

The Public Assistance Committee requisitioned rooms at Northgate Methodist Church, Ryecroft Methodist Church, Wesley Hall in Seymour

Road and Sherborne Street Mission Room as a combined public shelter and refuge, with feeding station, if the need arose, as the city of Gloucester found it was having to cope with neighbouring villages rendered homeless through aerial attacks.

The experience in reality, though, was that in the case of Bath and Bristol the raid weary left the cities at night and camped out wherever they could in the countryside. The 'trekkers' as they came to be called, could be seen carrying bundles of makeshift bedding either on bikes, in pushchairs, handtrucks, or slung across their back, and risked pneumonia from sleeping in a ditch rather than being buried under the rubble of a bombed house.

Cirencester ARP were looking at cellars in the town centre in September 1939 to augment the shelters on private premises which they had arranged for the public caught in the street during raids. H.L. Perkins in Dollar Street, A. Ovens and Dr H. Adams in Dyer Street, Milwards in Castle Street, and Brewery Maltings in Cricklade Street, with the Corn Hall in the Market Place, had already been made available at the outbreak of war. The Cirencester Brewery Company claimed to be the first firm in the area to construct an air raid shelter for its staff. This was also made available to the flat-dwellers over their offices. The shelter, entirely below ground

The first public shelter built in Cirencester was completed in August 1939 by the Cirencester Brewery Company for their staff. They are seen here testing out the shelter and already have their gas masks in boxes on their laps.

level, was constructed by the brewery's own building staff using concrete tubes made by Norcon's of South Cerney. The concrete tubes, 1 ft (0.3 m) long and of 6 ft (1.8 m) diameter, were joined by waterproof joints. With gas, splinter and blast-proof doors, armour-plated glass windows, electric light, first aid equipment and a supply of torches, the shelter of 28 ft (8.5 m) long with seating on both sides, could accommodate a total of thirty-five people. The entrance bore a cheery sign, appropriately naming the shelter as The Hop Leaf.

Trenches for 7,000 people were 'approved' in August 1939 for Cheltenham town centre. Stretching from the Athletic Ground in the north to the Winter Gardens in the south, and from east at Berkeley Gardens to west at King Street, the trenches were shored up with timber while waiting for concrete. Manufacturers reported that they were fast running out of materials to make shelters. Eventually, the 'approved' figure was not reached, and the trenches could only accommodate 4,000 by 9 September. The approved expenditure to provide accommodation for 4,000 persons to be sheltered elsewhere was a maximum cost of 35s. per person accommodated. Requisitioned premises gave the owners the right to compensation from the Government. Montague Burton of Cheltenham consented to their basement being used as a public shelter in the High Street, accommodating up to 150 people.

The construction, and later demolition, of air raid shelters alone provided work for thousands of otherwise unemployed people, apart from those involved directly in the munitions factories and forces and the other innumerable branches of the great war machinery. At Churchdown, when their brick surface shelters were demolished in April 1945, it was estimated that ten had used some 50,000 bricks in their original construction. In October of that year, Gloucester city's 222 street shelters were demolished.

'Sir, air raids are likely to run a bad second to black-outs. Air raids may kill their thousands, but black-outs are likely to kill their tens of thousands,' warned Claude Tickell, vicar of Latton-cum-Eysey to the editor of the *Wilts and Gloucestershire Standard* in November 1939. Numerous reports of accidents from falling over dogs' leads in the street, collisions between pedestrians, bumping into Belisha beacons or stationary buses and bicycles to fatal road crashes filled the columns of the local papers during the first year of the war. 'Spotter' of the *Standard* recounted an incident in which he fell over the Army and RAF — at least one representative from each of those forces — as they lay on the pavement in darkest Cirencester after colliding. As he joined their recumbent position they greeted him with a volley 'of well-modulated abuse', in return for which Spotter helped them to their feet and guided them — all by now cursing the black-out — to the

nearest hostelry 'where butter was applied to the bumps and beer to the stomachs'.

A commercial traveller declared Cirencester to have the blackest black-out in the country and declared that he would give the town a miss 'until the war is over' after his painful encounters with everything in the Market Place from newsboys to the Stroud bus. 'I don't see why Cirencester should be blacker than Cheltenham', queried Mr S. Boulton at the Council meeting to an accompanying 'Hear, Hear', from his fellow councillors. 'I think it absurd that a safe area like Cirencester should be blacked-out to the extent it is,' he continued. 'Aren't we likely to get proper street lighting at any moment?'

Mr W.G. Tovey replied that it was unlikely, but the Council had given permission through the Streets Committee for traders to paint the curb stones in front of their premises with white paint, having done so himself he declared the previous day and hoped that others would follow suit — not forgetting to do the top as well as the side. He then reported that the specially prepared lamps would cost about 8s. each. The council then debated on the expense of providing the town with two dozen; although it could 'prove an investment', one member thought they should be more prudent and make do with what they had already, but the surveyor laid claim on the hurricane lamps 'for any emergency'. So they mulled over how to black-out the remainder to meet the regulations until Mr Eric Cole pointed out that by the time they had spent money on the black-out paint, and the time for such artistry to conform exactly, they 'would have spent almost as much as if they had bought new lamps'. With these wise words, they agreed that the cost was justified. Cheltenham contended that their black-out was equally as effective and that tripping over dogs' leads was not peculiar to Cirencester; in fact, Cheltonians had considered requesting that all black dogs should be painted white! They had gone so far as to thin the branches of their trees — parochial pride in their promenade taking second place to their concern for the safety of their citizens — and trees on street corners wore a white disc.

'Wear white and walk left' urged The *Citizen*, following a talk on national safety at which Dr Gwynne Thomas said that pedestrians should wear a white glove on the right hand and, indeed, had got his wife to knit him one and it can be seen 'very well in the dark'. 'Wear white' was the theme which *The Times* took up in September 1939 relating the idea to the Cotswold 'Dursley Lanterns'.

With regard to the suggestion that pedestrians should wear white patches at night, perhaps a revival of 'Dursley Lanterns' would meet the case so far as men are concerned. The enclosed extract from the recently

published 'Kilvert's Diary' explains how people got over their difficulties a century or so ago: 'My mother says that at Dursley in Gloucestershire, when ladies and gentlemen used to go out to dinner together on dark nights, the gentlemen pulled out the tail of their shirts and walked before to show the way and light the ladies'. These were called Dursley Lanterns'.

White paint, or other white material, had to be applied to bumpers and running boards, or equivalent positions, of motor vehicles under stringent regulations under the Lighting Order of 1940. Only one masked headlight was permitted to show a white light. It was allowed to be fitted either side of the car but no light was to reach the ground nearer than 10 ft (3 m) distant from the lamp, or five times the height of the bottom of the lamp above ground level, whichever was the least. Intensity of illumination 'must not exceed 2½ ft [0.8 m] candles at a distance of 10 ft [3 m] from the lamp'. Direction indicators were permissible providing the light apperture did not exceed one-eighth of an inch in width. Combined head and side lights, and rear lights were restricted to 7 watts, and reflectors had to be painted dull black. Little wonder confusion reigned. For every black-out offence or excess of vehicle lights, there were two of cyclists having no lights or farmers having no rear light on their waggons, and soldiers home on leave having their lights back to front — all were fined with impunity, even the elderly woman who, according to The *Citizen*, 'unfurled a Union Jack and shouted God Save the King, to no avail', was fined 10s.

The editor of the *Gloucester Diocesan* magazine warned that 'car drivers can see nothing with ARP lights and they cannot hear a horse' following the report that one of his Rural Deans had taken to the use of his bicycle or horse to visit his outlying parishioners. Canon T.A. Garnett of Hawkesbury travelled to a distant village to conduct a harvest thanksgiving service on horseback, his robes in a haversack slung across his back. He was quoted as saying, 'It is easy to visit farms when one can ride by fields and bridle road. After dark no lights are required and a horse goes better by night than by day. He can be relied on not to stray into a ditch, and going home on a pitch dark night through fields will always make for the right gates.' The editor commented that the Dean should at least carry a torch.

It was announced in the local papers in January of 1940 that shepherds would be allowed to carry a torch during the black-out 'when lambing is in progress'. Dennis Moss of Cirencester respectfully requested that his clients should present themselves for photographing in daylight hours; shops were asked to adjust their opening times to get over the difficulty of lights showing every time the shop door opened and closed, and, at great

peril to their standing in the community, the politicians tentatively suggested that the pubs should act accordingly. While the country as a whole suffered the dangers and frustrations of the black-out, two sections of its public welcomed the total blackness. Astronomers declared themselves 'pleased with the black-out as it was perfect for research'; burglars, too, found it a rewarding time — but, as The *Citizen* reported, 'it should be known to all the criminal classes that the punishment given by the courts for offences committed during such a time in this country, will be very heavy'. Mrs Robert Noble appealed to women readers in the Cirencester and Tetbury areas to set up black-out groups at which neighbours and friends could knit and sew, making acquaintances without getting depressed about the black-out, and a Black-out Club was formed in February 1940 in Cheltenham, under the auspices of the Gloucestershire Youth organization. Such a step to providing facilities for the young people brought a flurry of protests from county councillors who pressed for a proper scheme for the whole county. One member saying, 'It seems that Cheltenham is the centre of the whole war, we must not leave out 'Gloucester Stroud, and other parts of the county'.'

Ironically, the predictions of the Revd Claude Tickell proved only too true, for it was revealed that in the country as a whole some 400 people were killed and 3,000 seriously injured in the first week of the war as a result of the black-out, compared with a total of 1,316 killed and 3,000 injured during all the air raids in the four-and-a-half years of the last war. Tragic, too, that it was a rector's wife who committed suicide at Bishop's Cleeve 'over worry of the black-out, and the fear that she would be 'had up' for insufficient covering of the Rectory windows.

## AIR RAIDS

The threat became a reality in 1940 when Britain started to experience a catalogue of incidents from aerial attack, ranging from full-scale blitz to indiscriminate jettisoning of bombs as the Luftwaffe lightened its load to make a speedy getaway after wreaking havoc on its carefully planned targets. It was the latter that meant there was no safe haven, despite the Cotswolds being officially designated 'a safe area'. Key aircraft industries were dispersed from high-risk areas and settled in the foothill vale and it was here that the actual raids occurred. To the west, Bisley church spire was reckoned to be the navigational point — and the village must have gleaned a mite of comfort from that fact, as it would be inconceivable that the enemy airforce would bomb its own landmark. To the north-east, Moreton-in-Marsh seemed to be the navigational point to guide

the bombers to the industrial heart of England. From the Cotswold hills around those two landmarks, the skies above Bristol and Coventry could be seen ablaze with the fires from the blitz. But many sorties criss-crossed the Cotswolds to bring fear and destruction, albeit on a comparatively smaller scale than that of the cities; Hitler's threat to fire the cornfields in an attempt to starve the country into surrender was no idle one and any damage to farms and livestock meant that much less food.

The proliferation of airfields on the high wolds all over the area increased the targets considerably, and then there were sheer vindictive random bombings and machine-gunning from lone raiders hell-bent on killing any-thing that moved — including children at play in school grounds and pet ponies grazing in the fields. It is due to these incidents, which are difficult to trace because they did not warrant the title of raids, that the complete calendar of Cotswold casualties — as, of course, elsewhere — poses such a challenge to compile. Contemporary newspaper reports were strictly cen-sored so no place names were given and often played down the seriousness of the raid — all useful intelligence to the enemy.

Records speak of the first German bomb to fall on British soil as 17 October 1939 at Hoy in the Orkneys. By the spring of 1940 the main-land was being targeted, and the south-west Cotswolds started hearing the drone of enemy aircraft, which was to become a sound most feared over the next five years, as Tuesday 18 June 1940 had a visit from a lone Heinkel. Two bombs were dropped within 200 yds (183 m) of the Bristol Aircraft Works at Filton. Two airmen on a nearby balloon site sustained injuries.

The Cotswold calendar was to be punctuated with incidents, some seri-ous, some seemingly insignificant compared with full-scale blitz campaigns elsewhere, but even an empty road being strafed meant disruption and costs to be borne from a country hard-pressed to fund the massive war effort. Such records as were gleaned came from ARP and other defence bodies, others from local knowledge — and probably, many were never recorded at all. Reports of necessity had to be brief and a kind of short-hand was used to denote what kind of bomb had been traced: HE — high explosive; IE — incendiary bomb; UXB — unexploded bomb. Likewise, approximate sites were given in many cases. The following diary indicates how few places in the Cotswolds escaped unscathed:

1940
   26 June Nether Westcote, near Bourton-on-the-Water: damage to the Methodist Chapel, farmhouse and cottages. South Cerney airfield was bombed by a lone raider with HE and IE—no serious damage.

30 June Cirencester-Cricklade Road had twenty-two bombs, Marston Meysey one.

9 July Fields around Horton had 4 HE; Badminton 3 UXB; 4 HE at Haresfield, hitting a water main and telephone connections.

25 July South Cerney airfield: 4 HE; slight damage to crops in nearby field. But it was the third plane to be sighted that afternoon that was to give the area its first encounter with the enemy face to face, with anti-aircraft fire. A Hurricane of the Kemble Defence Flight and a Spitfire from Aston Down were involved and brought down the German plane at Oakridge Lynch. The crew of four baled out and a posse of Home Guard, including the Miserden Company summoned by the church bells, arrested three but not before the ladies had played their part. The fourth, whose parachute failed him, was found dead in Oldhill Woods. One German was held at pitchfork and scythe point by a body of Land Army workers until the local police arrived. The second, described by Mrs Le Bailly in whose grounds he came down, as 'about eighteen and quite good-looking, just a boy. I saw him descend and told my maid, Mavis, and her brother Roy, the gardener's boy, that they had better go into the shelter, but they followed me as I approached the airman and helped me prop him against the wall, he was obviously shaken. I sent Mavis into the house for a glass of whisky, and when she gave it to him, he said "Thank you", then took her hand and kissed it. Then Mr Weston, the schoolmaster, from opposite us took charge of him while I rang the police.' Captain F. Guise, the platoon commander of the Home Guard, told a reporter of The *Citizen*, 'One was in a hell of a state and believed he was going to be bumped off, but when we gave him a cigarette he cheered up. He was only about seventeen years old. When one of the military came to take over and saw the oddly dressed but quite well armed Home Guard he remarked, "Isn't Jerry going to have a tough time if he tries anything with these fellows".' The third crew member narrowly missed landing on top of Captain Weston's school house, and was confronted by the headmaster's fourteen-year-old daughter. Running up to him she asked if he was alright and was taken aback when he replied in German. She called out to her father, and the German handed over his revolver with no fuss. After giving him a drink, Captain Weston was thanked by the German and was handed over to the authorities.

28 July Compton Abdale: 2 HE in a field.

29 July Lower Slaughter and Compton Cassey: 11 HE; 3 UXB in open country.

3 August Waterley Bottom: 6 HE; Calcot farmland 18 HE.

14 August Kemble RAF Station: 4 oil bombs and 18 HE damaged nine Whitley bombers. Chedworth-Coln St Dennis: a large number of bombs damaged roads.

Chipping Sodbury: 8 HE, bungalow damaged, Newman Henders at Yate sustained damage to the electricity plant and machine shop with four people slightly injured.

16 August Northleach: 3 HE killed a horse, a pony and a rabbit and badly injured another horse. Poulton received damage to four houses and a water main from 34 HE and 400 IBs. Ablington suffered road damage from 21 HE bombs. On the same day, some 46 Airspeed Oxford trainers were destroyed on the ground at RAF Brize Norton.

17 August Chavenage: 2 HE.

18 August The riverain village of Windrush witnessed what was reported in the local paper as 'Trainer Rams Enemy Bomber — a sergeant-pilot of the Royal Air Force crashed a Heinkel bomber by ramming it in the air. His gallant action cost him his life'. Sgt. Bruce Hancock, aged twenty-six was completing his course of instruction in a twin-engined Avro Anson, painted yellow as all British training aircraft were and unarmed, when the lone raider swept in, firing from 500 ft up. Heavily machine-gunned from close range, eye witnesses reported that Sgt. Hancock turned the Anson and deliberately rammed the Heinkel, which burst into flames at Blackpits Farm, Aldsworth killing all five crew; one of which was said to be not more than a fifteen-year-old boy. The German airmen were buried with full service honours at Northleach. The RAF provided an escort and firing party for the volley to be fired over the one large grave during the Last Post and paid tribute to them by circling overhead and dipping in salute. The cortege was watched by many local people. An Army convoy pasing through the town stopped in respect to allow the procession with its swastika-draped coffins through. The sacrifice of the courageous young trainee pilot has recently been marked by a plaque in the churchyard wall at Windrush.

19 August Hawling: 9 HE; Andoversford one HE. Bibury airfield was bombed by 4 HE, witnessed by a local man, Alan Lockey. 'I was taking my young daughter for a walk when I heard the drone of a strange plane and could see it over the Coln Valley. I pushed the pram under the cover of a stone wall as I could see the plane banking as it crossed the road, then it opened fire. A couple of airmen were firing a Lewis gun at it, but as it turned after dropping its load the tail gunner opened up with a machine gun killing one of the airmen. Three of our pilots scrambled their Spitfires; a new batch had just been delivered and one had been completely destroyed as it stood on the airfield and another damaged. They gave chase at terrific speed and we heard that the Ju 88 was brought down after a dog-fight over the Solent. One of the bombs was a delayed action type and exploded a little time after.'

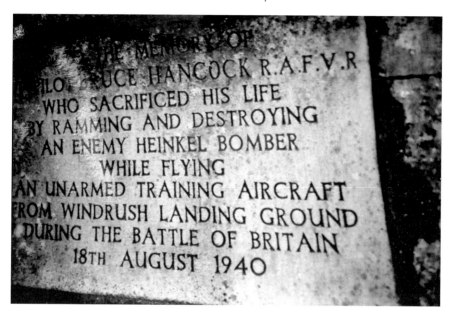

Memorial plaque to Pilot Bruce Hancock, RAF VR who sacrificed his life by ramming and destroying an enemy Heinkel bomber while flying an unarmed training aircraft from Windrush Landing Ground during the Battle of Britain 18 August 1940.

20 August Coates, Ready Token, Fosse Hill Farm and the Tetbury Road, close to Cirencester, received a rude awakening before dawn from a large number of HE bombs. Eastington House at Ampney Crucis received damage to the roof and windows with nearby telephone and electricity cables severed. A cyclist was blown from his bike, but was unhurt.

23 August Chipping Campden area received some 23 HE bombs; Moreton-in-Marsh had 5, none of which exploded.

24 August Again Chipping Campden experienced HE bombing, with one person injured. Incendiaries and HE bombs scattered around the countryside at Dursley, Wotton-under-Edge, Nailsworth and Chipping Sodbury before Bath's concentrated raid later that evening.

25 August Hesters Way, Cheltenham had UXBs. Ablington hamlet 7 HE.

26 August Cheltenham had a number of UXBs at The Reddings, thought to have been intended for Staverton airfield. At Cooper's Hill Farm HE bombs made 8 craters of 10 ft (3 m) diameter and over a foot deep. One ewe was killed outright and another was so badly injured that it had to be destroyed along with a two-year-old heifer. Compensation for war damage involved a lot of form filling, and the farmer had to prove that animals claimed for had been bred before the war.

28 August A dead owl at Tetbury and a dead rabbit at Cirencester must have left the inhabitants of those towns feeling somewhat thankful they had been let off so lightly on a day when three airmen were killed at Staverton barrage balloon post. The airfield suffered disruption from fractured mains and telephone wires. Elsewhere in the Cotswolds, incidents included the Gloster Aircraft Factory at Brockworth, Churchdown, Cranham Mill, Painswick, Badminton, Tormarton, Wickwar and Harescombe—all reported to have been poorly targetted, with the bomb at Harescombe escaping detection for three days. Captain Smart of Area 8 dug it out.

29 August Tewkesbury had one HE bomb damaging water mains; houses in the Brockworth area received some damage and bombs were scattered at Chenage Green, Gotherington and farmland near Wotton-under-Edge.

31 August The north Cotswolds attracted attention around Batsford, Blockley and Bourton-on-the-Hill.

1 Sept Blockley, Batsford, Naunton and Churchdown reported incidents.

2 Sept Yate, Kemble, Brockworth and Chipping Sodbury received some attention from the air.

3 Sept Buckland, Batsford and Dorn had HE bombs, and two oil bombs just missed a searchlight battery at Prestbury.

4 Sept Gloucester had its first HE bomb, but fortunately it did not explode even though it went through the roof of a house in Kenilworth Avenue. Notgrove also reported HE bombs in the area.

5 Sept Coln St Aldwyns, Chedworth Bottom, Stinchcombe, Windrush, Bibury, Cherrington, Taynton, Coney Hill, Badminton, Hatherop Hill, Hawkesbury, Hucclecote, Rissington and Painswick were among a long list of bombed sites in the West Country that was one of the worst twenty-four hours on record. Painswickians in particular had reason to be more jumpy than usual when the Royal Engineers exploded a delayed action bomb, causing two houses to have collapsed ceilings and the windows breaking in another four.

6 Sept Marshfield, West Littleton and Ampney St Peter were singled out for a brief bombing, with little damage.

8 Sept The road was blocked as a result of 8 HE bombs falling at Blockley.

10 Oct After a respite for the Cotswolds while Bristol and the south-west were being plastered, Hatherop and Eastleach area received two HE bombs on a day when three major cities were being heavily bombarded.

15 Oct The LMSR goods yard near Arle Bridge in Cheltenham felt the effect of two HE bombs, with a couple of men slightly injured on a night when London was coming under heavy attack.

16 Oct 'Sheds at an airfield near Cheltenham' was the claim on German radio when the streets at Brockworth were machine-gunned and several HE bombs damaged houses at Churchdown.

18 Oct Turkdean Manor Farm was shaken by 3 HE bombs, and Bibury received a dozen.

21 Oct Gloster Aircraft Factory suffered loss of life and injury of a number of workers in a raid by a single plane during the lunch hour. Mickleton received a couple of HE and an oil bomb. Painswick received a direct hit through one of its houses: the bomb passed through the roof, pierced a dressing table, a gas stove and a bag of onions to land in a passage. The house was evacuated. The following day the local policeman, PC Handley, is said to have borrowed a spade and without conferring with anyone on his intention, proceeded to dig out the shell which he then calmly carried to the police station and placed on the table, saying that he thought it was an unexploded bomb. His reception is not recorded!

22 Oct A scattering of mainly IBs fell on Barnsley, Beverstone, Rodmarton, Great Witcombe and Leckhampton.

25 Oct Cerney Wick area received 4 HE. Traffic had to be diverted on the A40 when over a hundred IBs fell near the Puesdown Inn. Local legend has it that the German pilot probably mistook the ghost highwayman who frequents the road as an important dispatch rider.

27 Oct Farm damage and fires in Witcombe Woods were caused by incendiaries such as also fell at Prestbury and Cooper's Hill. Forest Green also suffered some damage when Grist's flock mill was hit.

28 Oct Chedworth, Compton Abdale, Stowell Park and Sherborne had power and telephone failures through incendiary bombing.

1 Nov Three HE bombs fell near Snowshill.

5 Nov Three horses were killed at Lechlade when several HE bombs dropped just north of the police station; Great Barrington also felt the tremor of bombs being dropped close by the village.

6 Nov Another horse was killed at Northleach. Incidents were also recorded at North Cerney, Miserden and Ampney Crucis.

7 Nov Unexploded bombs on the roads leading to Perrott's Brook, Daglingworth and the main A417 caused disruption to traffic.

13 Nov Roads around Upton St Leonards were hit by a dozen HEs.

14 Nov The Luftwaffe concentrated its deadly mission on Coventry and people in the north Cotswolds were made aware of their own vulnerability as the sky filled with the dreaded purposeful drone as the raiders made for their navigational point at Moreton-in-Marsh. They kept a small reserve for the area, however, for Dowdeswell and Northleach. Stroud area also reported on raiders passing over for the historic blitz.

15 Nov Sudeley, Blockley, Eastleach and Daglingworth had HE.

16 Nov A considerable number of HE bombs were aimed at the small village of Upper Oddington.

17 Nov A total of twenty-two houses and the church reading room were damaged by two HE at Cerney Wick.

19 Nov The Cotswolds came in for a random bombing campaign which included North Cerney, Taynton, Kemble, Andoversford, Blockley, Brockhampton, Northleach, Hardwicke, Hawling, Prestbury, Snowshill, Leckhampton, Hillesley and Kilkenny, near Wotton reporting bombs. Cheltenham suffered property damage in different areas in the town, but the tragedy of the day was at Gotherington when Miss Elizabeth Kearsey lost her life in her thatched cottage after a bomb had fallen just in front of it causing an instant fire. A brave attempt to save her was made by the local rector who was the Head Special Constable, but to no avail.

21 Nov Hatherop was singled out for the only reported incident in the region.

22 Nov Single bombs were dropped at Notgrove Station, Hazleton, Laverton, Brimpsfield, Chedworth and Sudeley. Witney received two HE bombs in the centre of the town, causing damage to several houses, destroying a number of army vehicles around Church Green and halting production of the army blankets to which the famous Witney blankets had turned, when glass from the damaged windows of the weaving shed at Mount Mill severed the warp.

23 Nov Tarlton-Kemble area had 14 HE bombs, 5 of which turned out to be UXBs.

24 Nov A date marking the start of the Bristol blitz which was to go on for months. The Cotswold village of Ampney St Peter had its quiet Sunday afternoon enlivened suddenly as a German Ju 88 skimmed low over the roof tops, hotly pursued by a couple of Hurricanes; the drama of an aerial combat was enacted over the heads of a cheering group of Cirencester parents who were collecting their children from Sunday School. Eye witnesses were enthralled with the sheer verve and courage of the Polish pilot who after attacking the plane gave the Cirencester people a quick victory roll before disappearing into the sky, leaving the disabled enemy plane to a violent and fiery end at Coates Manor. Kath Fields was pushing her child along the country lane to visit her mother-in-law when the rat-tat-tat volley of fire opened up above her and she saw the German markings on the plane as it headed downwards in a spiral of smoke. She just glimpsed the English plane swooping low as if to check that its prey had been sent to kingdom come. Hurrying back to see what had happened, Kath was soon caught up with furiously pedalling cyclists and cars crammed with excited families.

The crashed plane was a burning inferno and no one could get anywhere near it. 'I could see the windows of the manor were scorching and cracked, and we stood back to let the fire service through, then I looked down and saw a man's hand still with its wrist watch on lying on the grass. The crew of four was buried at Coates.' Fred and Joan Haddrell found spent shell cases from the dog-fight on the roof of their house in Black Jack Street and a bullet hole was found through the sign of the Butcher's Arms at Ampney Crucis. Whether this was from the ill-fated Coates German plane, or from the time that Eastington House had a bomb in its front drive is impossible to say.

29 Nov The impact of a couple of bombs at Coates uprooted a beech tree and hurled it across the road; at Olveston Common some twenty-five houses were damaged from the effects of a mine being dropped by parachute.

7 Dec The explosion of a HE bomb at Charlton Kings was thought to be from a delayed action as no trace of aircraft was recorded for that day in that area.

11 Dec There was plenty of evidence of the source of attack on Cheltenham on this day. In the heaviest bombing the town was to experience during the whole of the war, the raid lasted from 7.40 p.m. until after midnight. More than a hundred HE and an estimated 2,000 IBs were dropped, killing twenty-three people, almost half of them from the houses in Stoneville Street from the huge explosion at the nearby railway embankment. The black-and-white coach station in St Margaret's Road was demolished and the Bristol No. 79 bus hurled over a wall. Some 600 people were made homeless and a newspaper report said that many of their bomb-wrecked homes had been looted. An emergency mortuary was set up 10 Waterloo Street. Pilley Bridge, spanning the Great Western Railway line, was reduced to matchwood and rubble. It was later replaced by a footbridge. Railway lines, water mains and other services were put out of action and added to the general misery. Bombs also fell at Witcombe Woods, Crickley Hill, Woodmancote, Upton St Leonards and Brockworth.

12 Dec Chalford, Tibberton, Fairford, Taynton, Chipping Campden, Cirencester, Weston-sub-Edge, Elkstone, Leckhampton, Prestbury, Toddington and Cleeve Hill all had at least one bomb.

22 Dec Dowdeswell had a solitary bomb.

23 Dec Frampton-on-Severn had such a pasting from 4 HE and 40 IEs that vibrations were recorded as far away as Dursley.

Bill Porter was just 17 and on Home Guard look out duty on top of a barn at Stokes Farm when landmines were dropped at his home village of

Swinbrook in the autumn of 1940. 'We heard this aircraft circling round, then one almighty bang. Very soon afterwards we were ordered home to see what had happened as the village had been hit. It caused quite a lot of damage to properties around — our kitchen ceiling was down and the east window of the church was blown out from the explosion of the bomb that landed in the river on the south side of the village. Gamekeeper Barnard found a second bomb a few days later, hanging by a parachute, hooked in a tree in Hensgrove Wood. This was eventually made safe and taken away. There was a great deal of speculation made as to why Swinbrook was the target, some say it was really meant to be the radio station at Leafield, or the RAF Base at Brize Norton. Others were convinced that it was Unity Mitford who was the target — she lived in a cottage next door to the Swan Inn after her failed suicide attempt on the day war broke out. She was a pathetic figure then, and looked very disturbed, we often saw her leading some goats on a chain round the village — quite different from when the Redesdale family lived at South Lawn and invited us village children up to their house for a Christmas party. Oswald Mosley came to her funeral — she is buried in Swinbrook churchyard.'

**1941**

2 Jan The new year was heralded in with a couple of HE bombs causing the deaths of seven people in Gloucester, a dozen injured and the wrecking of some twenty houses.

3 Jan Bristol was the target of some hundred bombers, a campaign which also robbed the food supply of a valuable store of 8,000 tons of grain.

4 Jan Alderton, near Winchcombe received two bombs — both of which exploded the following day. 5 Jan Kemble, Northleach and Oldland Common.

9 Jan Cheltenham received IBs.

11 Jan According to the reports from Area 8, Tunley and King's House Farms received 4 HEs. The only casualties were a few poultry. The farmer of King's House Farm, it was said, was fast asleep in an armchair and did not hear the bomb which caused such a crater within an arm's length of his house, but was awakened by the china falling off the mantlepiece. Such a sound sleep was reckoned to have been on the strength of the home-brewed beer!

16 Jan Gloucester and Cheltenham both had falls of incendiaries, though nothing to match the 20,000 rained down on Bristol that day.

17 Jan Aston Blank was hit by 8 HE and several IEs, and Gipsy Lane at Minchinhampton received a dozen HE bombs causing damage to buildings.

18 Jan Chedworth, Hartpury, Northleach, North Nibley reported incidents.

29 Jan Cheltenham and Gloucester area, including around Birdlip felt the impact of several bombs, but some failed to explode, although it was reported that a carrot patch by The Reddings was rudely uprooted.

Feb (no exact date given) Aston Blank school records state: the school windows were loosened when bombs fell locally.

27 Feb South Cerney airfield was machine-gunned, also for no known reason other than sheer vindictiveness was the home of Mrs Lister at Poulton. The scale of destruction which could be wrought by such lone raiders was illustrated most graphically at Yate when Parnall's factory was bombed, leaving fifty-two people dead and another 150 injured amid shattered buildings and machinery. Parnall's had been on the Luftwaffe hit list as documents and maps recovered from their files were to prove. The brief on the factory stated that it was the main producer of Frazer-Nash gun turrets fitted to combat aircraft and 'to destroy this factory would restrict production of fighter planes'.

1 March Fairford Park was gouged with several craters from a number of HE and IBs. Cold Aston also received a shower of IBs.

2 March Bibury was the target for one HE and some IBs.

4 March Small fires around Brockworth were the result of IBs.

7 March In an attempt to finish off the production at Parnall's, another lone raider swept out of the skies machine-gunning and dropping HEs on the already crippled factory, claiming another three lives and injuring another twenty workers. Salvaging what remained, the factory dispersed immediately to Boulton Mills in Dursley.

11 March South Cerney and Condicote received attention from scattered IBs.

14 March Windrush airfield reported a number of bombs in the vicinity, and others fell around Barnwood near Gloucester.

18 March Lechlade schoolchildren experienced a malicious attempt on their lives. The Log Book of St Lawrence's School states: At 10.47 a.m. a plane flying rather low and in cloud passed near the school firing a machine gun. The children were brought into school from their recreation until the danger was past.

19 March Brockworth and the neighbourhood of Aldsworth received some bombs.

26 March Gloucester railway station was the target, with six people killed and twenty-eight injured. Aircraft on the Babdown Farm airfield were strafed.

29 March Bombs fell around North Cerney, thought to have been aimed at the reservoir on Perrott's Brook corner. Chavenage also received a visit.

3 April Two bombs fell near the airfield at Moreton-in-Marsh.

4 April Incidents were reported from Elkstone, Guiting Power and Hawkesbury Upton.

7 April A single bomb damaged houses at Coaley Junction near Dursley.

8 April Cirencester reported 4 HE; Elkstone 3.

9 April Woodmancote received 7 HE; others were dropped at Swindon Village and in the Brockworth area. Later in the day the small village of Wyck Rissington was dealing with incendiaries.

10 April Edgeworth, Hampnett, Salperton and Northleach reported incidents, and nearby Brize Norton aerodrome came under attack. The extension of the airfield at Brize Norton meant that two essential taxiways had to cross the railway line and huge gates had to be installed to span the taxiways. The proximity of railways to aerodromes increased their vulnerability as enemy aircraft used the lines as navigational pointers and at night smoke and the glow of the old steam engines were easily followed.

11 April Mickleton and Oldborough Farm at Moreton-in-Marsh had unwelcome Good Friday visits.

14 April Fairford appears to have been the only spot in the Cotswolds to warrant attention, when some twenty-five HE bombs were reported.

15 April An oil bomb as well as IBs dropped at Farmington.

26 April Brockworth was bombarded with IBs.

6 May The Northleach and Windrush area received HE and IBs.

7 & 8 May The airfield at Moreton-in-Marsh reported a number of IBs.

10 May Four HE bombs fell at Brockworth without causing any serious damage.

11 May Naunton reported a single HE bomb.

12 May Marshfield escaped with little damage from a large number of bombs, as did West Littleton.

17 May One HE bomb narrowly missed Postlip Paper Mill at Winchcombe.

25 May Wotton-under-Edge houses were damaged from 2 HE bombs, and a farmhouse at Hillesley was also badly damaged in the same attack.

2 June Property was damaged at Mickleton and in the Standish area.

15 June Stroud district received its ninety-ninth Red warning about one o'clock in the morning. Ten minutes later the picturesque village of Painswick shook under the explosion of 8 HE bombs. A house in Tibbiwell received a direct hit and the Hollister-Short family declared that it was an old oak beam above them that saved their lives, but their

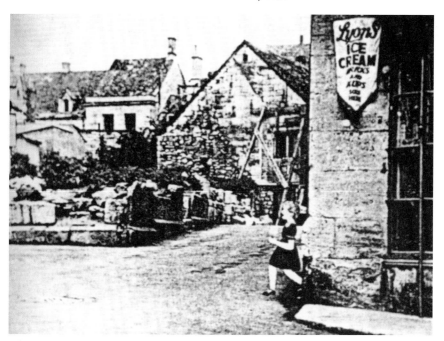

The bombed site in Friday Street, Painswick, after the rubble was cleared in readiness to build the Nurse's House.

home was demolished and Mrs Hollister-Short sustained serious spinal injuries. Poultry Court, the home of Mr Lewis, and Friday Street were hit. Two people, both evacuees, were killed; one an elderly refugee, Mr Harmer, was next door to the paper shop, home to Herbert and Hesba Ireland. Their daughter, Mrs Peggy Perrin, recalls the chaos and terror of that fateful night. 'We had got used to the drone of enemy planes going over almost every night, and we wondered which poor people were on the hit list. Then, suddenly, it was crump! and it was us. The house seemed to be collapsing around us and it was pitch dark as all the electricity had been put out of action. We could only stumble about among the rubble. The first thing I did was to jump into my wellies, put on my fur coat and grab the shop cash box. The smell of cordite from the explosion mingled with the burst casks of our home-made wine. The wardens got rid of us as quickly as possible to get on with the work of putting out the fires, so we spent the rest of the night with my in-laws drinking tea in Vicarage Street. At first light the army came in to finish demolishing our shop, along with others that were dangerously damaged. I remember being saddened at the lovely old Cotswold stone slates being smashed as they set about the demolition. We shall never know the truth of why Painswick received a direct hit that night; perhaps we had all got a bit

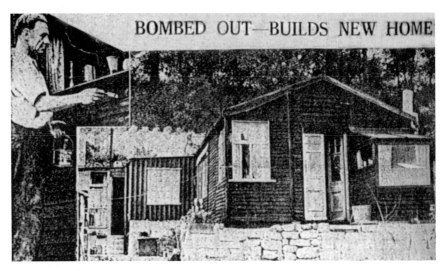

Resolute and resourceful, Mr H. Ireland converted a poultry house into a six-roomed bungalow for his family after his newspaper shop was destroyed in the bombing of Painswick.

Open-air service at Painswick. The vicar is standing on a rostrum built of stones from the bombed houses (Gloucestershire Record Office).

blasé — some people across the valley said Painswick was all lit up like fairyland; whether there were lights showing, we shall never know. My father bought a large poultry house from a farmer at Longhope who bred white turkeys. He got planning permission for us to have it to live in, being quite homeless. They granted his application to convert it — which he did and made it into a lovely six-roomed bungalow — this was until hostilities ceased. It was not pulled down, however, until 1989, almost half a century after the end of the war, and that was because the site was sold.'

17 June Brockworth, Badgeworth, Oaksey Hall grounds, Gotherington, Bishops Cleeve and Prestbury reported incidents.

22 June Barrow Elm Farm, Hatherop was bombarded with 10 HE bombs. There was damage to windows in the house and farm crops.

12 July A number of airmen were killed at Staverton airfield when it was bombed by a lone raider.

13 August The open fields some three miles north of Lechlade were bombed by anti-personnel type obviously intended for an airfield.

The threat of firing the harvest fields was not taken lightly. Shipton-under Wychwood School Log Book records:

13 August Material for making besoms for fighting possible fires in corn crops (from incendiary bombs) received from RDC. Started some senior boys on making them.

14 August Used up last of brushwood, only enough for 58 brooms.

6 Sept Some 30 houses were damaged alongside the Cirencester-Tetbury Road when 10 HE bombs fell at Courtfield.

25 Nov Hawkesbury Upton reported 2 HE bombs but little damage.

## 1942

4 April Ten men, five women and three children were killed, with nearly 200 other people injured when Brockworth was hit by a trio of raiders. It was Easter Saturday and the enemy struck as workers were getting on the bus after their day shift, leaving carnage and devastation in its wake. Fires were burning at the badly damaged factory for four hours.

25 & 26 April The infamous Baedeker Raids, so-called from the reprisal attacks of Hitler on the architecturally famous cathedral cities following Britain's raids on German fine cities — and selected from the pre-war Baedeker guide books, raged over two days. The resulting high death-toll and injuries were almost impossible to record with accuracy: one report spoke of a mass grave for up to 300 people, with some 800 others injured. Teams of rescue workers were drafted from the Cotswolds to help the city services.

27 July Cheltenham had its second worst raid of the war. Some 11 people lost their lives and 27 were injured; 12 houses were destroyed and a further 400 received structural damage. Another lone raider strafed the airfield at South Cerney and Culkerton then went on to murderously machine gun anything that moved in the streets of Cirencester, without hitting anyone but causing some small fires. It may have been that incident which has been etched into the memories of the Adams family. Mrs Edie Adams pushed her children under their beds at the sound of the low drone of an encircling plane. Little Mary, worried for the safety of the family pet ginger cat followed it out into the garden and running along the garden in her white nightdress must have attracted the German pilot, he opened fire with a machine gun as she ran indoors hugging the cat. The scorch marks from the gunfire are still to be seen on the house at 44 Bowling Green. A neighbour's window smashed from the impact.

28 July Hayricks were destroyed by IEs at Cockberry Butts Farm at Langley Hill, and several Anson aircraft were damaged at Moreton-in-Marsh airfield from 4 HE bombs.

17 August Farm buildings were damaged by bombs at Randalls Farm, Harescombe.

## 1943

31 October Folly Farm at Bourton-on-the-Water and Thompsons Farm at Aston Blank escaped with minor damage from a couple of HE bombs.

## 1944

4 February The farming village of Upper Slaughter was rudely awakened at 5.45 a.m. when an estimated 2,000 incendiaries were dropped, causing damage and fires to practically every building.

Tony Collett recalls his schoolboy memories of the pre-dawn intensity of noise of explosions and the flares from hundreds of individual bombs dropped on the farming village of Upper Slaughter on 4 February 1944:

I was sharing the top of the house with my sister at the top of the village when we were awakened by this awful noise and smell of burning. One bomb exploded in our garden as we looked out of the window, the whole village was alight and all the villagers were out trying to fight the fires. We rushed out to help; people were trying to get the horses and cattle out of burning sheds, they were terrified.

Trying to coax the big carthorses out was so difficult. Our mother had died and father was in the army. Our grandmother was eighty-six years

old at the time and the oldest inhabitant in the village. She had been the village headmistress. I ran to see if she was alright, and she was standing at the top of the stairs demanding to know what all the rumpus was about. When I told her the village was bombed, she calmly said, 'Oh, is that what it is'. Another old lady had an incendiary drop through her roof and it landed on her bed. The bed was alight and the vicar, who led the rescue work with the Head Warden was absolutely marvellous, they were trying to get in to put the fire out, but she had barricaded herself in, and kept shouting at them, 'I'm not having you awful Germans in here'. She was convinced that they had landed.

People were saying that some of the men had run across the fields frightened of another attack because they had been told that the Germans lit up their target to mark it for another raid ready for invasion. Afterwards, it was reckoned that the raider had been looking for Rissington airfield, and was being chased by our fighters so dropped its load on us to lighten his plane for more speed. The village school had a bomb through the roof and it burned a hole in the classroom floor. Of course, I was at Westwoods Grammar School so couldn't have the day off like the rest of the village children, and I felt I was missing out on that when I went off on the school bus as usual. But they soon roped off the corner and the others had to get back to school quite soon. Many buildings took a year to put right as materials were in short supply.

The bombing of Upper Slaughter was the last real raid in the Cotswolds. The Emergency Committee sent a letter from the County Controller commending the action of the villagers. The vicar, who was instrumental in leading them in saving the community from complete devastation, the Revd W. Stanley Bubb, replied:

> I am personally proud of the bearing of the people on that never to be forgotten morning. There was absolutely no panic; men, women and boys worked together as one and no doubt saved the village from worse disaster. We do not want any more such visitations, but if they come we shall be prepared to deal with them in the same sort of way.

On 28 March a 1,000 kilo mine was parachuted down on a field near Tetbury. It was probably this farewell gesture to the spasmodic campaign on the Cotswolds that killed cattle and poultry in the area, and blew Moonlight into local legend as parts of the fated cow were found on various doorsteps the next morning by the milkman on his rounds.

Bomb disposal squads had not been formed at the height of the bombing campaign. George Wadeley, who as a sergeant at RAF South Cerney, recalls

a couple of incidents to which he and Warrant Officer Hodgson Charlton
went to defuse unexploded bombs in the area.

> As we were armoured we volunteered to get out the bomb that fell at
> the bottom of Scantlebury's farm at Cirencester. We dug around it and at
> about 6 ft [1.8 m] down found the fuse, which was pointing outwards,
> everyone cleared off and left me to take it out, I had just started when a
> voice above me said, 'You've got down to it then'. I told him to buzz off
> as I was just taking out the fuse, and as the thing could go off I was fussy
> about the company I went off with. It was a policeman, but he took it
> in good part. Another couple were intended for RAF South Cerney and
> dropped in a field just to the right of the approach of the main gates.
> They were 250 lb [113 kg] bombs and the holes were still hot when I
> got there. I estimate they had been dropped from 25,000 ft [7600 m].
> I burnt my hand on the case metal, it was the first heavy bomb I had
> handled. I think Hodgson Charlton must have dealt with the one near
> the Packhorse pub. The one that fell at Col. Macleay's house at Ampney
> I got out quite easily, another in a field at Poulton had killed a cow and
> one was 15 ft [4.6m] down and had been blown up by a smaller bomb
> being dropped on top of it. We were soon all over the Cotswolds as the
> targets were the airfields. The one that dropped at Maj. England's trout
> hatchery at Bourton-on-the-Water had to be hauled up by rope after
> I had dug around it, before I could defuse it. I suppose a rough guess
> would be nearly 200 unexploded bombs I had dealt with before it was
> decided that it was too dangerous a job and I reverted back to armoury
> in 1943.

Dodging the bombing raids in other parts of the country, William
Townsend was working a ninety-hour, seven-day week delivering vital
parts of aircraft:

> Some nights while on aircraft work I had to take propellers of the
> Hurricane from Kemble to Brockworth where we had to fit them — they
> were ever short of propellers. At one time I had an armed guard with
> me from Weybridge to Birmingham as I had the complete plans for
> the Wellington bomber to deliver there with my load, all in my father's
> camouflaged cattle truck in which my sister and I collected pigs for the
> Cotswold bacon factories. One urgent project kept me driving for a
> continuous forty-two-and-a-half hours without a break. I took a can of
> cold water and washed my face every time I felt drowsy and had to finish
> the journey on paraffin as my petrol coupons ran out. You just kept
> going because you knew that the safety of your country depended on

everyone doing their job no matter what it took. I was in the Liverpool blitz and that was very frightening with bombs dropping everywhere and the pom-pom guns firing all round the docks where I was trying to get my load through. I saw Lewis's store crumble into rubble. I was also caught up in the Coventry raid and still have a piece of a German bomb that smashed the cathedral.

The sheer stoicism of the time is summed up in the humour reported 'in a small town in the west' as was the wording used to conform with censorship of press reports, when a Co-op branch was due to open. The day before the official ceremony, the *Wilts and Gloucestershire Standard* reported, the shop was blasted from a bomb and the front was blown in. With typical Cotswold humour, the townsfolk put up a big notice. 'Opened by Adolf Hitler'.

Crashed aircraft accounted for many incidents in the Cotswolds. Mrs Morgan of Sudgrove recounts that the German who escaped from a crash

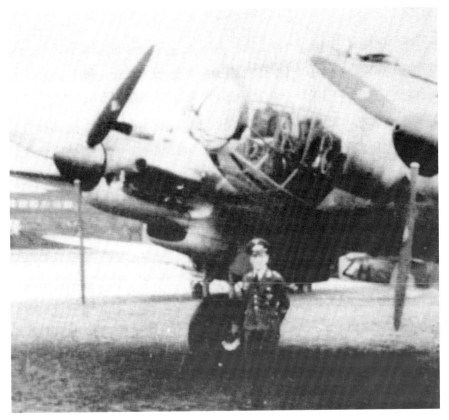

The Heinkel involved in the Windrush crash was brought down by Sgt Bruce Hancock who died in the incident in 1940.

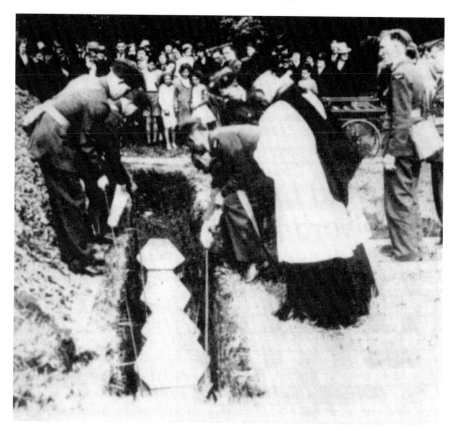

The burial of the German crew killed in the Windrush incident at Northleach, watched by local people.

at Strawberry Bank, Oakridge, gave himself up to Mrs Hamilton Mills at Sudgrove House. There were many tales of enemy airmen who had crashed giving souvenirs of their equipment to their captors, often as a token of relief that they were usually treated with compassion and cups of tea and not shot on sight. The Defence Regulations were amended in February 1941 making it an offence to keep any article such as goggles, field boots or diaries believed to come from enemy airmen or from their aircraft. Seemingly of trivial importance, such articles were of potential value to the military. It was not, however, an offence 'to pick up and read a pamphlet dropped from enemy aircraft — as it is in Nazi territory — but the authority was still to be notified'.

The humane standard of respect for another human being, even if he were the enemy, extended to respectful burial and honours accorded to his service. The Ministry of Health circulated all Rural District Councils in September 1940 that in the case of enemy airmen coming down in

their locality, the responsibility rested with them to remove dead airmen to a mortuary and to endeavour to get the RAF to arrange for their burial. Tetbury decided that their own council building in West Street should be designated a temporary mortuary.

Crashes on the approach to, or take off from, the many Cotswold airfields were tragically numerous, too. The Stroud Spitfire, so hard-won for the air service by the people in the district, crashed on its approach close to its presentation area when it was coming in to Babdown Farm airfield. A Lancaster crashed at Overley into a beech tree, thought to have been caused by the charcoal burning by the New Zealand troops at Cirencester Park.

Mrs Ceinwen Smith's memories of the crash at Ruscombe are still vivid:

We were sitting round the fire in our cottage making rag rugs. It was bath night. We had to sit on the edge of the big copper in the large stone-flagged kitchen, with our legs in the warm water and mother would wash us down. My older sister bathed in front of the fire in the sitting room, with two chairs in front of her with her clothes on to make a screen so that we couldn't see her. We had just finished and were cosily pegging the strips of cloth into the hessian sack which was the cottager's way of making rugs, when we heard this dreadful droning noise getting closer. Mother pushed us children under the big table and we started to cry. Then came the terrific thumping and thudding. Everyone ran out of their cottages, some of the men were in their pyjamas and all these figures around the pond just a little way from the bottom of our garden were shown up by the flames leaping from the crashed plane, so we could see they had ladders and trying so desperately to get to the men inside. There was so much noise and people were crying as they were defeated by the heat. I think the plane is still there and we heard it was a Wellington bomber which had been hit and tried to land in the field. After all these years there is to be a plaque, in memory of the men who died that night, in the little chapel at Ruscombe.

Malcolm Whitaker was a nine-year-old schoolboy when war broke out and looking back to that time at Harcombe Farm about half a mile from Syde village he recalls:

'When war finally came, it was a big disappointment to me. My cousin Paul and I had discussed the possibility of war and what it would be like. We decided that as soon as war was declared there would be a big black cloud in the sky to the east and there would be the sound of continual gunfire.' But Malcolm had to wait almost a year before gunfire was heard in the quiet valley.

It was 1940 'On July 25 at about 2 p.m., I was in the playground at Winstone School. Suddenly the anti-aircraft guns in Cranham Woods opened fire, their shells bursting somewhere over Birdlip. Then there was a loud explosion as two bombs detonated. The guns stopped firing as two of our planes attacked the German bomber. We watched entranced as the German plane with smoke pouring from it fell out of the sky and crashed near the village of Oakridge. The thrill of all this was indescribable. The head teacher, Mrs Davis, sent all the children home as she was afraid of the school getting a direct hit. We all ran up the hill to get our bikes and I remember Peter Golding saying, "You can smell the cordite". I thought cordite was a very big word. So this was war and we were in the middle of it. I thought it was just marvellous. When we got home the adults were equally excited but I'm sure they would have denied it.

My Father and Mother, having heard the gunfire, were standing by the back door and they were joined by old Dick, our neighbour, when the German bomber came into sight, approaching the house, he said "I suppose our planes will be in pursuit". He had scarcely uttered these words when the Spitfire dived out of the clouds with all guns blazing. Dick ran into our pantry and wouldn't come out. My uncle, who farmed Harcombe in partnership with my father, had gone into the field called Two and Twenty, to check the sheep and found one full-grown lamb dead. It was decided to take it into Cirencester. All the village children piled into his car and we took it to the butcher who extracted a bullet from the lamb's head. As we were getting back into the car my uncle saw two RAF officers walking down the street and he showed them the bullet. That night the police came for it and we could only think that it was a new type of German bullet — the RAF officers had obviously reported it. Later, we all got back in the car to look at the bomb craters just above the Gold Hart pub on the main road. Road blocks were at the Highwayman pub on the A417, then called the Masons' Arms. Some old farm machinery had been hastily pulled into the road to make a single track. Horace Locke who lived at Caudle Green, by profession a steam roller driver, was the Home Guard sergeant in charge of the group manning it and although he knew my father well he still had to solemnly show Horace his identity card.

On the night of 10 December at about 8.30 p.m. all the guns in Cranham Woods opened fire. The noise was deafening and the sky was lit up from gun flashes and the searchlights — there was a searchlight battery at Winstone and a machine gun nest at Miserden. Ten high explosive bombs rocked the house and blew out the Kelly lamp – the bombs had dropped about half a mile away, but an incendiary bomb had hit the house above

my sister's bedroom then bounced off into the field. Next day I found the nose of the shell I had seen burst over the house on the road by the garden gate. A group of us went to look at the bomb crater and search for shrapnel. I found a real treasure — part of the fin of one of the bombs. I remember thinking as I held it in my hand "A German has held this", it can only be compared to finding a bit of an alien spacecraft today. Three of the survivors of the Arnhem battle came to a cottage in Winstone, which the Army had requisitioned for them to recuperate. They brought with them Sten guns, 303 rifles and pistols and would amuse themselves by shooting at tin cans on top of the garden wall. Afterwards the local boys found hundreds of rounds of ammunition in the garden and this became a kind of currency among us. I managed to acquire some and Roy and I built a fire in the rickyard, threw this live ammunition in and lay flat while the bullets whined around us. It was very exciting.

When the news broke that Germany had surrendered the scenes of rejoicing were amazing. We carted loads of straw to the top of Basin Ground and when it was dark and the whole village had gathered, we lit it. I remember Mr Golding saying that he was sure it would be seen in Wiltshire. A few days later a fete was held in the Manor garden and Mrs Kaskel was guest of honour and asked to judge the competitions. Mrs Kasel had been in the Berlin congregation of the great Pastor Nieomollor who was famous for opposing Hitler and had been in a concentration camp since 1937. The Gestapo had interrogated Mrs Kaskel after which the family fled to England and she became housekeeper for the old squire, Mr Crewdson. Her four children were fostered by Quaker families around the country. Mrs Kaskel was much loved in the village and was probably the only German woman in the country to be so honoured at the victory celebrations.'

## AIRFIELDS

Of the eighteen military operational airfields within or just upon Gloucestershire county borders during 1939–45, most were in the Cotswolds and made the area particularly vulnerable to attack. Each has a long story to tell of those years, but space precludes more than a brief reference to their importance and influence on the life of the region. Their very presence meant a continual threat, countered by the very real sense of security that here in the heart of rural England was a fighting and defensive force. As well as the main airfields, numerous satellite airfields and landing grounds were built in close proximity to extend the facilities. Often these were near to woods which concealed

aircraft and ammunition, and buildings were often designed to look like farm sheds or residential spots from the air. In the same vein, a number of decoy airfields were staged and deflected attacks from the main arena to great effect until the deceptive ploy was pierced by enemy intelligence, nevertheless, their initial intent and economic outlay were both achieved and justified.

**Aston Down** utilized and extended the Minchinhampton airfield built for the First World War. It opened in 1938 with a decoy site at Horsley when it outgrew its original plan as an aircraft storage unit and became a training base; runways were constructed in 1941. Aston Down survived in many guises for some twenty years and became a base of the Cotswold Gliding Club.

**Babdown Farm**, three miles west of Tetbury served first as a relief landing ground for Hullavington's training school, then mainly for Oxford and Masters trainer aircraft after rebuilding in 1942. Its use as a trainer airfield ceased at the end of the war, but remnants of its wartime service are still to be seen in isolated buildings around the once active airfield, carrying on the flying tradition of the area started at neighbouring Leighterton which opened in February 1918. Leighterton's role as a training base for First World War pilots of the Australian and New Zealand services is commemorated every year by an Anzac Reunion organized by the British Legion.

**Barnsley Park** was a satellite landing ground for RAF Brize Norton and operated from June 1941 until September 1945. Returned almost immediately to agricultural use, the only remnant of its wartime use is carefully constructed in the design of the private bungalow which was the former headquarters and guardroom — an innocuous homestead from the air.

**Bibury** was selected as an ideal site for the overspill from South Cerney airfield and was in use by early spring 1940, firstly for Oxford trainers, then later for the eminent No. 87 Squadron of Hurricane fighters. The lack of accommodation on the airfield meant the ground crew had to camp out in tents and the pilots at nearby Northleach: the officers at Walton House, the sergeant pilots at The Red Lion. Northleach had many troops during the war, the most famous being the Kings Liverpool Rifles comprising most of the Liverpool football team including the then well known names of Jake Balmer and Harry Easton. Their garrison headquarters was West End House; several officers were billetted at Farmer Leach's Coalyard Farmhouse, and

the Cotswold Hall was the mess.

Bibury developed during the mid-war years but closed at the cessation of operational activities; only the odd hangar serves the farm it has been returned to.

**Blakehill Farm** near Chelworth, built in 1943 to take mainly Horsa gliders, relieved pressure from Down Ampney during the build-up to the Arnhem campaign when Dakotas flew vital supplies and paratroops. Towards the end of the war, Fairford was to act as a satellite for Blakehill for a period. The site was abandoned soon after 1947.

**Brockworth** was not an operational military airfield, but served the air force of the war by its major role as an aircraft factory, with its own airfield. Officially named Brockworth, the airfield actually ran across the parish boundary into Hucclecote and it was there that the original factory was sited. The airfield had been used as early as the First World War for testing aircraft and components built at Cheltenham's Sunningend Works. Expansion on the site culminated in a full-scale factory completion in November 1940. Effectively camouflaged, including realistic hedgerows being painted on the surface of the airfield, production from what became known as the Gloster Aircraft Company included Hurricanes, Albemarles and Typhoons—of which some 3,300 had been built by the end of the war. Hawker designs of Hardy, Hart and Audax became well known with the company's own famous and much-loved Gloster Gauntlet and Gladiator holding a special place in the hearts of local people who worked on them. The prime importance of the factory resulted in prudent dispersal of some of the work.

Britain's first jet aircraft, the Gloster E28/39 was assembled at Regent's Motors in Cheltenham and drawing offices were settled in various places. By 1944 the twin-jet Meteor fighter was produced; this was followed by the formidable Javelin. The last one to be built at Brockworth was in 1960. In 1964 the famous site became the Gloucester Trading Estate as a new era demanded different production and a new generation wonder why the pub is called The Gloster Flying Machine.

**Castle Combe** at the very border of the Cotswolds was a small grass landing ground; despite many improving features the airfield was unusable for long periods due to waterlogging. It was not until the end of the war that it received the injection of major regrading to cope with the extra load created at the closure of the satellite at Long Newnton.

**Chedworth** opened in April 1942 with two runways crossing, and the much loved Spitfires moved in to activate the airfield in August.

The entire workforce with Albemarle bomber at the AW Hawksley factory.

It was used initially as a satellite of Aston Down and increased its activity accordingly as fighter-bomber training got under way mainly with the Gloucester-built Typhoons. It closed as the war ended in Europe and has now reverted mainly to farmland, with the reopening of a road across it to Withington. Model aircraft now drone and dive above the deserted runway.

**Chipping Norton** has more remaining evidence of its being than most others: air raid shelters, huts and a rifle-range have survived half a century of disuse.

**Down Ampney** is more than a hymn tune by Ralph Vaughan Williams of 'Come down, O Love divine', commemorating his birthplace. Its operational life in the war was brief, for it did not open until February 1944, but it was a life full of activity with Dakotas and Horsa gliders. Thousands flew from the south-eastern Cotswolds where the rolling wolds flatten to meet the Upper Thames Valley. In the village church is a memorial window commemorating the part played by the First and Sixth Airborne Divisions and Air Despatch Groups RASC in the Arnhem operation in 1944. A special panel is in tribute to Flt. Lt. David Lord, the only member of the RAF Transport Command to receive the Victoria Cross in the Second World War. H.N. Andrews, DFM, known simply as Andy, was one of the first glider pilots to arrive at Down Ampney. He remembers well the day that 'Lumme' Lord sacrificed his life to drop supplies to them behind enemy lines:

> There was a kind of mutual ceasefire at Arnhem as everyone watched Lumme circle in his blazing plane to complete his mission. He had two more hampers which he knew were vital to our men, and despite his aircraft burning round him he returned in the face of renewed fierce

enemy fire to drop them. I cried with anger and frustration that so much bravery should be sacrificed as many supplies fell into the Germans' hands. I only received a red beret and a Sunday newspaper, instead of the fuel and ammunition we were so desperate for. Jimmy Edwards towed my friend Lofty Rancom on the night operation of 5–6 June. Poor old Lofty was captured and lost an arm. I still keep in touch with my friends, Joyce and Rob Ricketts at Down Ampney. We all feel a great affection for the village.

The late Jimmy Edwards was on a similar mission two days later and was shot down after their fourth air drop over Arnhem. He ordered his crew to bale out but when he found that one soldier had been hit and could not jump, he courageously held the Dakota with fire burning his face and ears until Harry Sorensen, the navigator, managed to bale out—only to be captured and spend the rest of the war behind barbed wire. Flt. Lt. Edwards then crash-landed the blazing plane and with his wireless operator, Bill Randall, and the injured soldier were picked up by the Dutch Resistance and hidden in the forest until they were transported under cover of darkness by horse and cart to the safety of an army hospital. Jimmy Edwards was awarded the DFC, and until his death returned to the little Cotswold village to meet again with the pilots, navigators, nurses and ground crew every year at the reunion, spearheaded by Alan Hartley, who will be remembered with great affection for his tireless efforts to keep the memory of those Down Ampney days alive. At exactly the same time as the memorial service at Down Ampney, Dutch children place flowers on servicemen's graves at Osterbeek. The Battle of Arnhem is so interwoven in their history that it is within the school curriculum. Parents tell their children of the bread from heaven—baskets of loaves baked by Mr Herbert and dropped in Operation Manna to the starving Dutch, many of whom were surviving on stewed grass and tulip bulbs. One Dutch lady who made the journey to join in the reunion said simply, 'Thank you, Down Ampney'.

Down Ampney was for many, the first sight again of Britain after battle: as well as the combat airmen, the coolly courageous Air Ambulance nurses flew out almost daily to bring back some 50,000 wounded servicemen to the Down Ampney Casualty Air Evacuation Hospital. One of the nurses, Bobby Jackson recalls the time when she was only too glad to find a ditch in which to close her eyes for an hour in an effort to snatch a little sleep between hair-raising rescue missions. Married during the war, her wedding cake was made by Mr Herbert the local baker. Meeting the wounded as they were unloaded were members of the local voluntary medical services.

**Down Farm,** three miles south of Tetbury, served throughout the war years as one of the best dispersal/storage sites. The woods of Westonbirt Park provided good natural cover and a landing strip was made on the farm. Plans to extend it into a full-scale airfield were scrapped after protestation, in view of its complete fulfilment of its original purpose.

**Enstone** served from 1943 until the end of the war as a second satellite for Moreton-in-Marsh, and at one time became a relief landing ground for Little Rissington.

**Fairford** opened 18 January 1944 and was actively engaged in intensive training programmes in readiness for many missions of great secrecy, dropping agents and supplies into enemy territory. Stirling IV bombers and Horsa gliders took part in the D-Day and Arnhem campaigns. After Operation Molten retrieved repatriated servicemen from Italy, the airbase became a satellite of Blakehill Farm. After surviving the vagaries of defence policy fashion, Fairford was extended and shot into fame as the test base for Concorde and now hosts the annual Royal International Air Tattoo.

**Kelmscot,** immortalized by William Morris who made it his last home, can lay claim to some participation in the preparation for the Normandy invasion. On the landing strips and flying lanes, for it did not run to runways in the literal sense, Polish parachutists were dropped in Exercise Noggin from Down Ampney on practice operations. The airstrip also served as a training patch for Oxford pilots to practise blind approach techniques.

The Glider Pilot Regiment at Fairford, June 1944 which took part in D-Day. The pilot on the extreme left back row is Cyril Shuttlewood, who on his retirement from the RAF became Postmaster at Fairford for many years.

Horsa gliders of 620 Squadron at Fairford during September 1944 for the Arnhem operation. (Bart M. Rijishout Collection via John Rennison).

**Kemble** has been in and out of the news since it was opened as an aircraft storage unit in 1938 and put under armed guard when placed on a war footing in August 1939. Expansion was rapid and so was the role of Kemble when a Ferry Pool was formed there a year later and some one thousand aircraft had been despatched from there in that much time. A defence flight of Hurricanes arrived to the now vulnerable base. The 30th Battalion of the Glorious Glosters tested its defences, and Horsa and Hotspur glider testing was carried out. Extensions and expansion increased as production of Typhoons and Lancasters joined the programme for Kemble. Retained as an RAF Maintenance Unit for the most part, Kemble has hosted the world famous Red Arrows aerobatic team, and is the occasional hopping-off point for Prince Charles and the Princess Royal returning to their Cotswold homes. Its survival has always been a matter of great local concern for the employment it affords to many civilian workers.

**Little Rissington** strides across the high rolling wolds with a history of one of the highest operational airfields in the region. From its inception, the airfield was home to Spitfires and Wellingtons, and became a Service Flying Training School. Later it was redesignated an Advanced Training Unit. An attempt to integrate a sprawling service unit into the Cotswold countryside by building a traditional dry stone wall facing the road, and

South Hill House which had to be demolished to allow space for the approach to Fairford airfield.

In civilian dress, members of the Polish Air Force at Fairford Park, which became a Polish Hostel at the end of the war when it was vacated by the USAAF hospital.

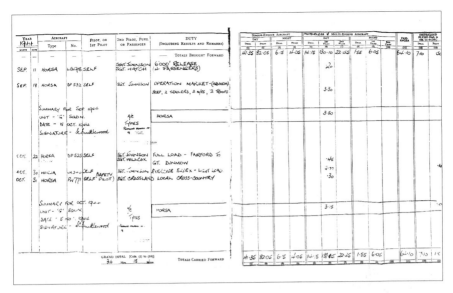

An extract from Horsa Pilot Cyril Shuttlewood's log book showing the entry for
18 September 1944 for Operation Market Garden (Arnhem) (Courtesy, Heather
Shuttlewood).

retaining as many trees as possible, is appreciated. The villagers reciprocate
by maintaining and caring for the servicemen's graves in the local
churchyard, the focal point for an annual service at which schoolchildren
place a posy on each grave.

**Long Marston** is about the most northerly point of the Cotswold airfields.
Used initially by the Ferry Training Unit, the three runway airfields became
a satellite station for Whitleys and Wellingtons.

**Long Newnton** has an interesting history stemming from an air to ground
firing range in the First World War for locally based Australian Flying
Corps to become a decoy site to deflect attention from Kemble. Then,
unusually for a dummy airfield, artistically transformed into a patchwork
of hedged around fields with the aid of a lot of paint and ingenuity, it was
promoted to the full status of a satellite airfield for South Cerney. At the
end of hostilities it reverted to farmland.

**Moreton-in-Marsh** was hurriedly constructed at the outbreak of war but
still far from operational when Bomber Command arrived in January
1941. The station's main role was the training of Wellington squadrons.
Sorties from Moreton included dropping leaflets and participating in
'Bomber Harris's' strategic 'thousand bomber raids'.

One of the Wellingtons reported missing from Moreton's 'Nickel' raid
on Nantes, No. W5705, was the one that crashed at Ruscombe in the
pond in the field at the bottom of Ceinwen Smith's garden on 29 January
1943. This once so active airfield has been rescued from an ignominious
retirement as it is the base of the Moreton Fire Service Technical
College.

**Moreton Valence** opened at Haresfield in November 1939 and originally
operated under the name of the village, until it was rebuilt in 1941 and
housed Ansons from Staverton. In 1943 it became a testing centre and
assembly unit for the Gloster Aircraft Company and later as a satellite for
South Cerney and, in 1945, for Little Rissington.

**Northleach** had a very short-lived career as an airfield for the use of Stoke
Orchard. A flight of gliders arrived in 1942 but the poor surface soon
caused them to return to Stoke Orchard, who administered the relief
landing ground as a satellite for another year as the weather improved.
After that brief abortive attempt at being an airfield, Northleach slipped
into obscurity.

**Overley** used the cover of the sheltering woods to effect when it stored
reserve aircraft for Aston Down. Opened at the start of 1942 as a satellite
landing ground, Overley extended its runway and scope to become
a training ground for a small number of Oxfords. Bungalow-type
headquarters and a guardroom were designed, as at Barnsley Park, and
the deception deepened as a hangar to house Super Robins was made to
look like a farm shed. The site was taken out of operation immediately at
the end of the war.

**Rendcomb**, the fifth oldest First World War airfield, belongs to an age of
the Red Baron legends. It was not operational during the Second World
War, but is of intense interest now for its restoration and plans to house
vintage aircraft.

**South Cerney** became a Flying Training School in the tense days before
war was declared, and remained operational with advanced training until
the end of the war. Stretching across what was once the race-course of the
village, South Cerney has been used by a number of units up to the present
day, and still sports its windsock and much of its wartime appearance.

**Southrop**, small in comparison with others, was a relief landing ground
with two runways and a surprising capacity. The instructional site

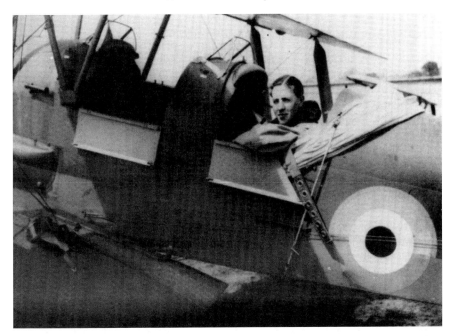

Pilot Officer Masterson seen in the cockpit of a Tiger Moth trainer. He was a native of Dublin and had only one hour's solo experience on Harvard trainers when he crashed near Chalford in November 1939 (Paul Aston via John Rennison).

accommodated full armament and navigation training rooms, an intelligence library and a photographic block. WAAF quarters and a hospital block were sited in Macaroni Wood. The personnel complement was estimated at around 800. After use as an initial training ground, Southrop became a satellite station for South Cerney.

**Staverton** grew out of an airstrip of the Cotswold Aero Club which Sir Alan Cobham, who did much surveillance work in selecting suitable sites for wartime airfields, supported as a potential local airport. The site at Down Hatherley was purchased by the Gloucester and Cheltenham Town Councils and it opened in 1936. The Cotswold Aero Club agreed to train pilots for the Civil Air Guard as the Air Ministry started taking interest in Staverton for wartime use. Training and airwork servicing and flight testing all made use of the site along with Rotol, Folland and Gloucester Aircraft works. Much important and interesting work was carried out at Staverton and the ghosts of a million machines are locked into its land, which to this day is home to a successful small airport and commercial enterprises.

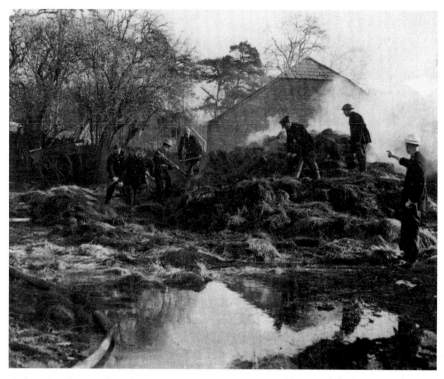

A burning rick on Major Witts's farm at Upper Slaughter, near Bourton-on-the-Water, in February 1944 (Courtesy, Cheltenham Reference Library).

**Stoke Orchard** began active life in 1941 with a unit of Tiger Moths training, it became a Glider Training School. Many of the pilots took part in the Normandy and Arnhem campaigns. The airfield was not activated again after the war and is slowly crumbling away.

**Windrush** opened in the frenetic summer of 1940 as a relief landing ground for Little Rissington and, as such, diverted some of the attention from that base when the Luftwaffe took an interest. It survived pretty well unscathed to serve the training programmes which were based on this plateau commanding extensive views of the rolling wolds.

## THE ATA AND THE SPITFIRE

'To celebrate the RAF's 90th anniversary without a Spitfire would be like marking the first lunar landing without mentioning Neil Armstrong. It would be ludicrous,' said Richard Arquati, spokesman of the RAF Charitable Trust, as the International Air Tattoo prepared for its 2008

programme. The Spitfire, with its distinctive shape and sound, still stirs the heart of all those who lived through the World War II days, and even a younger generation who feel the surge of pride as they relive them vicariously through old wartime movies. The unique sight and smell of the Spitfire is always a head turner as it soars across the sky at any air show, and holds a special place in the heart of those brave and daring young pilots who flew it.

Joy Lofthouse had scarcely left her Cirencester Grammar Schooldays behind her when she became one of the youngest of those who were taught to fly on being recruited to the Air Transport Auxiliary. The majority of those who served in what was in effect an aircraft ferry service were pre-war fliers- the largest contingent being a whole bevy of 'ridiculously brave' elite beauties drawn from five continents to join the British high-fliers to deliver aircraft from the factories to the operational airfields. 'We were the trailblazers. We were the first women to touch aircraft,' said Joy.

The initial idea of forming the ATA, whose members were dubbed the Ancient and Tattered Airmen — because to be eligible to serve one had to be ineligible for the RAF but still able to fly and be entrusted with brand new, expensive and valuable aircraft ready for action in the war zone. Far from being ancient or tattered, the ATA became a glamorous elite force in a stunning gold-trimmed navy-blue uniform epitomizing daring and dynamism to the general public, guaranteed to turn heads and be greeted by shy smiles of admiration. Proving beyond a great degree of male prejudice that these young women were as brave and brainy as they were beautiful, was the initial battle they won over the first couple of years of the war. The editor of an aeroplane magazine gave vent to his chauvinistic views in his spiteful report. *The menace is the woman who thinks that she ought to be flying a high-speed bomber when really she has not the intelligence to scrub the floor of a hospital properly, or who wants to nose around as an Air Raid Warden and yet can't cook her husband's dinner.* A few of the ATA might concede that he was right about the dinner — totally wrong about the menace as history records their unique heroism and contribution to the war effort.

Unlike fighting pilots, the ferry pilots flew without radios, instrument training or weapons in aircraft that were still targets for any Luftwaffe pilot who spotted them. Sometimes they were mistaken for enemy aircraft by bored or bleary-eyed ack-ack units and were required to fly in all but extremely atrocious conditions. They also had to fly badly damaged planes to maintenance units for repair or to be broken up, and expected to fly any new type of aircraft with no notice or training period to familiarize themselves with its peculiar settings — a mere twenty minutes alone in the

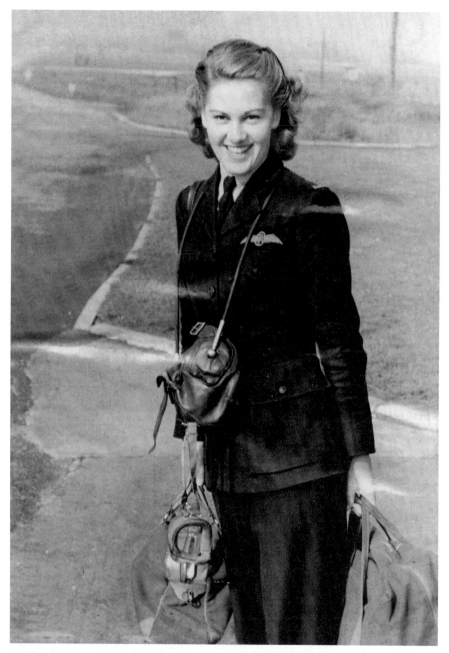

Joy Lofthouse, ATA pilot, kitted up in readiness of 'putting up' an aircraft, carrying parachute bag and an overnight bag and her helmet hanging round her neck. Joy said: 'we always carried an overnight bag on longer flights in case bad weather forced us to land — having no 'blind-flying' training we were very much fair weather fliers' (Courtesy, Joy Lofthouse).

cockpit with the official Ferry Pilot's Note that tucked into a breast pocket was their only guidance.

Diana Barnato Walker, who became the fastest woman in the world and the first British woman through the sound barrier, recorded her recollections of her time in the ATA with a near miss over the Cotswolds when caught in an impenetrable blanket of condensation and had to consider baling out of her Spitfire. Her problem was not one of being bashful but of having a reputation to consider as she favoured a regulation skirt rather than slacks, and was wearing large knickers made from parachute silk and wartime stockings that ended just above the knee. She put the Spitfire into a shallow dive from 6,000 feet. At 800 feet, 50 feet above what she hoped against hope might be the Little Rissington aerodrome she landed – falling out of the sky into a series of enormous puddles to be met by a startled RAF officer, gallantly striding towards her with a coverall cape — and led her back to a Nissen hut at RAF Windrush!

Joy Lofthouse said 'the Spitfire was the pilots' favourite. You just felt part of the aeroplane. It was the nearest thing to really flying. It was the perfect lady's aeroplane, as many of us said, you just felt as though you were wearing it. I remarked as much to Dr Gordon Mitchell, that his father must have designed it specifically for the ladies. To the contrary, he thought his father, Reginald Mitchell, would never have envisaged the day that women would become pilots to take on such an important role as we in the ATA did.'

Acknowledged as changing the course of British history by designing the Spitfire to become such a decisive weapon in the Battle of Britain, as the smallest an aircraft could be built around man and engine, Reginald Mitchell viewed it as a work in progress, the Spitfire going through 40 different incarnations, with more than 20,000 planes produced by the time it was retired in 1954. The Supermarine Spitfire appeared as part of the Royal Mail's 2009 postage stamps collection of British Design Classics. Such a legendary and iconic masterpiece has, inevitably, attracted a few myths and half truths about RJ and that he, of all people, hated the name Spitfire — leading to many a misquote of the truth. As Dr Mitchell explains: 'It's a case of bending the truth to make it sound more dramatic. In 1934, my father, who on returning to work after a major operation for rectal cancer, designed a single-engined fighter, the first time he had ever designed a fighter and this was given the name Spitfire by the Vickers Chairman. However, this plane was a dismal failure in every way and when Sir Robert wanted the new fighter to be given the same name (Spitfire) as the previous total failure, my father felt it would be asking for trouble(!) to give it the same name as a failure. Hence his verdict that it was a bloody silly name to give to his new fighter — not that he disliked the name Spitfire per se.'

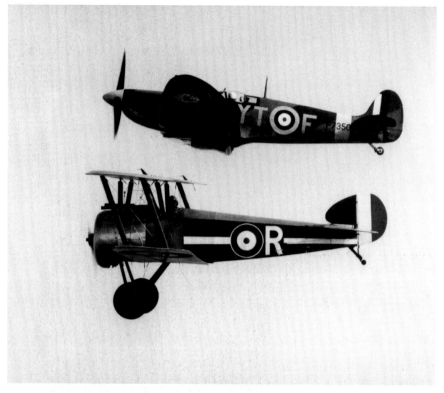

The legendary Spitfire, described as 'the perfect ladies' aircraft', and the braced-by-wire Sopwith Camel, said during the Great War to be 'matchless in combat but extremely tricky to handle' (Courtesy, RIAT).

Ironically, the legendary Amy Johnson, who had lived at Stoke Orchard to the north of Cheltenham before the war, never flew a Spitfire, but has gone down in history as the inspiration for wealthy and spirited young women to follow her as she joined the ATA. Lady Theodora Macleod, who had been living at Miserden when she joined the ATA, recalled her flying days as a contemporary of Amy Johnson.

She was very nice, but a bit grand. And our CO would often say to us, 'You're not going to let Amy give you a lesson are you', if she had taken off and we had thought the conditions were not right. The weather was absolutely dreadful on the day Amy made her last flight. We all tried to stop her going, but she just would not listen—she had achieved so much fame against all odds, but we were not setting out then to break records, we were responsible for delivering expensive and much needed aircraft to the RAF, relieving serving pilots from precious hours and transport duties. Unfortunately it was the wrong decision she took that fateful day,

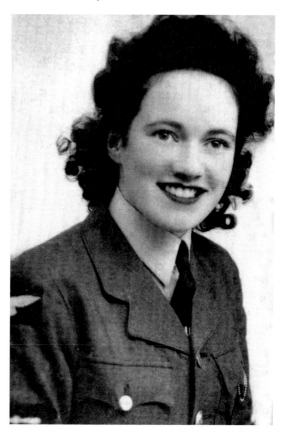

Lilian Foster, WAAF waitress, who got 'jankers' for wearing her stockings inside out! (Courtesy, Arline Vlietstra).

and another life was lost in an attempt to save her when she crashed into the Thames.

The tragedy and, many sources say, the mystery of the death of Amy Johnson became one of the statistics of the fifteen women and 158 men who lost their lives in the service of the ATA and to put the dedication, consummate skills and immeasurable courage of the ATA into perspective they moved more planes each day in mid-1942, at the peak of British aircraft production, than British Airways did on a typical day in 2006. In all, the ATA delivered 308,567 aircraft, of which 57,286 were the much loved Spitfires.

Lilian Foster's fond memories of serving as a waitress in the Women's Auxilliary Force at RAF stations at Fairford, South Cerney and Charmy Down, near Bath, are coloured by the strict discipline that extended to all ranks and personnel. Quickly earning the title of Jankers Queen, from notching up a list of punishments for minor deviations from the

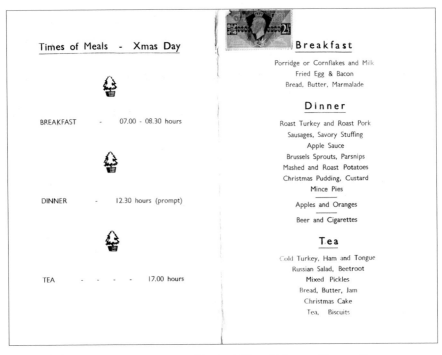

| Times of Meals  -  Xmas Day | | Breakfast |
|---|---|---|
| | | Porridge or Cornflakes and Milk |
| | | Fried Egg & Bacon |
| | | Bread, Butter, Marmalade |
| | | **Dinner** |
| BREAKFAST | 07.00 - 08.30 hours | Roast Turkey and Roast Pork |
| | | Sausages, Savory Stuffing |
| | | Apple Sauce |
| | | Brussels Sprouts, Parsnips |
| | | Mashed and Roast Potatoes |
| | | Christmas Pudding, Custard |
| | | Mince Pies |
| DINNER | 12.30 hours (prompt) | Apples and Oranges |
| | | Beer and Cigarettes |
| | | **Tea** |
| | | Cold Turkey, Ham and Tongue |
| | | Russian Salad, Beetroot |
| TEA | 17.00 hours | Mixed Pickles |
| | | Bread, Butter, Jam |
| | | Christmas Cake |
| | | Tea,   Biscuits |

Menu of Christmas Dinner 1944 served in the Officers' Mess at Charmy Down.

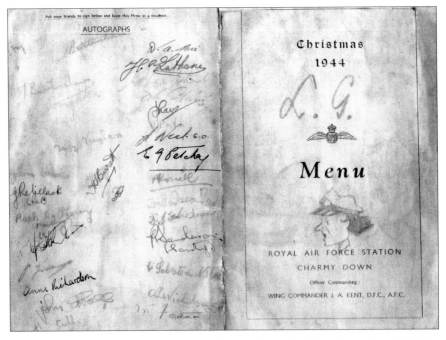

Cover of menu, with the back autographed by the officers for Lilian Foster their WAAF waitress.

regulations, Lilian recalls that one instance was for wearing her stockings inside out! 'Our thick grey lisle stockings were fuzzy on the outside', she said, 'and much more silkier and glamorous on the inside — so I turned mine but the Sergeant in charge reported me to Fanny Fie, as we called her, and I had four days jankers. This entailed doing extra work and being escorted as we marched on parade and made to stand under the flagpole in the morning when the flag was raised, and again in the evening when the flag was lowered so that I was on show for disobeying rules. It was all part of being in the Services, and I look back at that time when I was at Fairford in 1944 as part of an advance party when so many trees were being taken down for the runway to be built. It was a busy, hectic time, but we had better food than our folks back home and when we went on leave we were given a chit for them to have extra rations to feed us. We all made a lot of friends and enjoyed the many dances that were held.'

# CHAPTER FOUR
# Secret Service

## PRESS AND PROPAGANDA

The hardest worked profession during the war, George Bernard Shaw maintained, were the journalists. The public, hungry for news, became infuriated by scant reports of what they calculated to be serious raids appearing in the press as 'there was an incident last night somewhere in the south-west', and long descriptions of the work carried out by the emergency services. But such were the restrictions, and locations were strictly forbidden as were accurate weather condition reports — all useful information to the enemy. In July 1939, representatives of the press of Gloucestershire, Worcestershire and Herefordshire met to discuss how each of the counties could help the other to maintain provincial newspapers if one or the other were incapacitated by enemy action.

Reconciling the responsibilities of a free press with stringent censorship, and communicating serious news and notices without scaremongering, was an editorial headache. Morale-boosting photographs and an attempt to show that life went on much as normal produced a curious juxtaposition of news from the front line with parochial pieces. Subtle warnings of how to stock your larder for an emergency, and the precautionary measures to be taken to survive a 'possible' aerial attack, were set against the beautiful Betty Pye of Avening shown milking her cows, and bonny babies beaming out of pretty bonnets at baby shows. Some readers penned their protest at what they termed frivolous reporting; obviously they were totally unimpressed that Ashton Keynes had grown a giant hollyhock. The long paragraph rhapsodizing the onion was probably accepted as a hint to grow it in profusion in the campaign to produce home-grown food.

The stock conversation of the English being the weather 'in these days of war it is one of the subjects that a journalist hardly dare write about for fear of getting beheaded', one wrote, 'but of late it has created a good deal of comment for the marvellous shades of rich green that have delighted the eye, broken somewhere in the west in fields scarred by a shell or two'.

The restraints of the censorship, juggled around with such as in that report, brought such a virulent attack from American journalists that Robert Casey cabled the following report to the *Chicago Daily News*:

> An undetermined number of bombers came over an unidentified portion of an unmentioned European country on an unstated day. 'Recently' is the official word for it. There was no weather. Had there been, it would have been considered a military secret. The alert sounded at no particular hour because the enemy — one hesitates to label them with a proper name — are not supposed to know the right time.

The report, with much more in the same tone, was passed by the British censors. This fact, and that it was holding the British communiques up to ridicule for the little information they contained, relaxed the restrictions sufficiently to allow identification of major towns and cities, but still not explicit enough to allow the man in the street to know what was going on around him.

'Happily we still have the freedom to criticize,' said C. Hollinshead, editor of the *Gloucestershire Echo*, when speaking of the difficulty of war news suppression. And criticize people did: the government, authorities, and one another — attacks and counter-attacks sparked off warring factions on all home fronts.

'Humanity has had enough of these ghastly interruptions of human progress, yclept wars, and calls for the relentless extermination of those human vermin, the War Mongers,' wrote the Revd Claude Tickell — vicar of Latton-cum-Eysey, but hedged his bets a few months after by conceding that 'Hitler has bitten off more than he can chew let alone digest.' However, as his vicarial voice went apparently unheard or unheeded by either the War Cabinet or Herr Hitler, he pointed his pen at what he called 'The Ministry of Misinformation' for 'stating that inoculation gives almost complete protection against diphtheria' — without justifying why or how it did not.

'Birth prevention, now prevailing everywhere and intensified by the war, constitutes the main danger to the peace of the world. If civilisation is to survive, not the trifling half-wit, the gigantic evil of contraception must be got under control,' were the feelings expressed by J. A. Thomas, of Westcote Rectory of Kingham, on the war situation and its consequences.

If not actually causing the war, the threat to peace and prosperity was blamed on contraception by some clergy; the communist 'active friends of the enemy who surreptitiously pushed leaflets on *Nine Reasons for Stopping the War* into Cirencester letterboxes, and took good care to be invisible when any incensed householder appeared'; and the Peace Pledge

Union who produced this 'pernicious publication' aimed aspersions at the Air Raid Precaution (ARP) whose main purpose, it claimed, was 'to prevent the public from panicking, i.e. expressing its disapproval while the RAF is bombing the enemy population'. Malmesbury got a special mention in the local press for its 'sober and sane spirit', with no war fever as it had generated in the First World War when 'even in loyal Malmesbury, there were many sympathisers with Germany'. At that time long tribunals were held to hear appeals for exemption from military service; but now, in September 1939, 'we have not met with one conscientious objector, every ounce of local strength is concentrated in support of the nation's efforts to stop Hitler's world-wide domination'.

The Chief Commissioner of the Brotherhood of Boy Scouts objected to being labelled a conscientious objector; and the Boy Scouts' Association objected to being confused with the Brotherhood of Boy Scouts — despite the claims from the Brotherhood that 'several choirboys had joined which is certainly proof that some boys prefer this movement and troop'. However, it was agreed that there was room in Cirencester for both troops of scouts to continue and parents were circulated on the difference between them,

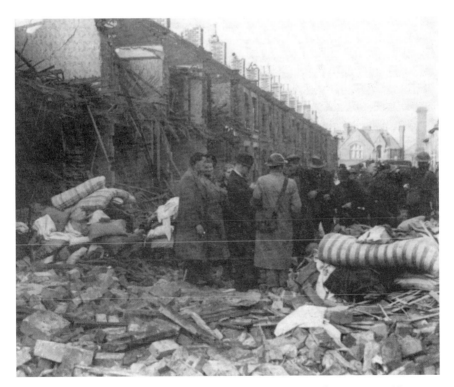

Devastation in Stoneville Street; an *Echo* reporter gathers an on-the-spot story. (Courtesy, Cheltenham Reference Library).

'and every fresh recruit will be questioned, so that such a thing will never happen again'.

Passion was aroused in parochial breasts again in October 1940 when it could be seen that the war had left Cirencester without a band to head its parade of the Home Guard, 'impressive in size and bearing', and Chedworth had to be called on to fill the gap. 'Time was,' the report stated, that 'the appearance in Cirencester of a band from Chedworth was an occasion to arouse political feeling to a high pitch, which had its results later in the establishment of a second band in Chedworth.'

Warnings were issued to everyone from everywhere on every conceivable subject. The War Agricultural Executive Committee warned the farmers that they could be displaced from their farm if they did not meet the 'efficiency' standards. The farmers warned them that if their wives 'get to know that your committee suggest that they undertake the work of fire watching, when they are working as hard as the men, you may have to close and barricade your doors'. The fact that County Council road men were given time off in lieu of fire watching duties and could be seen sauntering off to work at 11 o'clock in the morning following a stint of fire watching, while farm workers were still expected to start work at 5 a.m., added more fuel to the flame of discontent at the ambiguities imposed on different sectors of the working population.

However, after the initial volley of verbal and penned attacks, there was an almost unilateral consensus that the real enemy was being overlooked. But not before the press had one final poke at the parish magazines who, they said, were not playing the game with the censor to the same degree as newspapers. Entreaties were made by the Minister of Information to editors of 40,000 technical and religious magazines, through the Censorship Division, to take their lead from the local papers, for, as one stated, 'if the press makes no reference to bombs being dropped on a certain village, the vicar should likewise refrain from expressing sympathy with Farmer Jones in the loss of his cow when bombs fell on Appletree Farm'. The *Citizen* of 5 September 1939 warned 'Nazis are Watching Parish Magazines'. A warning that obviously went to the heart of the vicar of Sherborne and Windrush villages, for the Revd G. Warner asked in his next month's parish magazine, 'not to hate the German people', and advised that 'war-germ carriers should be blotted out as surely as their names will be blotted out of the Book of Life'.

> Actual evidence I have none,
> But my aunt's charwoman's sister's son
> Heard a policeman, on his beat,
> Say to a housemaid in Downing Street,

he had a brother, who had a friend,<br>
Who knew when the war was going to end.

Reginald Arkell, the Cotswold author of those lines which he wrote in *All The Rumours* in the course of the First World War, was amused that so many people quoted them and carried cuttings of them in their pocket that 'they imagined themselves to be the author of them!' In the foreword of his subsequent book *War Rumours*, published in 1939, 'and good value at a nimble shilling', Reginald Arkell acknowledged the public adoption of his verses. 'My grateful thanks are due to those many excellent authors who have allowed me to print the verse which appears on the cover of this little book. The fact that I wrote it myself does not lessen this sense of obligation.'

The idea that German Intelligence were actually scouring the local papers emboldened many a report directed at Hitler who, it was said, had quoted Charles Dickens to prove that 'Britain is Germany's poisonous, grasping brutal enemy full of cynical contempt for humanity'. Squeers of Dotheboys Hall was seized upon in particular as 'a classic symbol of hypocrisy which has hounded the Polish nation to destruction'. The Polish airmen were under no such delusions for, as members of the force who were at the Polish Hostel camp at Fairford after the war said, they often inscribed messages on their bombs delivered to Germany such as: 'Good morning you...' followed by the Polish equivalent for one of canine parentage; others carried a note of personal vindication such as 'revenge for my sister killed at Warsaw', and 'this carries the blood of my mother's slaughter'.

The first Christmas of the war brought forth boastful reports of how joyful the feasting and merry-making were in England compared with what Germany were having to make do with. 'Cheltenham enjoyed an excellent Christmas, thank you, Mr Hitler. The turkeys were plump and toothsome and the mince pies and plum puddings sizzled. The traders had a splendid Christmas. We defied the black-out and danced till 2 in the morning with paper hats on our heads. Gott in Himmel. Haw! Haw! How your people would have loved it.'

Although not quite so effusive in description and provocative in style, the following year's reports still aimed at trying to put across a reassuring feeling that things were not too bad after all. Santa Claus had visited Stanton village and distributed gifts to seventy-five children. Kempsford's competition for the most popular girl was won by Iris Cleaver. 'A right happy time' was had by the fourteen patients at Cirencester Evacuee Hospital and some 123 roast beef dinners had been enjoyed at the communal kitchen at the Church Hall, with a further 100 dinners on Boxing Day,

organized by Mrs Sackley — and, porridge would be cheaper in the New Year. Weird and wonderful, quaint and curious, were the reports published of the enemy's life ranging from a ban on German women having perms to save electricity, to a newsflash from Moscow that German women's shoes were to be made of glass. Russian peasants, it said, were besieging their dentists for the type of stainless steel artificial teeth which were being fitted to their cows — the sets being taken out daily and cleaned by assistants — to prolong the grazing, therefore production and life of milch cattle. As German coffee supplies ran out, roasted acorns from Bulgaria were said to be substituted. Whereas back home, the vicar of Siddington entertained evacuee children at Sapperton with such 'conjuring tricks as producing boiling cups of tea from apparently empty canisters'.

The War Office ban on photography was reported as 'causing unnecessary alarm among amateur photographers who failed to read the news paragraphs about it in a calm and objective way'. Sidney Jones of Bourton-on-the-Water, found himself 17s. 6d. the poorer and his photos confiscated when a Mr Butt, to whom the film was taken for developing, found three of them were of aircraft — which Mr Jones had only intended to have as a keepsake as they were standing outside the place where he worked.

## PERSONAL DIARIES

The restrictions on giving locations seem to have been ignored when it came to publicizing such incidents as Mr Jones's innocent snap-taking, and Ernest Young driving an overcrowded bus from Stow-on-the-Wold to take twenty-six young soldiers, home from Dunkirk, to the pictures. The fact that the army had commandeered his 36 seater bus the previous week, and petrol rationing made it all very difficult, was acknowledged, but he was still fined £1 and, like Mr Jones 'of excellent character', got his name in the paper — something that Cotswold folk do not like. The censors seemed to miss the point that the information of both cases divulged the proximity of air and army bases — and could have had far greater repercussions than either of the minor breaching of the restrictions.

A directive was issued to clergy and registrars restricting the amount of information to be given on notices of, and certificates for, marriage and the registering of same of any member of the armed forces. 'In no circumstances,' it ordered, 'must the name of the ship or the unit, regiment or corps, be recorded'.

No doubt the vicar of Bibury, Mr Spurrier, kept his church diary away from prying eyes for in it he entered his services and notes of sermons,

the weather and war news in a jolly jumble of juxtaposition, as illustrated by these few extracts:

6 Aug **1939** (After notes on the services at 8, 11, 12 and 6 o'clock) NB The Bibury and Aldsworth Platoon left for training on Salisbury Plain for a fortnight.

3 Sept 11.15 The Prime Minister's announcement viz WAR. 'We are at war with Germany' 6.30 Evensong and Intercession

4 Sept 11 o'c Intercession. The *Athenia* torpedoed off the Hebrides.

8 Oct 6th week of war. Winter war services — first time. All our troops are in France now, 158,000. We bagged 4 bombers.

19 Jan **1940** Frost in Moscow 70°. Soldiers frozen to death. No food.

21 Jan Service in Village Hall 27° of frost. Most appalling experience, everyone frozen. The Finns are doing well. Sexagesima — a churchless Sunday. Rain fell on Saturday night on the top of snow. Frost came and turned everything to ice. The roads here are quite impossible to walk on. The trees are doubled up with the weight of the frozen rain — all the tops snapped. The poplars on the Coln opposite the Vicarage are all spoilt. Crashes were heard all day long. No one moved from home unless obliged to and no church was possible. TCHABOD. All telephone and telegraph wires are down. Trains were twelve or twenty-four hours late. No one has seen its equal.

10 May Hitler's big effort begins — Holland and Belgium invaded.

14 May Queen Mary passes through Bibury

15 May Holland surrenders

21 May News very grave. The Channel ports are threatened.

22 May Our backs to the wall. Intercession 11 o'c. The enemy in Boulogne

28 May Leopold King of the Belgians capitulated. Comment is needless! No losses reported of our Bibury lads. Some came home for a few hours.

10 June A stab in the back — Mussolini has joined Hitler.

14 June Paris has fallen.

26 June German bombers over Bibury. Mr Southwell's at the organ. Collection £1 2s. 9d.

10 July A glorious rain. 40 German bombers and machines destroyed in last 60 hours. The Royal Engineers in village.

16 Aug 21 bombs fell on Old Walls Landing Ground and thereabouts.

30 Aug Bombs fell fairly frequently in the district, but none in Bibury is hurt. The Home Guard had a full parade at 8.30

15 Sept A grand show of flowers, fruit and corn. Lovely weather, though the drought is severe.

12 Sept Buckingham Palace and Chapel bombed. King and Queen safe.

15th: for the first time in history Bibury Court has a shooting party all day today.

23 Sept The Children's ship to Canada torpedoed in mid-Atlantic without warning in gale and darkness.

9 Nov Neville Chamberlain passed away.

Christmas Day 1940

8.30 Holy Communion. 42 Communicants. Offertory £1 19s. 3d.

Lovely day. No wind. No snow. Just sufficient frost to dry the roads. The sky was clear and not too dark in church. The decorations were very good, but little holly and ivy. HHS at Nairobi.

29 Dec Italy is crumbling. Goodbye 1940.

The weather phenomenon of which the vicar wrote in January 1940 was thought to be localized in the central south-west Cotswolds. Local people had never seen its like before nor since. The glazed frost which the Meteorological Office, then based at Wycliffe College at Stroud, studied, happened as rain fell from the warmer air to the colder temperatures nearer the ground, and vegetation was entirely encased in transparent ice. For many years after, it was possible to see the splintered tree trunks in Sapperton Woods, from where the weight of the ice had doubled them over. Many people still recall the sound of tinkling icicles, like bells, as the branches swayed before cracking off in great explosions. Birds froze to the trees where they had roosted for the night, and it was only due to the manpower and equipment of army units in the Cotswolds that emergency travelling was able to take place at all. It was calculated that a sprig or tuft of grass bore sixteen times its own weight with the ice encasing it; a twig weighing 3 oz (85 g) became 3 lb (1.4 kg) with as much as a 3 in (75 mm) coating of solid ice on it.

The wartime diary kept by the late Mr A.W. Hughes, editor of the *Gazette Newspaper* at Dursley, was — as Derek Archer who has now edited and published it in the series 'Pages from the Past' calls it — a journalist's rebuff to censorship. Under no circumstances could the detailed incidents of bombing and casualty figures be published during the war; such information would have assured the enemy that they were on target and boosted their morale had they learned of the toll and damage. But how difficult for Mr Hughes to have all that information at his fingertips, as Information Officer, and not to be able to convey it to his readership. Fortunately, for the local historian, the detail behind the scant press references can now be studied from the contemporary reports, condensed into *Glo'shire at War*.

Individuals kept diaries, too, but these tended to be servicemen recording life in foreign parts as a personal record for their family.

Letters had to pass the censors and often a letter would arrive with holes cut
out of it where a slip of the pen had mentioned a ship's name or an army
base or a reference to the size of the unit and its work. The service address
comprised simply name, rank and number and a field postal number. Air
letters incorporated a certificate stating, 'I certify on my honour that the
contents of this envelope refer to nothing but private and family matters'
had to be signed by the sender.

Setting stakes on when it was all going to end could not have counted
as information useful to the enemy, as Reg Fisher's letter to Elsie and Vic
Holland of Chedworth bears the censor stamp as 'passed Censor No.
5088', April 1945. Reg wrote, 'We run a sweep in the squadron for the
date of ceasefire. You pay 100 lire which is 5s. for a ticket, which has a
date on it. If the war with Germany ends on that date you win £50. My
date is June 2nd, but I'm quite willing for someone else to win it providing
the war ends before then.' Which really says it all for those so far from
home.

## INTELLIGENCE AND SPIES

The Secretary of State for Air issued an order on 3 September 1939 to
control pigeons in Britain. Permits had to be obtained from the police to
keep them, and it was against the law to harm or liberate a homing or
racing pigeon. Immediately following the order, a Cheltenham man was
fined 5s. for shooting a homing pigeon; the report on the case stated that
pigeons were valued as lifesavers in wartime. Just how, was not revealed
until after the war, but the use of birds as carriers of messages dates back
to the Ark, and in the First World War some 100,000 did war service —
the fine for harming one then being up to £100 or a six-month prison
sentence.

The technological advances in the Second World War looked like being
so sophisticated that the simple pigeon would never be called upon again,
but it was. Even some fifty years on, the Swiss employed some 30,000
pigeons to act as communicators as they were unable to be tracked by
electronic equipment. Official figures give the total number of pigeons
parachuted into occupied countries in the last three and a half years of the
war at 16,544. There were heavy losses; the pigeon service was not a British
preserve, and every good spy story included one — with the classic being
the woman at the market having her bosom fly away on being arrested.

The Cotswolds hold the proud claim of the first pigeon in the Second
World War 'to be used with success for secret communications from an
Agent in enemy occupied France while serving with the NPS

(National Pigeon Service) in October 1940'. The citation and the Dickin Medal, the animals' VC, were presented to Kenley Lass, Pigeon NURP 36 JH 190, to give the brave little bird her full military title, who had been bred by Mr Donald Cole of the Bull Inn in Dyer Street, Cirencester. Kenley Lass was parachuted in with a British Agent and remained hidden with him for eleven days before being released to fly back to base with her message — a flight of some 300 miles, which she achieved in one day. She carried out a similar mission in February 1941.

British Intelligence sources divulged through the press in September 1940 that the Japanese were trying to train honey bees to take the place of their carrier pigeons in army communications. The Japanese scientists, aware that only bees and silkworms in the insect world had been domesticated by man, set their celebrated scientist in charge of perfecting the work in Yamagata. Ironically, as it turned out it was bees imported from America that were being used in the experiments. Known for its high degree of intelligence, the bee wore a tiny harness, with a pocket, fitting snugly round the body so as not to interfere with its wing movement. Into the pocket a microscopic message on fine rice paper was packed. Exactly the same principle had been used in 1150 BC by the Sultan of Baghdad — but he had the tiny rolls of papyrus fitted into capsules which were fastened to the back feathers of a bird. Caesar's conquest and Wellington's victory at Waterloo were both conveyed in the first instance by carrier pigeon post. No wonder the discovery of mysterious gauzy white film in three different places in the Cotswolds in the autumn of 1940 caused some consternation. It was thought that the presence of small swathes of the white film caught in the hedgerows was another secret invention gathering intelligence; that is, until the naturalists were consulted and they confirmed that it was simply a thick coat of cobwebs. A similar drift of such dense white cobwebs had been recorded by Gilbert White in the eighteenth century.

While the home defence services were prepared to give the Gemans as tough a time as they were able should they have the temerity to land their troops on British soil, there was the danger of the 'stranger in our midst', whose presence demanded close scrutiny for purpose and allegiance. For this reason conscientious objectors were registered, and allocated non-combatant-type jobs, but often had to ride local scorn and derision for what the majority saw as cowardly opting out at the country's, therefore their home's, gravest hour of need. There were 181 registered conscientious objectors against 62,325 who registered for National Service of one form or other in Gloucester.

The local trust in knowing their own was pretty well an insurance in its own right, for a close-knit community would have had an inherent sense of justice had the occasion arisen to have that trust broken.

# CIRENCESTER PIGEON " V.C."

## BROUGHT FIRST NEWS FROM OCCUPIED FRANCE

Kenley Lass, owned by Mr. Donald Cole, Bull Hotel, Cirencester, was presented with the Dickin Medal (" Pigeon's V.C.") for meritorious performances on War service.

Kenley Lass, the Cirencester-bred pigeon with her Dickin Medal (Pigeon's VC) awarded for meritorious performances on war service — the Cotswolds claimed to be the first to use the National Pigeon Service successfully.

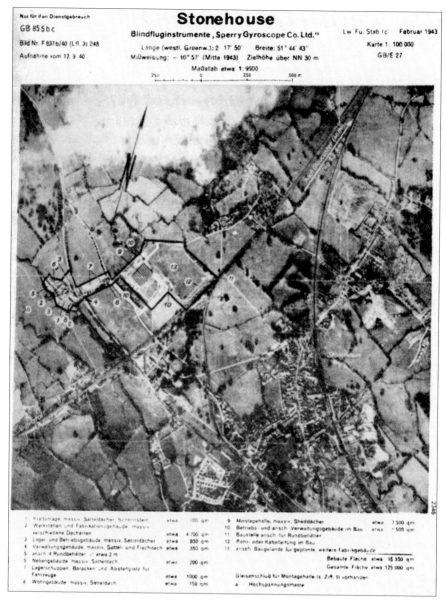

Stonehouse — Aerial picture taken by the Luftwaffe on 9 September 1940 and detailed for a raid planned for February 1943.

But it was the foreign stranger in our midst which gave rise to concern: not unnaturally, of course. Local feelings ran high in Fairford in October 1939 when it was reported that ten householders were losing their allotments at the west end of town to enable a Frenchman to build a house on the site; not only was it a local issue, but the allotment holders questioned the political priority when the planning permission for a foreigner to build on productive and cultivated gardens came just at the time as the Government urged people to produce more food.

When some of the East Enders evacuated to Fairford bridled at having to address one of the Women's Voluntary Service (WVS) as 'lady', after she had reminded them that she was not plain 'missus', they murmured that Hirtzel had a decidedly foreign ring to it — especially as the lady in question did not seem to know anything about pease-pudding! Lady Hirtzel, in turn, murmured, but rather more loudly to fellow helpers, that 'she had heard from someone who knew someone else, that ought to know' Fifth Columnists were at Barrow Elm. 'There were people there called Jones, who kept out of the way, and a couple called Ustinov — very east European; the husband was something in "secret service"; the wife could be seen making sketches of the Cotswold countryside, and there was a son doing something somewhere.' The son, of course, as Peter Ustinov has related many times, served as a private in the British Army. His father, Jonah, was part Russian but had German nationality and was awarded an Iron Cross in the First World War when he was in the German air force. He later threw his medals away and motivated by his hate of Nazism became part of MI5 after escaping the Russian regime with his young wife, Nadia Benois — a talented artist, daughter of the architect to the Tsar, thus giving Sir Peter Ustinov British birth in 1921. In order to get British Nationality to serve in MI5, Jonah Ustinov — code name Klop, had to get sponsorship and publicly declare his intention of becoming British in a newspaper, to allow any opponents of the move to raise any objection. As this was too risky to do, given his former role as press attaché at the German Embassy when the ambassador to London was Joachim von Ribbentrop (who became Hitler's Foreign Minister) Klop conspired with the British Intelligence service that the announcement should be made in a Welsh language newspaper, under the correct assumption that the Gestapo was unlikely to have sufficient experts in Welsh to decipher his intentions. A talented linguist himself, Klop carried out daring and dangerous work during the war in intelligence and rescue work in Holland, Portugal and Switzerland. It was Klop who provided critical evidence of Hitler's agenda, including his plan to invade Czechoslovakia. So sensitive was his role that British security officials hid Klop's identity when relaying warnings to Neville Chamberlain and Lord Halifax, the Foreign Secretary.

Jonah Ustinov resisted the pleas from a number of publishers to write his memoirs as he did not want to mention any of his more 'interesting activities' for fear of 'letting the side down'. But Nadia hinted at her husband's secret work, set against his colourful and intriguing background, in her book *Klop and the Ustinov Family*. Writing it a few years after Klop's death, in the Tudor cottage at Eastleach to which they had retired, Nadia's artistic and erudite company attracted a whole circle of interesting people, each with a tale to tell worthy of a book in itself. Among her close friends were Lord and Lady Howard from Dean Farm and Nadia revelled in Francis Howard's modest account of how, as a member of a secretive group of Commando 62, he took part in a successful raid in Normandy, capturing all seven Germans manning the beacon of the Casquette lighthouse and wrecked the radio station. A later raid, in 1942, planned to land close to St Honorine to scale the cliffs and attack a German emplacement from behind, went hideously wrong as they landed much further east, on what would later become known as Omaha Beach, only to be faced by Germans, alerted by a barking dog. The group's commanding officer and two other Commandos were killed. Lord Howard suffered a serious leg injury, which severely

Klop — from an oil portrait painted by his wife, Nadia Benois Ustinov. Klop was the nickname given to Jonah Ustinov, one of Britain's most important MI5 agents.

handicapped him for the rest of his life, and after a long period in a prison hospital was repatriated the following year. Typical of his wry humour he voiced his amazement that he might be the only British soldier not to receive a medal for active service in the war, whereas he had been reliably informed that the dog that betrayed his group was awarded an Iron Cross which it wore on its collar for the duration of the war!

Individuals were one thing, the influx of a whole community, another. In 1937 donations were invited through the Rural Community Council, Gloucester, for funds to help a group of exiled Germans who had their property confiscated by the Nazi regime, and their Society of Brothers dissolved, to establish the Cotswold Bruderhof between the villages of Oaksey and Ashton Keynes. The farm which formed the nucleus of the settlement comprised some 300 acres, with 6 acres for garden produce alone. The old farmhouse was converted into a school for its sixty children; workshops turned out furniture made by craftsmen, pottery, weaving and a self-contained printing and book-binding workshop, communal bakery and. laundry, all created a viable village unit in isolated Cotswold countryside. Most of the labour came from the Bruderhof members, but there did seem to be some urgency in getting the settlement completed and local builders were taken on for some of the work.

As war broke out Dr Eberhard Arnold, a German scholar, who founded the Bruderhof in Gemany in 1920 moved with his commune to the Cotswolds, following Nazi persecution. His public announcement of allegiance and gratitude to the British Government and people for their friendly and sympathetic welcome and acceptance included an offer to extend their food production to help the British war effort. But the British people in the Cotswolds did not want food grown by Germans on their land. And they declared as much. Having divulged that the community was some 250 strong, with well-equipped accommodation and workshops, their own printing facilities, and a library of some 10,000 books, Dr Eberhard Arnold set the local people thinking — and talking. His offer to 'help the neighbouring farmers' was not taken up. It only fired speculation as to its motive and there was bitter resentment that the Home Secretary allowed the Bruderhof to continue despite strong protest.

Calls for the German colony to be interned were ignored, much to the bewilderment of local people who could not understand the double standards being practised on this issue. South Cerney air base, in which the Bruderhof is said to have taken an interest, was strafed in June just as the training school from Middle Wallop had arrived, and on numerous occasions after. The Oaksey part of the Bruderhof estate was auctioned in November as most members had left having 'certain plans about which we do not wish to have any publicity at the moment'. The final members left at the end of the year.

So ended the stay of the stranger in our midst — subversive spies practising the treachery and cunning of the Nazi to infiltrate; or simple Christian community striving to achieve fellowship and commune with nature where in the Cotswolds they could integrate?

Neither has been proven. The true reason for their coming and going will perhaps never be known now.

Little did Frank Smith at the tender age of three years, newly evacuated to the Stonehouse area and, deciding he did not like it, making off to walk back to London 'in my little pink painting pinny', foresee that he would return to be a master of Wycliffe College for more than a quarter of a century. 'My friend and I had walked all of 300 yds [270 m] when a big policeman stopped us and said, "Allo, allo, what have we here then?" We told him of our intent and he kindly showed us the way — straight back to where we had come from!' Little, either, did Wycliffe Scouts abroad in 1936 foresee that the Hitler Youth they met in Germany in friendly circumstances were to be their enemy in such a short time. Neither could the member of the Observer Corps, under the direction of Capt. T.M. Sibly, who fired a shot at the German Dornier which had the temerity to cruise down the Stroud Valley and above their post on the roof of Springfield, have foreseen that while his aim was off target the reconnaissance shot was dead on. A perfect aerial photograph was taken that day on 9 September 1940, and drawn up as a target for a heavy bombing raid on nearby Sperry's Gryoscope and Hoffman's Ball-bearing Works. Had Goering and his Luftwaffe carried out the raid planned for Stonehouse, they would have also netted a valuable destruction of the Air Ministry Meteorological Office which had taken over Wycliffe College, and Old Wycliffians would have more to mourn than the heinous sin of the Ministry building huts on the cricket field. The Admiralty branch at Ryeford also escaped as the plan for the raid never materialized. Just why can only be conjecture, the opening up of the Eastern Front probably diverted attention from the Cotswold targets.

The extraordinary thing was that it was an Old Wycliffian who found the map in the Luftwaffe premises at Lubeck when the Allied Forces advanced into Germany and the RAF occupied them. Michael E. Gardner, a student at Wycliffe from 1928–36, was the first to enter the Luftwaffe Target Room. From the central table, strewn with papers and charts, he picked up the aerial map of Stonehouse which he later sent to the college. Wg. Cdr. C.V. Winn, an Old Wycliffian himself, was shown the map when he visited his old school and identified it as a plan to launch a heavy attack on Stonehouse as the detailed information on it illustrated. He was able to add his own personal experience of the thoroughness of the espionage of German Intelligence. He had himself gained access to the dossiers compiled

by the Gestapo for every officer in the British Services, and discovered his own very accurate and comprehensive life's history among them. It came as a bit of a shock to find a photograph of himself taken at Wycliffe in a prefects' group which was published in the college magazine The *Wycliffe Star*! Just how Himmler acquired a copy of the school magazine remains a mystery.

The *Citizen* carried the news in its City Special that the first Nazi spies caught in this country since the outbreak of war had been executed at Pentonville on 10 December 1940. The two enemy agents had been found in possession of a German wireless transmitting set and batteries; the set weighing only 1 lb (0.45 kg); together with a morse code key and large sums of money. 'They had been made to believe that they would shortly be relieved by German invading forces.'

## SOE AND SAS

'If we had been caught we would have been shot as spies and saboteurs', says Don Miles who was awarded the Distinguished Service Medal for his hair-raising adventures while serving in the SOE. A naval man, thirsting for adventure, Don was assigned to the special training centre at Hatherop Castle after his time in France. 'We were all operational people, mostly Danes and Norwegians. Hatherop Castle was a holding ground

Cowbridge House, Malmesbury — secret war factory where Radar was developed (Courtesy, Bob Browning).

between missions and our CO was Col. Andrew Croft, DSO, OBE, a pre-war Polar explorer who had served in the Spanish Civil War and featured in many books for his talent for adventure — the title of his own story. We had no rank while at Hatherop, as part of the SOE we were called students and had no uniform except a kind of battledress, but mostly we were in dungarees—it was a dirty job crawling between steam trains! We used to motorcycle around the Cotswolds on our training exercises, ranging from blowing holes in rail tracks and waterworks, getting in and out without being seen. Of course, we used dummy charges but the local railway chaps got to know us; very difficult to remain unobtrusive in a small community where everyone is known to everyone else, but of course at that time there were so many troops and foreign people around. We used a fog signal attached to wires and I remember falling into the Coln on an exercise getting up river to Bibury using logs as a raft. We would be taken out into the Cotswolds in the back of a closed van and dumped with only a compass to find our way back — all good training for what we had to do on the other side of the Channel. In the woods was a cottage we used for attacking and defending. There was also an assault course. We had special weapons that the army didn't have, and there was a firing range in the castle ground. What with that and learning to blow safes, the bangs must have been heard!

An armed guard at the rear of Wycliffe College attracts the attention of schoolboys. A protective blast wall can just be seen behind the railings.

The bangs were heard, and it was with more than inquisitive interest that Henrietta and Rachel Cadogan would risk being caught by a stray bullet being fired into the woods when they tried to spy on the activities going on at their home. 'The firewood was quite useless,' Rachel — now Mrs Bennett — recalls, 'it was so full of gunshot we were frightened to put it on the fire; even our half-brother Sir Thomas Bazley had to have a pass to go up to his own home.'

'We had to have a pass to get out of the castle,' Don Miles said. 'We used to keep fit by playing touch football in front of the house and football sitting on our backsides in the great hall, it was a terrific way of keeping fit. All the lovely paintings and furnishings had been removed, of course, all the treasures from the big houses taken over were stripped, then fitted with bunks and benches army style. There was talk of Fifth Columnists in the area, there no doubt were double agents infiltrated into highly sensitive units such as ours — just as we penetrated the German Intelligence. That is war. There were a couple of bombs dropped nearby, and a peculiar light which was said to be seen from the top of the castle but no one could find it, and it was only seen from certain points.'

One of the oil bombs dropped at Hatherop landed in the Bartletts' blacksmith's yard and shook Denis out of bed. Denis recalls his father who was a Special Constable getting frustrated about the glow that appeared sometimes from the direction of the castle. It could only be seen from the cemetery at the top of Quenington Hill and at one spot at Barrow Elm, and when it did he would report angrily to the castle about it. A search would be made of all the rooms and nothing found. It was only after the war when Sir Thomas Bazley asked Denis to cut out a huge water tank from the castle tower that the rogue light was discovered. 'The tank was so big and built up that you could walk underneath it,' he said. 'The bulb was alight and must have been on all through the war years, it wasn't any more than a 40 watt and I do remember it was a Philips bulb — so that says something for its longevity. It would have been impossible for anyone to find it in the position it was in the tower, but it was aligned to the slots in the tower and would have only been visible at a distance at the right angle, and seemed to be on a separate circuit.'

Corporal AR Chappell of RE Section, HQ Squadron, wrote home to his mother 1st June 1944: 'Have you been having this heatwave round your way? We have had three days of terrific heat, but a heavy thunderstorm put an end to it all yesterday — for a time anyway. Today has been dull and unsettled. As usual these days news is scarce, so you will have to excuse a short and somewhat stilted effort. Cheerio for now. My best love, Roy.'

The weather was of crucial importance at that date and on the eve of D-Day he wrote: 'I expect you have been somewhat puzzled by my mail

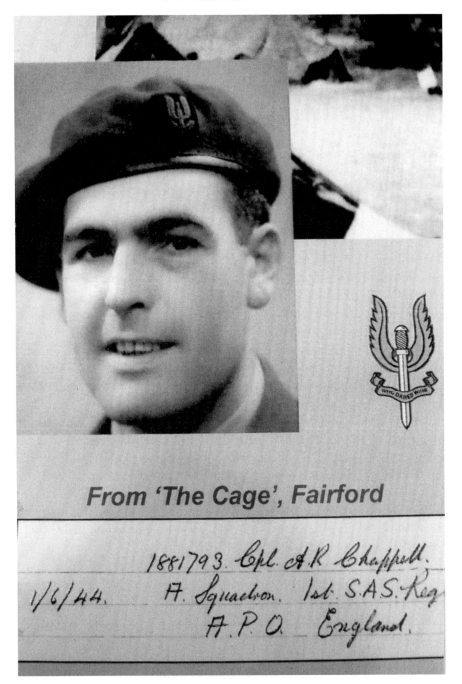

Cpl A. R. Chappell of the SAS — the tented training camp known as The Cage at RAF
Fairford is just seen in the background (Courtesy, David Mundy).

lately and have been wondering where I am and what I am doing. I'm afraid that will have to remain a secret for the time being anyway — and you will have to be content with the old phrase so common in letters from the Army — "I am quite happy and in the best of health — " etc., etc. So the dentist bill is paid at last! £2 2s was not too bad a price to pay for making me good-looking again was it!! By the way did you ever do anything about my suits? They are of little use to me now and if you can get rid of them somewhere you might just as well. What about getting Mrs G on the job — she gets around!! There is no need for you to worry, I'm quite OK and everything is under control.'

The letters were sent from 'address as before — APO England'; in reality they were written in what became known in SAS circles as The Cage — a tented secret transit camp, literally caged in by barbed wire just above Totterdown Farm on the perimeter of the RAF Base at Fairford, which was built in readiness for the invasion of Europe in 1944. Here, after intensive training for SAS operations, the men were briefed for their special missions. Following the drama and tension of the D-Day operations there was no let up for the Stirlings supporting the Special Forces as activity behind the German lines increased. Mrs Chappell received an official letter, dated 18 August 1944.

Dear Madam, The following information is available regarding your son, Cpl A Chappell. He was dropped by Parachute into France on — and up to the time of writing was quite safe and well. You may take it for granted that he is safe unless you hear from the contrary from us. He will not be able to write to you for some time, but will be able to receive your letters, so please keep writing. Cheerio, keep smiling and don't worry. Yours sincerely, G Rose MM.

These extracts from Cpl A. R. Chappell's report give a vignette of Operation 'Trueform' Night 16/17 August 1944 when he was parachuted into Normandy just west of the River Seine.

The party consisted of: Cpl (A/Sgt) Chappell, Spr Dow, Spr Warren. Spr Briggs, Spr Baxter. The flight was made in a Stirling aircraft and my party formed the second half of a stick of ten men, the first half consisting of a Sgt and four men of the Belgian SAS. The Belgians jumped with kitbags. We jumped with one British and one US haversack each, attached to the body, carbine pushed under the harness across the chest. Very uncomfortable whilst in the plane, but all made successful landings, in spite of very bad DZ which was thickly wooded in parts and orchard in others, with no clear spaces.

The object of the operation was to search out and destroy enemy fuel and petrol dumps and thus hinder the flight back to the Seine. No particular targets were given as the speed of the German retreat had made accurate

1881793. Cpl A. R. Chappell
5/6/44.        H. Q. Squadron. 1st S.A.S. Regt.
              A.P.O.   England

Dear Mother.

I received your Whit. Sunday
letter the day before yesterday, so it is
high time I answered.

I expect you have been somewhat puzzled
by my mail lately, & have been wondering
where I am, & what I am doing. I'm afraid
that will have to remain a secret for the
time being anyway, — & you will have
to be content with the old phrase so
common in letters from the Army — "I
am quite happy & in the best of health
" etc, etc.

So the dentist's bill is paid at
last.! £2"2/- was not too bad a price
for making me good & looking.

Letter sent from Cpl Chappell to his mother just before D-Day (Courtesy, David Mundy).

information impossible. The jump was made 'blind' not being met by any member of the SAS or the FFI organizations. We had no means of sending a message back unless FFI could be contacted. Each party carried a midget receiver for receiving daily Trueform broadcasts. After concealing our 'chutes we had great difficulty in passing through the woods in the dark. The undergrowth was chest high and almost 100% briar.

On the outskirts of the village of St Marcel enemy traffic very light, probably six vehicles all day, about half were fitted with Producer Gas equipment, all heavily camouflaged over the cab and body with branches and undergrowth. Upon reaching the outskirts of La Chapelle we went into the cemetary for a rest. This spot served as a listening post over the village. I decided to investigate and obtain water. I took Spr Warren with me and all our water bottles. All gardens were locked and high walls around them, no public water pumps but found water at the village communal wash place. We then hid up in the woods and from there did a 'recce'. In the flat countryside to the NE of Reanville we found signs of recent levelling, which looked suitable for a temporary landing field.

The morning of 19 August there was a sharp shower of rain and we were able to collect enough water in outspread gas-capes to get a good wash and shave. We watched a farm for two hours, no German soldiers seen so I decided to contact the occupants. We managed to isolate one of the men and made ourselves known to him, he took us to a stable and food and drink were quickly brought, then he sent another man off on a cycle, he returned with another man who said his name was Baillie, and his parents were Scottish although he had lived almost all his life in France. He knew the men running the Resistance in the district and told us of the movements of the enemy in the district. Horses had been commandeered by the Germans from many of the local farms and a large proportion of the motor transport was running on wood fuel (Producer Gas). There were no petrol dumps in the area but enemy vehicles were still using the north to south crossroads at St Colombe Pres Vernon — I decided to lay in ambush for isolated vehicles at these crossroads and arranged to meet the local Resistance leader at Baillie's home on the night of 21/22 August. The people at the farm were able to supply us with food for 48 hours. Spotted German a/c for the first time. Two planes flying low and showing navigation lights (three white bars of light beneath one wing). Took up positions for ambush that night, but again no luck. Heavy rain continued, found smocks useless in heavy weather. At 1200 hours we heard occasional shell-fire and later machine gun fire coming from the SW, I moved my position in the woods to a spot where we could watch in this direction but rising ground permitted only about a half-a-mile view.

Roy Chappell, who had been promoted to Acting Sergeant on 6 August, was Sergeant of the RE Section from the end of the mission until demob in 1946. He concluded his report on Operation 'Trueform' describing how his party eventually joined up with the American 5th Armored Division where they were given positions on a vehicle belonging to the 49th Infantry Brigade, and by way of Le Mans and Bayeux before returning to base.

This was just a brief look at one of the 394 missions that Fairford Stirling squadrons flew during the month of August 1944 from this quiet corner of the Cotswolds. Recognition of the elite force who made bombing raids across the German heartland and dropped SAS troops behind enemy lines at low-level, often under heavy flak, has been seven decades in the making. Now, following a reunion of 620 Squadron in 1997 at RAF Fairford, a roll of honour listing the pilots who died in active service takes its place in the Heritage Hall of the Base.

## THE BRITISH RESISTANCE – CHURCHILL'S SECRET ARMY

Subterfuge of secret plans wore many guises. Jack Archer was often asked why he was not in the army — true, he was well known as an instructor for the local Home Guard in his home town of Highworth, and his replies had to be innovative as well as evasive for behind the innocent training of Dad's Army was Jack Archer, commander of one of Churchill's undercover Auxiliary Units of the British Resistance. Churchill had appointed Colonel Colin McVean Gubbins, a guerilla warfare expert who had studied everything from the IRA to Chinese insurgencies, to spearhead the formation of a civilian army of saboteurs who could go underground at a moment's notice to destroy supply lines and installations of an invading force. Colonel Gubbins enlisted two leading fellow officers — Peter Fleming, brother of Ian Fleming the creative force behind James Bond, and Michael Calvert, a Royal Engineer a prominent figure in creating the SAS.

It was a hard kind of double life one had to lead; signing the Secrets Act binds you to secrecy for your lifetime. The orders for forming a secret resistance army came from Winston Churchill after Dunkirk when the threat of a British invasion was imminent, and we as a country were so inadequately armed that it would have been impossible to find a rifle for each of us. My main job was training the group in small arms, but I was also responsible for knowing my men — you had to be absolutely sure that they would not let you down when our backs were to the wall, it was no place for softness. I was trained to be as tough as the toughest of the King's Royal Riflemen and had to pass that on in my training. Having

committed yourself to the cause you could have been sent anywhere in the world, but I was lucky and had my secret training at night, and was well aware of the nature of activities going on at Coleshill House, behind the high walls — headquarters of the resistance in the eastern part of the Cotswolds. There were a lot of French and Norwegian reporting there, but one never asked questions.

Jack's intimate knowledge of every field and hedgerow in the area was of paramount importance as each cell of chosen men operated in a network of underground bunkers, officially designed as Operational Base (OB) in total isolation from other units. Essential to the security of the operations, there was no contact between them, even when in action. The members of the Auxiliary Units were fully trained as military men, but were not enrolled in the British Army to preserve their identity in the case of the expected German invasion. Priority was given to the Auxiliary Units for the best equipment to do their job. Weapons included rifles, Sten guns, a .22 rifle with telescopic sight and silencer and hand grenades. Detonators, explosives and timing devices and all the kit needed by a saboteur, were in readiness for use. Each member had his own .38 revolver — some of the weapons and equipment had to be secretly stored in the member's own home well away from the family's inquisitive eyes. A number of weapons, such as the Thompson sub-machine gun, were used in training at Coleshill House long before they were seen by regular troops; so, too, was the use of a new plastic explosive. The weapons were to be used for personal defence only, there was to be no free for all fighting with enemy troops — theirs was a different form of warfare and depended on the individuals' survival to wreak as much damage as possible to the infrastrucure to hinder the advancing invaders. The training manual — a comprehensive handbook detailing the parts and functions of the various weapons and a saboteur's guide to explosives and booby traps — bore the down to earth innocent, but double-meaning, cover:

The Countryman's Diary — 1939. HIGHWORTH FERTILISERS DO THEIR STUFF UNSEEN UNTIL YOU SEE THE RESULTS! With the compliments of Highworth & Co. YOU WILL FIND THE NAME HIGHWORTH WHEREVER QUICK RESULTS ARE REQUIRED.

Two of the other five men in Jack's cell were former bank robbers, released from prison as explosive experts were considered of more value serving the country's underground resistance movement in such desperate times. It was later revealed that even the luxurious lavatories in the stately homes, which were seen as the possible quarters of Nazi officers, would be booby-trapped to give the invaders as uncomfortable a time as possible!

What did upset Jack was not the tough training and long hours but the secrecy under which he had to work, knowing that he was risking his life if the invasion had come and yet appearing to the folk of Highworth that he was not doing his bit in the war. Market gardening and Home Guard duty seemed a soft option compared with the lot of the fighting forces — as he was often reminded and taunted about by mothers who had lost sons, and wives whose husbands were on the front line.

One woman who had three sons overseas stopped me one day in the street and put a white feather in my coat. After the war she, and a few others who had taunted me, apologized when Churchill released information about the units and they realized the importance of what was going on in the underground movement.

One person who was in the know was Mabel Stranks, the postmistress here in Highworth. She was a brave lady and a lovely person. We knew a little about what each other was doing, but we never spoke about it in all those years. When it came out about what her role was in the resistance, she refused to be decorated and said she was just a link in the chain.

It was imperative to preserve the name and location of Coleshill House, and the quiet country post office at Highworth was chosen as an ideal front as the link in the chain — it was a place to which everyone, locals and strangers, had cause to visit. Those who were recruits or agents gave some sort of code word and said they were looking for the Auxiliary Unit. Mabel Stranks, a rather austere widow who could have stepped straight out of an Agatha Christie's thriller as a real-life Miss Marple, would then command them to wait awhile. After a telephone call to a secret number to say that a parcel had arrived and was ready for collection, and unobtrusive watching by Mrs Stranks, a car would pull up with blacked out windows and the agent taken by a circuitous route to Coleshill House with no idea of how far it really was from Highworth, or how to get there. It has never been revealed as to their destination if they did not pass the Mabel Stranks test. The exact extent of her role in the line of the British Resistance during those years may never be known. Her skills as a trained telegrapher and the fact that as a postmistress she had signed the Official Secrets Act, and her loyal and trusted position made her an ideal choice for the crucial link in the chain. She refused to take part in a television documentary about the Auxiliary Units and never divulged to her closest family just what she did. Mabel Stranks may have been unwittingly caught up in a dangerous web of wartime secrecy, or she may have played a more prominent part in the initial

Mabel Stranks, Highworth Postmistress who was a crucial link in the British Resistance chain (Copyright Highworth Historical Society, Courtesy, Paul Newton-Smith).

vetting of agents' credentials. One thing is for certain that she was whole heartedly committed to her duties, for it has passed into local legend that she gave Field Marshal Montgomery a pretty tough time, insisting that he prove his identity when he visited the post office! Recognition of her intriguing past is as modest as the lady herself — a simple plaque was erected by the Highworth Town Council on the former post office. It reads: Postmistress Mabel Stranks Highworth Old Post Office, The Auxilliary Units Gateway 1941-1944.

The third point of the secret triangle of the underground resistance movement based in this south east corner of the Cotswolds was at Hannington Hall. Early in the war it became the first headquarters of the Auxiliary Units' Special Duties Section under the command of Major Maurice Petherick. Senior Commander Beatrice Temple was overlady of the ATS. A niece of William Temple, Archbishop of Canterbury, Beatrice operated under the alias of Belinda Blue Eyes. The ladies who worked there in Special Duties Section communications were dubbed the Secret Sweeties – a term they hated. When the Section first moved into the mansion the Fry family still had fourteen servants and always dressed formally for dinner. One wing was requisitioned to become an ATTERY for ATS personnel and all the comfortable furnishings were replaced by iron bedsteads with Army issue mattresses, known as 'biscuits'. Mrs Fry remained in residence in the front of the house while daily transport took the ATS girls off to Coleshill for training alongside the men in what has been called Britain's most secret army, to be ready for anything from blowing up bridges to silent killing if and when they were called upon to face an invasion. A central core of communications operated direct from Hannington Hall. Both men and

Hannington Hall, the first headquarters of the Auxiliary Units' Special Duties Section (Courtesy, Jo Clark — Highworth Historical Society).

women were involved in gathering information as they travelled around in normal everyday work, the surveillance results were then transmitted by secret radio operators to HQ Special Duties at Hannington Hall. They and the operational patrols of the underground resistance units were completely unaware of one another's roles and involvement in the secret web of intelligence work. With the confidence that the end of the war was in sight, the Operational Branch of Auxiliary Units, whose organization involved some 3,600 personnel throughout Britain in 1941, was stood down on 30 November 1944. A letter from Colonel FWR Douglas congratulated those who served in the units, concluding with the paragraph

In view of the fact that your lives depended on secrecy no public recognition will be possible. But those in the most responsible positions at General Headquarters, Home Forces, know what was done; and what would have been done had you been called upon. They know it well, as is emphasized in the letter from the Commander-in-Chief. It will not be forgotten.

The letter was addressed c/o GPO Highworth, Nr Swindon, Wilts. Recognition, again, eventually came: some of the activities of the 'most secret army' have been publicly portrayed in documentaries and publications and the surviving former members have recently been awarded the 1939-1945 Defence Medal. But many stories, such as those that Mabel Stranks could have told, will never be fully known for many, like the country town postmistress sleep the eternal sleep now with their secrets. A British Resistance Organisation Museum dedicated to Auxiliary Units all over the country opened in 1997 at Parham Airfield in Suffolk so, as Colonel Douglas promised some half a century before, their part in the war will not be forgotten.

# CHAPTER FIVE

# War Effort

## PRODUCTION

The Cotswolds have never been a highly industrialized region; what pre-war industry there was settled mainly in the Gloucester Vale and on the edge of the Cotswold escarpment. The largest industrial works at that time was Lister's at Dursley — a vital point gleaned by German Intelligence according to its strategic position marked on an aerial photograph taken by the Luftwaffe in September 1940. Lister's war effort began some five years before the outbreak of hostilities, with an order for 18 lb (8.1 kg) of training shells for the army. In 1936 they were one of only six companies in the country to begin production of Bofors shell casings; the War Office then issued orders for Lister's diesel generating sets for searchlight, portable bakery and other installations. With the first year of the war, the pressure in the works to make these led to the cessation of shell production.

Security scares in the months leading up to the war were common, and on one occasion the railway engine of the town's 'Dursley Donkey' was locked in on a siding on Lister's property, much to the inconvenience of the late-shift workers. Wartime production of JP3 and JP4 diesel engines at the rate of 1,652 in 1939, tripled in output by 1944. The Lister engines, coupled to Mawdsley generators on trailers supplied by Taskers of Andover, were the sole sources of energy for wartime radar and searchlight units. Lister engine 9–1 saw service on D-Day invasion barges in 1944, when the production had risen from 79 in 1939 to 569. The Cotswold firm also supplied engines for emergency power as the battle for Europe ravaged and crippled power stations. Shell cases and sheep shears were of equal importance, agricultural implements and air screw hubs, packing cases and Air Raid Precaution (ARP) ladders and bases for engines kept a full work-force fully worked and greatly impressed Queen Mary when she visited at short notice on Maundy Thursday, 1940. The part women played in wartime Britain was well illustrated at Lister's. Some 850 employees had served in the armed services by the end of the

war, many in the Gloucestershire Regiment and the Royal Gloucestershire
Hussars. Some 350 women stepped in to carry on the men's work, and it
became company policy to retain those women who wished to continue
in 'non-office' jobs by 1945. Lister's was the first company to get a sub-
factory under way in wartime when a carpenter's shop and stores were
taken over and converted at Nympsfield. From an initial workforce of
eight local women, who became known affectionately as 'Nymps', in
1942, Nympsfield became an all-women sub-factory of twenty-eight
under the foremanship of Mr Trigg. From this small unit 'on the Edge'
components were assembled, pipes made, spares for searchlight sets, tank
landing craft and other wartime ironmongery were packed, and later, the
all-age all-female factory was assembling heavy duty engines. Such was
the attachment of the Nymps to their factory that they appealed against
the Company's plan to close it after the war, and it remained open until
1972.

Another sub-factory was opened at Wotton-under-Edge in 1943, and one
in the Forest of Dean the following year. Again, at Wotton it was entirely
staffed by women, and at one period they even turned their hand to building
engines. Such was the enthusiasm of the Wotton workers to provide a
speedy service they accidently packed a colleague's lunch — later returned,
somewhat mouldy, with a request for a refund as the sandwiches were not
then required! The ladies worked a thirty-hour week for 35s. assembling,
brazing and soldering. The sub-factory was set up in three bays of Lewton's
coach garage in the High Street, requisitioned by the Ministry of Supply.
As the work and workforce grew to meet demand, 'uncontrolled ladies'
— those officially 'over age' and mothers of young children accounted
for some 150 war workers, and a Spitfire hangar from Aston Down was
transferred to Wotton to accommodate them. Parts of the hangar that had
been constructed in Windsor Great Park, in readiness should the royal
family have to flee the country in the event of an invasion, was utilized by
Lister's immediately following the war to extend the Dursley workshops.
Further workshops were built in the post-war period using parts from the
Mulberry floating harbour used in the Normandy landings.

Shakespeare's Avon at Tewkesbury was also the scene of hush-hush
activity starting with the taking over of the boatyard by L.A. Robinson
of Lowestoft at the beginning of the war. Boat building had been a major
industry in this Cotswold Vale town for the best part of a century on a
site near King John's Bridge; Bathurst's steamers were well known in
Edwardian times, and the name carried on until the end of the Thirties. As
private craft stopped, work was undertaken for the Admiralty — the first
to be built were three B-type Fairmile prefabricated launches, 112 ft (34 m)
long with an 18 ft (5.6 m) beam.

Dennis Vickeridge was apprenticed at the yard, but when the Bathurst's boat-building firm finished, many old craftsmen either had left or were called up. The eventual workforce of around 130 was conscripted from many diverse trades: lecturers and piano makers worked with cabinet makers; coach builders from Swindon Railway Works fitted well into boat building and the many skills produced a significant number of harbour service launches, or pinnaces, motor fishing boats to be used as liberty boats, six tugs, and converted two landing craft for the Normandy invasion, as well as maintenance and repair work. He recalls two very large vessels in a field on the banks of the Avon, opposite the original boatyard, and a big shed of corrugated iron being built around them. One worker was so impressed with what they were doing he brought in a camera to record it. The camera and film were confiscated by the police. Tewkesbury was regarded as a remote yard in a safe area. Somehow it escaped the bombing that struck the Vale towns at the foot of the Cotswold hills, and the stray bombs that fell around Bredon.

From this inland port the harbour defence launches left the Cotswolds down a slipway above Healing's Mill, down the Avon into the Severn and on to Sharpness canal and the open sea to do duty with the Royal Indian Navy, Australia, France, Palestine and Turkey. All survived the war. Although the German raiders passed regularly along the Vale, the only disruption to production was that of serious flooding, which has beleaguered the low-lying plain of Tewkesbury since time began.

The Gloucester Railway Carriage and Wagon Company turned its skills from the railway rolling stock, which the Government closed down at the outbreak of war on completion of existing contracts, to military manufacture and produced its first Churchill tank by July 1941, and a further fifty-three by the end of that year. Some 764 Churchills left the works by the end of the war.

Early in 1940 the Port of Gloucester had handled the highest tonnage since 1913, despite the impact on imported timber owing to the disruption of trade from the Baltic and White Sea ports. With an eye to the future and prosperity of peace, the Port Directors obtained from the Government their co-operation to expand and equip the port with additional berthing to speed up the handling of cargoes. *Gloucester Labour* News complained in May 1940 of 'talk of dismissals of many skilled workers from a large local engineering factory on account of shortage of work'. And in the same issue decried the wartime permits that allowed apprentices to work *overtime*. A few months later it reported that 'a certain local engineering firm is working seven days a week', and pointed out the anomaly of 'during the normal working hours the workers are not allowed to smoke, but during overtime periods smoking is allowed ad lib'. Craftsmen, employed on a

Sunday could, apparently, smoke all day and received 3s. per hour. The weekday workers, who were not allowed to smoke, were paid 1s. 6d. per hour. A sit-down strike, against the management implementing a reduced wage rate for time taken in waiting for jobs to be finished elsewhere in the factory before they could do their bit, brought victory to the sitters-down.

'Music while you work' was encouraged in factories throughout the land, as Kathleen Field remembered when working at Newman Hender. Fuses for the army were made in the bond shop — that much the workers were told. It was not until April 1945 that the women who made the detonators which fired the shells could appreciate the power of their work. They were given a demonstration by the Royal Artillery firing a battery of four 25-pounder guns.

Factories throughout the region answered the call for versatility with promptness and efficiency. The then small factory of H.L. Godwin in the

A Churchill tank, a product of the Gloucester Railway Carriage and Wagon Company, preceding Queen Mary's car on her tour of the company.

village of Quenington, so famous for its windmill pump that it became known internationally simply as a 'Godwin', turned out work for the Oxo factory when it was bombed. Production during the war years also extended to machine gun nozzles and mountings.

The pin-making factory of W.H. Cole and Son switched to aircraft sub-contract work, where an elaborate system of roof and side window blinds allowed work to be carried out in a reasonable amount of transmitted daylight for the manufacture of Hawker Typhoon, Tempest, and the Gloucester Meteor elevators and pilot ejector seats.

The war marked the end of the grand country estate of Cowbridge at Malmesbury; no longer was it to be the seat of noble and illustrious families — the last of which, Sir Philip Hunloke, became Sailing Master to King George V. When Sir Philip put the estate up for sale in 1939 it fulfilled all the criteria needed for the company of Eric Kirkham Cole — whose initials became a household name of EKCO, appropriate for a business involved in radio and sound waves and, the latest technological craze of the late 1930s — television sets. The company moved from Southend to Malmesbury and Cowbridge House became a War Factory. Internally, the house became customized for the purpose, and workshops and assembly plants were built on what had been beautiful terraces and lawns where, in happier days, dances were held and croquet played. Top secret drawings,

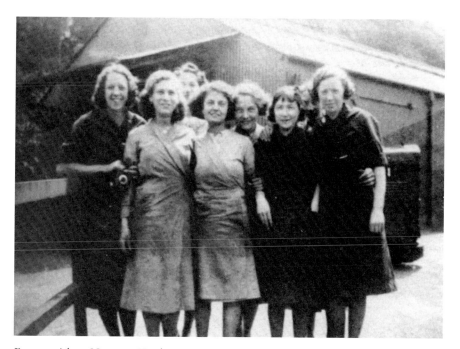

Factory girls at Newman Hender.

transferred to specially prepared pure Irish linen using pen and Indian ink, were carefully protected by those working in the conservatory with its notorious leaking roof — one woman just carried on with her work under an umbrella during a storm.

The German air ship Graf Zeppelin had carried out a reconnaissance flight over the south and east coast of England to discover what wavelength was being used by our listening stations. Radar was still very much in its infancy, but was researched and developed at Cowbridge under strictest security to play such a vital role in the war that the outcome would have been a different story without it. Despite natural screening by its position surrounded by trees and cautious camouflage, the fact that Lord Haw Haw had broadcast that the Luftwaffe knew the whereabouts of the factory and that they would 'Pay it a visit' made EKCO workers more than a little apprehensive, especially when Derek Stratton saw a German plane drop flares near their home at Crab Mill in Lea — the target obviously being nearby Cowbridge House.

'Cats Eyes' Cunningham, as Wing Commander John Cunningham was popularly known, was every war-time schoolboy's hero — a super star of the skies. The first man to shoot down an enemy aircraft using Radar, Cunningham was dubbed with his nickname as part of the Air Ministry propaganda, attributing his exceptional night vision to his unusually high consumption of carrots. 'Eat up your carrots so that you will be able to see in the dark' became a household homily, quoting 'Cats Eyes' Cunningham as living proof — and detracting attention from the technology of the newly invented Radar. The visits to EKCO by this handsome celebrity class pilot to see for himself the progress on the Radar front was a great boost to staff morale.

Workers' Playtime, the popular radio lunchtime concerts, which ran from The Blitz to The Beatles era, was another morale booster and caused great excitement when the stars of the day came to EKCO, although in keeping with the security regulations the location was never disclosed: it was always 'From a works canteen somewhere in Britain'.

Malmesbury's population doubled as a result of the factory at Cowbridge House, and as the home situation worsened the workers were often referred to as 'unwelcome visitors'; every shortage from cosmetics to fish and chips and cinema seats being blamed on their numbers. Maurice Lipman as Works Manager accused the local town of being very feudal, but very conscious of the situation he invited the much respected social research organization, Mass Observation, into the factory hoping to learn from their reports how he could help lift morale and boost output.

Only four people knew the true identity and purpose of the 'unskilled workhand' who had first worked for Mass Observation just prior to the

outbreak of war, distinguishing herself reporting on the London Blitz whilst working 'under cover' as a 'Nippy' as the waitresses were known. Celia Fremlin was well aware that all spontaneity and the true picture would be lost if the other workers knew the real reason for the image she promoted as being a compulsive letter writer whilst, in fact, she was writing notes on conditions, hours of work, attitudes of both management and staff and everything she considered relevant. 'Using a writing pad perched on my knee during tea breaks and slack periods, I would start the page with "Dear Emma" or "Dear Sammy" or whatever, and proceed to record dialogue as continuous prose, without capitals, punctuation or quotation marks, which renders it almost unintelligible to the casual glance', she explained. Neither the factory nor the town is named in her book published as *War Factory* in 1943, although both are easily recognized by anyone who knew them well at that time. The upheaval and social tension about to be endured by both the EKCO staff and the townsfolk of Malmesbury were astutely observed by the author and appear in the opening paragraph. 'In a tiny country town of ancient cottages and winding streets, with traditions going back to Saxon times, there has suddenly sprung up in a matter of months, a modern war factory employing nearly 1,000 people staffed mainly by brisk town-bred men who have no connection with the locality.'

Over 500 men and women throughout the country kept personal diaries between 1939 and 1955 which they sent to Mass Observation. Of these, ten men aged between 18 and 64 whose occupations ranged from student, clerks, postal sorter, RAF site clerk to letterpress machine minder, and three women — an 18 year old garage assistant and under gardener, a 52 year old nurse companion and a 54 year old housewife — recorded everyday life in Gloucestershire during the war years. They all form an invaluable social history of what life was really like at that time — a different picture in many cases from the official propaganda powered press reports, and are now part of the Special Collections Archive as a public resource held at the University of Sussex Library.

Gloucester Aircraft Company expanded rapidly in the five years leading up to the war after Hawker Aircraft Company took it over. The floor space spread over nearly one million square feet and production of Hawker aircraft — Harts, Audaxes and Hurricanes joined the famous names of the Gloster Gladiator and Gauntlet fighters to leave the Brockworth factory. Britain's first jet aircraft was conceived at Brockworth, but spent most of its gestation period in heavily shrouded secrecy at the factory's dispersal works at Regent's Motors in Cheltenham; the Gloster E28/39 had its first official flight in May 1941. The twin-jet Meteor was well on the production line by 1944, and the Hawker Typhoon became a major

part of the Gloster's work, to be followed by the powerful Javelin.

A visit by the King and Queen on 10 February 1940 to Gloster Aircraft factory was seen as setting the royal seal of appreciation on the vast war effort made by the thousands of workers at Brockworth. Their Majesties were said to 'be deeply impressed with the wonder planes they saw being assembled'. The Queen was reported as showing a special interest in the work the girls 'in their brightly coloured knitted jumpers standing out against the drab overalls of their men colleagues' undertook — the delicate kind of assembly which 'their deft fingers are particularly suited to'. On 21 October 1940 the factory received a visit from a lone raider during the lunch hour. Several bombs were dropped around in the fields, but one fell with deadly accuracy on No.7 machine shop killing and injuring several workers. An earlier attempt to target the works in August missed, but a return raid in 1942 on Easter Saturday brought destruction on a devastating scale to the Gloster Aircraft works, its workers and neighbours: six bombs claimed the lives of eighteen people; three of them children, including an eleven-month-old baby in a nearby house. Between 150 and 200 people were injured in varying degrees of severity; damage to the factory was extensive, some buildings totally destroyed and fires from the blast raged for hours.

The posts which supported the camouflage, which entirely concealed Smiths Industries Works during the war, can be clearly seen here during a fire-fighting drill (Courtesy, Smiths Industries).

Camouflage, ingenious in its design and intricate in its making, covered the whole of the Smiths Industries factory at Bishops Cleeve near Cheltenham as soon as it was constructed. The entire site was covered with wire netting supported by telegraph poles. The netting was angled down to ground level on the outside and covered completely with chicken feathers. These were painted in natural colours to blend into the countryside. To complete the illusion from the air that the area was but part of the farming terrain, a dummy stream was painted on the top. There was a slight problem when nature put down her tenacious roots and grass started spurting up through the paint of the stream — but this could not have been detected by the marauding enemy as the factory escaped unscathed. And there was never any evidence that it had been discovered and targeted.

The attacks Smiths did suffer were verbal, and published by the locals strongly opposed to what they saw as despoiling that area. The news that a huge new factory, providing work for thousands and a big housing development, plus an aerodrome for the use of the firm, was to be built on Kayte Farm at Bishops Cleeve, was published in the *Gloucestershire Echo* in April 1939. The feature made front page news opposite the lead article that stated 'Hitler Ends Naval Pact With Britain — Herr Hitler Does Not Want War With Britain'.

'Englishwoman' was the first to object. Not to the idea of having a factory which was much needed in the area — but the spoiling of Bishops Cleeve. 'One of the Unemployed' gave his case as loving Cheltenham as much as the employed or retired, but preferred having a factory to provide immediate work than waiting for six months for a good meal to grow at Kayte Farm. 'Disgusted' made a vitriolic attack not only on the decision to spoil the lovely approach to the racecourse, but against the unemployed which 'is their fault. Why not give them the job of keeping every street clean'. And the workforce expected from Cricklewood to start up in the new factory would be to 'bring all the riff-raff to work and live in working-class houses'. This, 'Disgusted' warned the *Echo* readers, would 'keep any newcomers from settling in Cheltenham, and the colleges would suffer as the children would be taken away by parents fearful that a factory would attract air-raiders'. Another 'Unemployed' asked 'Disgusted', through the courtesy of the editor, if he thought the raiders would stop to admire the scenery while on their way to litter the streets of Cheltenham with more than paper, and reminded him that residential places were destroyed as well as factory towns in the last war. (And this proved to be the case again as Cheltenham was bombed and the factory left unscathed.) Further, he noted that 'Disgusted' was really categorizing Cheltonians into three classes of people: Unemployed, too proud to work; Riff-raff, too poor and have to work; and dividend-chasers, too pretty to work.

The factory had its first unit built by May 1940. Production under the new company, S. Smith and Sons (Cheltenham) Limited, had already been set up in Cleeve Grange for the hairsprings needed for the special aviation clocks. The hairsprings had previously been imported from a German firm; the acquisition of the vital diamond drawing dies and design data for them involved the Company Secretary, Ralph Gordon-Smith, in a hurried visit to Switzerland just days before war broke out to collect them from a pre-arranged handover point after being brought out of Germany, across the border, by car. A complex of mobile homes mushroomed over the Grange lawns and tennis courts as temporary accommodation for the key personnel from the firm's factory in Cricklewood. An old army hut was procured and set up as a shop; toilet and washroom facilities were installed in the stables. Conditions were harsh for the newly evacuated workers from Cricklewood: their first Christmas morning spent at Cleeve was a cruel awakening to the fact that many were actually frozen to their bedding. A particularly hard frost had frozen the condensation which had run down the internal walls of the caravans on to the beds. Other luckier ones had been found rented digs in town, but until they could be supplied with bicycles they had to walk each day to and from the factory from Cheltenham as public transport was at a premium.

Priority was given to build fifty-two houses off Gay Lane and the first ten families moved in the new Meadoway Estate in March 1941. Further houses followed, and spearheaded the Bishops Cleeve Housing Association, which became virtually a company village built for Cheltenham employees. In the course of expansion the tiny post-war village of Bishops Cleeve lost its racecourse garage and The Newlands pub from the crossroads on which the main entrance is now situated.

Work buses were later run for employees living as far afield as Evesham, and, until sufficient houses could be built, further accommodation was provided at a hostel built in 1942 in Stoke Road run by Butlin's Holiday Camp, complete with the famous 'Wakey, Wakey' morning call. The neighbouring aerodrome in Stoke Road provided plenty of Hotspur glider training to watch and weekend dances; some still yearned for their home town life though and cycled up to London and back rather than waste precious off-duty hours waiting for erratic time-tables and overcrowded trains. Smith's collective output was a staggering 61 million speedometers, meters and various gauges; over 10 million aircraft instruments and mechanisms; 4 million clocks and escapements, and 24 million hairsprings.

Not so fortunate to escape the attention of the air-borne enemy was Parnall's factory at Yate. An aerial photograph of the site had been taken in August 1939 by a German spotter, and full details of it and the fact that Flugzeugzellenfabrik Parnall Aircraft Company Limited, Yate (7451) was

the main producer of power gun turrets for bomber aircraft, were found with the map in the Luftwaffe files.

Although outside the definition of the Cotswolds, Bristol Aircraft Company at Filton, home of the twin-engined Bristol-type bomber later known as the Blenheim, attracted a great deal of enemy action. And blazing signals that Bristol had suffered intensive raids could be seen clearly from Stinchcombe Hill; fire service and rescue squads often went from Dursley and Wotton-under-Edge to Bath and Bristol to help in the aftermath of air raids.

A top secret underground military base, that was the central ammunition depot serving the majority of southern England, was opened in 1942 to include an emergency aircraft factory as a back-up in the event that the Bristol factory was destroyed. Deep under the southern Cotswold hills between Chippenham and Bath, it is estimated that some two million tonnes of stone had to be removed to build the huge complex which housed a number of factory units, offices and canteens for the workers whose access to it was by way of a secret branchline which split from the main rail line underneath Box Tunnel. One of the engines produced at the underground factory was the Bristol Centaurus IV.

The first woman, and possibly the first person, in Gloucestershire to receive the George Medal at the hands of the King in 1941, was Miss Bobbie Tanner of the Old Rectory, Edgeworth. The award was to mark her conspicuous bravery in driving relentlessly through London's worst blitz with petrol to replenish the fire engines. The report on her investiture said that 'she probably found her dash into the blitz an exciting substitute for a dash over Cotswold fences on her roan mare'. At the same ceremony, L/AC George Gill of Cirencester was awarded the BEM for rescuing a pilot from a burning plane.

Another Cirencester native, John Mills, found himself pictured in a number of London papers in October 1940 above the caption, 'a workman using a sieve to sort stained glass from the wreckage of windows blown out by the blast of a bomb on Westminster Abbey'. Mr Mills had followed his father's craft as mason on Earl Bathurst's estate prior to his move to London on permanent restoration of the Abbey. The press commented on Mr Mills's 'Cotswold doggedness and tenacity of purpose' for an accident three years previously had severely injured his leg, but he had returned to work confounding the opinion of several surgeons who had said he would never walk again.

Mr. F.R. Hooper, a Gloucestershire invalid, was also held up as an example of Cotswold perseverance in the face of adversity for the war effort. Press restrictions could not give Mr Hooper's exact address or to which aeroplane factory he hand-drove his invalid chair eighteen miles

Doing 'your bit' was aimed at everyone to help the war effort and support the Services.

# A COSY PULLOVER for an A.R.P. WORKER

AIR RAID
SHELTER
←—‹‹‹

W ITH the No. 11 needles commence at the lower edge of the back by casting on 130 sts. and work in ribbing of k. 1 and p. 1 for 3 in., dec. 1 st. at the end of the last row (129 sts.).

Now change to the No. 8 needles and work in pattern as follows :

1st pattern row (right side) : * K. 2, p. 2, k. 1, p. 2, k. 1 ; repeat from * until 1 st. remains, then k. 1.

2nd pattern row : * P. 2, k. 2, p. 1, k. 2, p. 1 ; repeat from * until 1 st. remains, then p. 1.

3rd pattern row : Same as the 1st row.

4th pattern row : Same as the 2nd row.

5th pattern row : P. 4, k. 1, * p. 7, k. 1 ; repeat from * until 4 sts remain, then p. 4.

6th pattern row : K. 4, p. 1, * k. 7, p. 1 ; repeat from * until 4 sts remain, then k. 4.

7th pattern row : Same as the 5th row.

8th pattern row : Same as the 6th row.

Repeat the last 8 pattern rows over and over again until the back measures 15 in. from the commencement, then shape the armholes.

At the beginning of the next 4 rows cast off 3 sts., then dec. 1 st. at both ends of alternate rows until 105 sts. remain.

Now work in pattern until the back is 23 in. long, ending with a right side row.

Next row : Work across 34 sts. in pattern, then loosely cast off 37 sts., pattern to end of row.

Now work one shoulder at a time, casting off 10 sts. from the armhole edge in alternate rows, meanwhile dec. 1 st. at the neck edge in every row, fasten off.

Rejoin the wool to the neck edge of the other side and work to match.

## THE FRONT

Commence and work as for the back until only one row is left to work before commencing the armholes, then work as follows :

Next row (wrong side) : Work across 41 sts. in pattern, loosely cast off 47 sts., then pattern to end of row.

Work one side of the front at a time, continuing in pattern and shaping the armhole by casting off 3 sts. at the beginning of the next row and of the following alternate row. Then dec. 1 st. at the armhole edge in alternate rows for 6 times (29 sts.).

Now work in pattern without shaping until the armhole corresponds in depth with the back armhole, ending with the wool at the armhole edge.

Now shape the shoulder by casting off 10 sts. from the armhole edge in alternate rows twice, then cast off the remaining sts.

Rejoin the wool to the inner edge of the other side and work to match.

## THE SLEEVES

With the No. 11 needles, commence at the wrist by casting on 54 sts. and work in ribbing of k. 1 and p. 1 for 4 in., inc. 1 st. at the end of the last row, making the sts. number 65.

Now change to the No. 8 needles and work in pattern, inc. 1 st. at both ends of every 6th row for 18 times (101 sts.).

Continue in pattern without shaping, until the sleeve measures 19 in. from the commencement, then shape the top. Still in pattern, dec. 1 st. at both ends of every row until 29 sts. remain, then cast off.

Work the second sleeve in the same way.

## THE SCARF VEST

With the No. 8 needles cast on 60 sts., work in single ribbing throughout. Work 1 row in ribbing.

Next row : Rib until 10 sts. remain, then cast off 4, rib to end.

Next row : Rib 6, cast on 4, rib to end.

Continue in ribbing for 4 in. from the last buttonhole, then make another buttonhole at the same edge as before.

Continue in ribbing without shaping until the work is 27 in. long from the commencement, then cast off in ribbing.

## MAKING UP

Pin out each piece face downwards and press with a hot iron over a damp cloth avoiding all the single ribbing.

Sew together the shoulder seams, and sew the sleeves into the armholes. Then sew the vest into position, letting the cast-on and cast-off edges completely overlap each other and take particular care that the unstitched edge turns out over on to the right side so the sweater is to form a collar, and the button holes are on the left side.

Press the seams while the work is flat, then sew up the underarm and side seams. And finally sew on the buttons to match the buttonholes.

---

### MATERIALS
*You will require 14 oz. of Sirdar Majestic Wool, 2 pairs of Strainoid knitting needles Nos. 8 and 11, and 2 buttons a little larger than a shilling.*

### MEASUREMENTS
*The sweater measures from the shoulder to the lower edge 23 in., the sleeve seams 19 in. long, and chest measurement 38-40 in.*

### TENSION
*The knitting worked with the No. 8 needles produces about 7 sts. to 1 in. in width and about 8 rows to 1 in. in depth.*

---

15

War-time knitting pattern.

each day, 'leaving his pretty little villa home at 5 a.m.' Driving his chair at 8 mph through the crowded traffic of cyclists and buses meant an eleven-hour day and hard work hand-driving the 1,200 miles he had travelled to and from his job in four months.

The heavy work in munitions factories earned praise, too. In one works it was reckoned that the women were lifting about 180 gun bodies a day, totalling something like half a ton in weight. And one joked that 'it was easier work than a hard day's washing'. As women were called on more and more to fill the place of men called into armed services, war nurseries were started: Cirencester had their first in the Querns House and later in the Abbey Way in a single storey bungalow; Gloucester opened a nursery centre in the cathedral precincts specially for the children of mothers on war work.

The part played by the Women's Institute extended much wider than knitting and jam making. Gloucestershire Federation had been requested by the Government to grow in this county 25 ton (25 tonne) of onions and 15 ton (15 tonne) of outdoor tomatoes, in addition to the amounts needed for their own households to be as self-sufficient as possible. When Frank Davis, a shunter at Kemble station, suggested to his daughter Violet that she might try for the job as a railway passenger guard she pursued the idea with all the enthusiasm of a seventeen year old. The alternative of working in munitions did not appeal to her half as much as continuing the family tradition; her grandfather was a navvy who helped build the Sapperton Tunnel. Violet recalls some of the memories of her total war years' service as guard on the Cheltenham-Honeybourne run:

During my training I was treated exactly the same as the men. The only thing the women did not do was to work straight through the night. My uniform was a tunic top and a choice of skirt or trousers. I chose the latter because of climbing up and down into engines or the guards van. My round cap said Guard in gold braid across the front. I had a large watch with GWR on the front, it was in a stainless steel case, a very loud whistle, a lamp which was lit by a wick and smelly paraffin — we had to clean our own. You flicked the handle round and it had three glasses in red, green and clear. Two flags, red and green, which I kept in a leather bag which I got secondhand from somewhere, and stitched two straps on the side to hold the flags. We also had an issue of five detonators, a rule book, and road notices which were the speed restrictions. Sometimes I used to climb on the engine and have my egg and bacon cooked on the steel shovel in the firebox, also a brew of tea in my enamel mug which I carried everywhere. I can still recall the smell of the Jeyes fluid, which was used to clean the footbridges and platforms, and the dank smell of

early morning through the high banks of the Forest of Dean. The salmon fishermen in their coracles on the Severn was a sight of early morning on the Gloucester train. The banks were full of wild flowers — it was truly God's Wonderful Railway.

I was married at nineteen and widowed with a young son to look after and returned to pick up my job. Everyone was very kind: farming families on the local runs in the Stroud Valley got to know me and helped supplement our rations with a rabbit or eggs and the lovely Blaison red plums. Troop trains full of Americans meant cigarettes and chewing gum, lumps of sugar and a rare treat of nylons. A sailor once gave me two lemons — precious things at that time.

A moving train was always a potential target so I had to check every carriage to make sure the blinds were down. It was all so dark in the winter. I could tell where the train was by the sound of the wheels on the ballast and in the cuttings and tunnels. I had to lean out of my window at the small halts and swing my light on white to help the driver know exactly where to stop. Then back again after the country folk had got on or off. In the black-out I had to shine the lamp in my face so that the driver could see it was me. Often we had to do a turn collecting and punching tickets. I remember talking to a very tall elegant lady by the ticket gate at Gloucester for quite a while; she said her name was Miss Bowes-Lyon. She must have been a relation of our royal family. We carried everyone and everything. In my van I had muzzled dogs, baskets of pigeons and even coffins. I once had to collect and sign for a secret document, sealed with a big red waxed stamp, and take it from Hereford to Aldermaston. The prisoner of war trains always pulled up in the middle road of Gloucester Station with the blinds drawn. Some of them did work on the railway on very menial tasks. They were very conspicuous in their brown overalls with a large orange circle stitched on the back. When they called after us girls we would just cock a snoot. I think I was probably the youngest of the seven lady guards at Gloucester during the war period.

Gloucester had the first railway van woman, employed by the London Midland & Scottish Railway as a carter. Miss Vera Proctor, a farmer's daughter from Broadway, began working in the railyard at Evesham and offered to drive the horse rail van. It was believed to be the only instance of a woman being a railway carter in September 1940.

The Government in turn took the step of bringing forward in wartime the decision, for which some 100,000 spinsters had campaigned tirelessly for five years, to give them equal rights with married women to receive their pension at sixty, instead of being forced to work until sixty-five, as

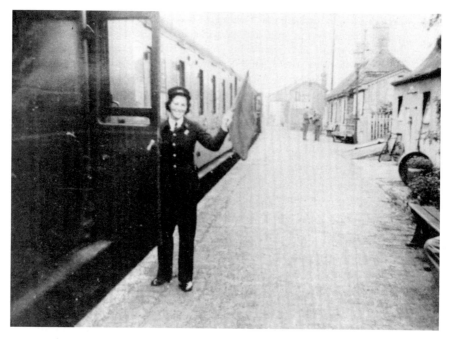

Mary Butler at Fairford Railway Station, one of the first and youngest, women guards to be employed by the GWR during the war.

had been the case formerly. The male-dominated *Gloucester Labour* News warned that once the first score of Hitlerite Germany was won, there were 'a few deep-laid scores to settle at home' and looked forward to taking up the political cudgels as soon as the next General Election could be staged. Until that time they made do with as many prods at the other party as came to their notice.

## SAVING AND SALVAGING

Saving and salvaging became a national preoccupation, spurred on by intensive advertising: the do's and don'ts and why's faced the public from every conceivable point, and a great quantity of paper was used in telling everyone not to use it unnecessarily. Supported by staggering statistics, the crime of waste or imprudent use took up nearly as much space as hard facts on the war itself. There was a Paper Controller who urged the public to save the newspaper in which they were reading his messages — for salvage.

School log books are punctuated with figures of their individual collections and the schoolchildren of Kempsford and Dunfield went

regularly on the last Sunday of every month with Mr Akers, who provided a horse and cart and his son David, to collect from the villages. Work did not stop there. Their methodical sorting into sacks ready for the District Council's contractors to take away revealed a bottom set of false teeth!

Esparto grass, the essential raw material for paper used in book production, was imported at a rate of some 272,000 tons in 1939; three years into the war there was none, and paper-makers were forced into using home-produced substitutes such as straw and salvage. In 1941 the government's aim was to salvage one ton of waste paper per thousand people and this led to great deal of indiscriminate turnout of books to be pulped for their paper. It then became apparent that many volumes were irreplaceable and no thought had been given for the reading needs of the Services and public libraries which had lost their books in bombing raids. 'Hurl your books at the foe' was a popular slogan to encourage donations for 'A Mile of Books' campaign in 1942, and inter-town rivalry developed as to which community could collect the 'Longest Mile' or the largest number of volumes. Cheltenham reached a grand total of 141,000 books, well beyond Oxford's 34,000 by July. By May 1943 Oxford had made massive moves to increase their total and some 400,000 books had been collected, of which 41,000 were directed to the Forces.

The Bodleian Library at Oxford, who had also received a good number of the donated books, administered a type of international library loan system, under the watchful eye of the Warden of London University Hall of Residence, for prisoners of war. From the beginning of 1940 the Geneva Convention's rules of POWs having the right to receive parcels of 'comforts' through the Red Cross organization, was extended to include educational books on request. C.S. Lewis and J.R.R. Tolkien, two of Oxford's most prominent academics and literary figures, were on the advisory panel for the Educational Books Section of the Red Cross and compiled an honours-level degree course in English, volunteering to mark examination papers sent from German prisoners-of-war camps. The principle of allowing examinations to be taken in POW camps was agreed between Britain and Germany in the Autumn of 1941 — but not by the Italians. Interestingly, Hitler's private library was estimated to contain 16,300 books. Post-war discoveries of his literary horde, some 3,000 of which had lain hidden in a Bavarian mineshaft, revealed an eclectic taste in his reading matter – from the inevitable obsession with the Jewish race, military histories and strategies and the occult to something like a ton weight of penny dreadfuls!

Laurie Lee, the Cotswold writer who was to achieve world-wide literary acclaim for his classic recollections of his Slad Valley childhood, together with Charles Lamb and Cecil Day-Lewis, were employed by the Ministry Publications Division which had a substantial brief for commissioning all

books, leaflets and pamphlets required for the work of the Ministry. In 1942 it was recorded that the War Office alone used more of the restricted paper allocation than any other Service or Ministry.

It is interesting that in an earlier age it was a Cotswold antiquary and bibliophile, Sir Thomas Phillipps who lived at Middle Hill near Broadway, who saved for the nation vellum manuscripts that were being sold off to goldbeaters, tailors and glue-makers for use in their trades irrespective of the literary value in the mid-nineteenth century. Phillipps overspent his considerable wealth to amass the largest ever collection of books and manuscripts, the sale of which, at his death in 1872, took several days and attracted buyers of governments from the Continent to buy back important manuscripts relating to their countries.

The Village Dump Scheme was abandoned by the Ministry of Supply in June 1941 for other scrap materials, and merged with the Rural District Councils' salvage scheme. Dumps had been a scavenging centre for many people during the war years when American troops arrived in the area — for they were known to throw away what British people could not get, including tins of food. Wooden packing crates, discarded clothing, oranges and Spam could be salvaged by those willing to ferret among the foul-smelling piles of smouldering and rat-infested dumps. Dumps were created for scrap metal which was so much in demand for manufacturing weapons, vehicles, aeroplanes and munitions. Again, this was something to which the public could relate; many a housewife sacrificed a saucepan or colander at the thought of its metamorphic form as part of a gallant little Spitfire defending the skies above her family, in less desperate times she would have extended the life of her pans with a pot-mender — the twin metal circles which were screwed together each side of a hole to patch a pan.

As a strange kind of retaliatory justice, parishes who had spent their rate-payers money on purchasing German guns captured from the First World War, to stand as a reminder of 'the war to end all wars' in some prominent place in the town or village, donated them to the national scheme to help destroy the homeland from which they had come a mere two decades before. Fairford decided to turn over its German gun in June 1940. It had stood for some twenty years on the London road on the verge of the triangular gardens of Croft End Cottages. Its vacated site, Lady Hirtzel said, would be an ideal spot to which the dump that stood on the opposite little triangular patch, at the entrance to her home at East End House, should be moved. The Parish Council replied that the dump was more suitable where it was, and had the iron railings in the High Street added to the mounting pile. The town was very proud of its gas lamps, however, having its own Gas Works from the mid-1800s, and the Parish

Council voted to pay 10s. per lamp standard to the Swindon United Gas Company to cover the whole period of the war for taking down, storing and refixing. Like the paper mountain, the scrap iron dumps proved to be more difficult to clear for the purpose of getting the material where it was needed. Bones were kept separately as they made munitions and fertilizers. In the first two months of war the nation had garnered some 80,000 tons of scrap metal to hurl down on the Germans.

Gloucestershire undertook a survey scheme of its own and miles of wrought iron railings were uprooted in a vigorous assault prodded by the Ministry under what became known as a voluntary scheme. Cheltenham donated her two Crimean cannons which stood outside the Queens Hotel, and donated them along with the railings round the Montepellier Gardens, those in front of the Municipal Offices in the Promenade and round the Winter Gardens.

Cirencester had censored the War Office Trophies Committee, which had been set up to offer items of captured German ironmongery to towns and authorities throughout the land at the end of the First World War, because it had not provided the cannon which they had applied for. The Urban District Council took begrudging delivery of the one machine gun (damaged), although complete with ammunition box and belt, rather than have no war trophy. And sent its workmen out to rip out railings around the town for their contribution to the second war with Germany.

Regency Cheltenham was spared the rape of most of its wrought iron balconies and porches. Their salvation was due to the fact that they were actually attached to the fabric of the buildings, not for any aesthetic or architectural merit. Tons of Regency wrought ironwork of unique design and delicate craftsmanship were ruthlessly removed for scrap from other parts of the Cotswolds.

Not all railings were of ornamental value only; most, such as at Shipton-under-Wychwood School, were substantial boundary fences. The Bishop of Gloucester wrote in the Gloucester Diocesan magazine that although a faculty would be needed in a few dioceses to remove iron railings from churchyards and from graves, he would be only too pleased to get 'rid of the many unsightly railings which, in some cases, disfigure our churchyards'. Another correspondent held the view that such railings were superfluous anyway: 'Since those who are outside don't want to get in, and those inside can't get out'!

The euphoric sense of urgency and satisfaction that it was all so vital to the war effort dissipated as the months went by and travellers on the Cheltenham to London railway saw great mounds of railings rusting within view of the line. Suspicion smouldered into frustrated fury as rumours were circulated of massive dumping of the beautiful ironwork

in an isolated field. Just how much was used and how much was, in fact, sacrificed to a scheme to keep up the drive as a kind of morale booster — and even ended up as an embarrassing response or over-zealous effort, will perhaps never be really known.

The so-called voluntary scheme of railings turned even more sour as the compensation rates were worked out by those who had so willingly contributed them for the national cause. Compensation was payable under the Defence Regulation 50 B (4), and was dealt with by the Ministry of Works. The true cost of their contribution was that an average householder lost about 2 cwt (101 kg) of railings. Compensation was at 25s. a ton (as they had no secondhand value as scrap material); therefore Mr and Mrs Average received 2s. 6d. for their rails, plus secondhand rate for their gate (valued at time of severance). The gate would therefore give them 25s. However, the cost of replacing the contributed rails and gate with new ones, at the end of the war, 'of simple design' was £11, plus the cost of erection.

## FUND-RAISING AND ENTERTAINMENT

Clubs and associations took root in the wartime on a scale never before known: there was the Horse and Drill Thrift Club; Poulton Slate Club and one for soldiers and their sweethearts, for which de-requisitioning of the Bingham Library in Cirencester was proposed by the Revd E. Wearne. 'I want this scheme to be on a strictly spiritual basis,' said Mr Wearne, 'beside a recreational room there should be an oratory or prayer room set aside for serving men and, to a lesser degree, for their female friends.' Cotswold Sea Cadets vied for membership with established Boy Scouts groups and Red Cross. The build-up of aerodromes and landing strips and airfields brought a new dimension to the Cotswolds, and the thrill of air power attracted the young to join local Air Training Corps. In the usual inter-town rivalry, the news that Fairford was hoping to raise a Flight, prompted a Cirencester correspondent to write in the local paper: 'I am glad to see that for once Cirencester is ahead of Fairford, for while Fairford is hoping to raise a Fairford Flight of the ATC, Cirencester Grammar School has a Flight already in being and only awaits official recognition'. Bourton's Services Club was officially opened in January 1940, to which the Bourtonians con-tributed billiards, darts boards and table tennis equipment.

The purposes of the many clubs throughout the region were two-fold: primarily to provide recreation with training, and to have a body to raise funds for the war effort. The national drive to get the public to respond to the War Loan Securities offered in the first three months of the war

exceeded all expectations. National Savings Certificates and Defence Bonds were bought to the tune of £9,125,000 in the first week, and ways to keep the nation investing in the war effort exercised not only the politicians' minds, but local organizers anxious to get spare pennies out of the public pocket to help their individual campaigns.

By December 1939, the figure quoted by Sir John Simon was that the expenditure for the war was running at £6 million a day. In the face of such statistics, the Civic Fathers of Cirencester took the unprecedented step of Grundyism in the extreme and requested the supervisor 'to speak to the police about discouraging carol singing — the children pestering for pennies from door to door when the householders have been already called upon to give generously to other funds'.

The exteme frost that hit the Cotswolds in January 1940 was turned into a fund-raiser, when Earl Bathurst allowed his frozen lake in Cirencester Park to be used for moonlight skating, raising nearly £14 for the Red Cross Funds. One shilling was charged for skaters and sixpence 'for just looking on'. Ice hockey was also played and the Red Cross, for whose funds it all was, were in attendance — and netted one broken leg in the two nights of the activity. Fairford collected some 1,700 items at its Hospital Supplies Depot in the Croft Hall in the first year to aid the Cirencester Red Cross unit. The WI held competitions and donated the knitted gloves prize won by Miss Brenda Whiteman to evacuees, then raised their sights to knickers. Funds were set up for cigarettes for the forces. Still, the public were exhorted, 'don't let your efforts slacken'. Blood, announced another authority, was 'the best Christmas present you can give'. In an effort to boost the call for good Cotswold blood, it was published that in the first three months Cheltenham had given more of her blood than anywhere else in the region: some 600 donors had given; Gloucester veins had yielded a further 253 pints; Cirencester 143 and Stroud 77.

It was the hard weaponry of the war machine that really took hold of the Cotswold imagination though. Knitted knickers to keep a few bottoms warm, a few gallons of blood and the transitory comfort of a smoke in the barracks were one thing; the actual ironmongery that could be used to hurtle at Hitler and his henchmen would bring them to book and end the whole wretched business all the quicker. And towns and villages put their heart and being into raising money for war weapons. None was more popular than the Spitfire appeals.

'Shall Ciceter present the Royal Air Force with a Spitfire?' asked the UDC. 'It is about two months ago that the existence of a desire to this end was first recorded in this paper', reminded the *Wilts and Gloucestershire Standard* in August 1940. 'The cost of one of these nippy little fighters which have struck deep terror in the hearts of the Nazis is generally put

at £5,000. Can Cirencester find it?' Obviously a prudent pause here — 'or Cirencester and district'. The latter seemed a better possibility and a subscription list was opened with Polly the parrot collecting the very first coin. Polly sets the ball rolling as a thank you to the RAF, announced the Standard the following week, and Polly said a thank you every time a coin was dropped in her box on the counter of Mrs Lock's bakery in Watermoor Road. Bobbie Tillett, an evacuee with Mr A.T. Cripps, collected 10s. 'from visitors to the scene of a recent German raid'.

Meysey Hampton sent in its contribution with a note that every single villager had given something. Fairford Spitfire Fund raised £29 5s. within two days. Bibury Girl Guides raised £8; 'sheltering in the Corn Hall' £1; ARP control room 17s. 9d. and Miss J. Townsend's 'bun pennies' 10s., added to the Cirencester Spitfire Fund.

Gloucestershire National Farmers' Union declined to contribute as they thought they were big enough 'to raise a fund themselves, not for a Spitfire, but a bomber!' Eastleach preferred to go it alone, too, but with staunch parochial pride and loyalty they wanted their money to go to the anti-aircraft gunmen and searchlight crews commanded by their own Maj. Gen. Goschen. Tetbury opened its fund in October 1940 and raised a total of £500 immediately, thanks to seven-year-old Michael Wood contributing his life's savings of 5s. 8d., and the 11s. sent in from 'Gran, Gran and Little Tim'.

Burford and District announced their £201 had been sent direct to Lord Beaverbrook, and Malmesbury boasted a £10 start from the Capital Burgesses of the Old Corporation for its Bomber Fund. The local Girl Guides decided that they were concerting their efforts to present a mobile canteen or a hut for YMCA use, and to this end a seven-year-old was awarded 3d. for having her tooth out; policemen's boots were cleaned and raised 3s., and 'for teaching church members to skate' raised another 3s.

'Spitfires Up, Mean Nazis Down', Cirencester announced in a desperate Big Appeal: another £4,339 was needed for the nippy little fighter; the closing date was extended; Poulton Pig Club raised a cool £20, and the New Zealanders in Cirencester Park gave a demonstration of their skill as axemen to boost the fund. Reg Grundy the twice world champion axeman and his lusty colleagues felled trees and sliced the trunks into planks with deadly speed and accuracy. 'We didn't come here to cut trees, we came to fight,' they were reported as saying, 'but your Forestry Commission wants timber and while we're waiting to fight that's a job we can do. But when the time comes we shall drop the axe and grab a gun.' No one was in any doubt as to what a formidable chap the New Zealander was with either in his hand. Despite these efforts, the 'nippy little fighter' eluded Cirencester; the final cheque for £1,375 12s. 7d. was sent to Lord Beaverbrook and

prompted a reader in Scotland to taunt 'Stranraer beats Cizeter' — a population of just over 6,000 raising over £5,366 for 'their' Spitfire. Nearer home, Tetbury boasted a final total of £1,820 and an Air Ministry Club, initiating the OFM — the Order of the Friendly Mug. Smiths employees alone at the Bishops Cleeve factory subscribed £6,500 for a presentation RAF Spitfire. Named 'Smithfire', it served with 145 squadron.

Stroud District quietly set about their Spitfire Fund on 16 August 1940 and had raised over £5,000 by 13 September; on 22 November the Air Ministry had approved the name of 'Stroud' to be placed on the aeroplane and 'it was hoped to send photographs of it to the town'. Presentation Spitfires were not 'specially ordered'; but were selected from current production models to bear the name suggested by the donor. The name was marked, according to official instructions, in 4 in (10 cm) yellow characters on the engine cowling, but this ruling was not rigidly applied and some limiting factor was necessary in order not to compromise essential camouflage. Stroud and District, officially numbered P8381, served with three operational squadrons during its first seven months, and was then relegated to use as a training aircraft with Nos. 61 and 52 Operational Training Units. There are some discrepancies in the records between the official lists and the movement card for 'Stroud and District P8381: namely, the official history gives the service from 20 June 1941 as for No. 425 Squadron, whereas the movement card states No. 452 Squadron (as above); it is also recorded elsewhere that it crashed on 11 February 1942, the date of its allocation to 52 OTU, at Babdown Farm,

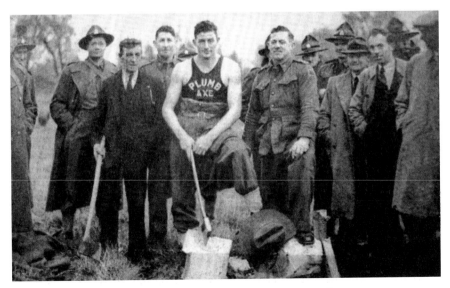

Reg Grundy, champion New Zealander forester at Cirencester Park.

which would make it on its delivery flight. No accident card for it has yet come to light, nor have any photographs (to date).

Probably one of the last Spitfires to be built, and not put into active service, was the renovated Mark 16 with clipped wings which stood for some years outside the entrance to RAF Kemble. There has, for some time now, been a policy not to display the much-loved Spitfire in the open due to corrosion problems, and since 1976, at least, the gate has been guarded by a Meteor Jet, F8 WH 364, in the markings of 601 Squadron.

Perhaps the most salient contribution towards the Spitfire fund came from a local farmer who asked two RAF flying instructors, who were practising take-offs and landings close to his farm, if they could locate his lost sheep. A search party and the local police had failed to find them. The flying 'Bo-Peeps' did, on their very next flight — and the farmer rewarded them by donating to the fund.

1941 saw a massive collective drive of fund-raising for War Weapons Week in June. Dursley suffered a drenching from a thunderstorm which lasted an hour-and-a-half as the parade of 800 assembled. It was the anniversary of the first Red alert, and on 17 June they received their hundredth. The total of all the alerts recorded for the town and its immediate neighbourhood had just reached 1,490. The incentive to make an all-out effort for war weapons was very real. Their target of £100,000 doubled, then passed the quarter million and finally £280,041 14s. 11d. was recorded as Dursley district's total for the week.

Tortworth parishioners contributed nearly £40 per head of its small population in a separate effort. Wotton-under-Edge held a week-long programme, opened by the Duchess of Beaufort, and involved just about everyone in the town from bonny babies, who were entered in Surprise Competitions for an admission charge of a 6d. savings stamp, to the mass and might of all the Services from Girl Guides to the Home Guard.

Stroud raised £80,654 on its first day, which was set off in grand style with a mile-long procession of the fighting and home defence services, and the crowning of the War Weapons Week Queen, Miss Joan Amor. Cirencester collared a real queen to launch its efforts, and Queen Mary became the first subscriber to their fund when, on opening the ceremony, she insisted on paying for the gift tokens presented to her. To aid them in their efforts to make the week as successful as possible, the UDC decided that 'the Rural District was entitled to have its official opening and Fairford was the natural choice for this, as Fairford inhabitants work whole heartedly for any cause they support'. So, the week's work began with a massive turn out of the Services, who, after filling the parish church, formed a solid square outside, 'deeply fringed by inhabitants of the town'. Tetbury had launched their week at the beginning of the month and had first call on the Queen's services, and 'auctioned a Boy Scout' for his

services.

The North Cotswold District Council set themselves the target of £75,000 to buy fifteen Spitfires. Sherborne Home Guards played an Army XI at cricket in the park as part of their contribution, and every resident was requested 'to lend every penny to the nation and not buy anything that was unnecessary'. Northleach RDC raised £130,724 6s. 9d., which, in a strictly agricultural area of 7,400 inhabitants, worked out at £17 13s. per head. A popular appeal to promote savings was devised by Mr Walter Sparkes, the Lechlade undertaker. He made a full-size coffin which he decorated with the swastika and mounted it on wheels, by which means he and Miss Emily Ryman pushed it round Lechlade inviting those who bought a savings stamp to 'drive a nail in old Hitler's coffin'.

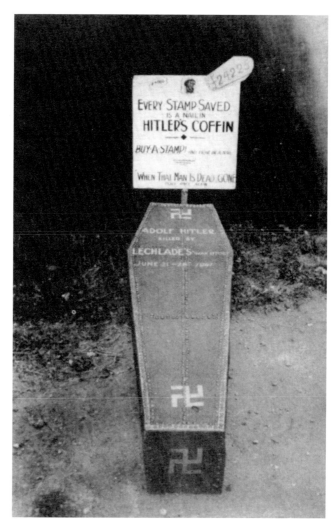

The coffin is labelled: 'Adolf Hitler killed by Lechlade's War Effort June 1941'. Every savings stamp that was bought entitled the purchaser to hammer a nail in the coffin — made by the local undertaker, Mr Sparkes.

'Small savings' obviously appealed more to Cirencester than outright giving: having failed to buy a nippy little Spitfire to present to the nation, the town's name appeared on a Sherman tank as part of the Tanks for Attack scheme, whereby an increase in small savings of over 20 per cent of the amount raised in the corresponding period of the previous year gave towns and districts the privilege of having their name painted on the side of a tank. The size of the tank bearing the name related to the increase in percentage of the savings. Bigger and better was the aim of 1942. War Ships Week brought the small savers digging deeper into their pockets to invest in the war effort: the town lent the Government some £450,000 and received a plaque acknowledging the adoption of a Unity Class submarine to commemorate the prudent savings of the district's inhabitants. HMS P31 became HMS *Uproar* and close ties were maintained between the town and the crew for the remainder of the war years.

Dursley raised £143,727 in the town itself, with a further £109,184 from the district, for the hull of HM submarine *Trident*. Lister's ran a Comb and Cutter Beauty Parlour for and by its employees to raise funds for the various war efforts and its own War Service Fund for its serving colleagues. The Parlour was a secluded corner among the jigs and tools in the blacked-out factory. And, according to the firm's magazine report,

> ... you are tucked into your sheet, and the operator starts the plant by pulling a plug attached to a suspended motor... a proper ½ hp 230 volt affair. He uses the hogging comb first, then the cow clipper, and finally the sheep-shear, and you know how much wool the average farmer leaves on his sheep with one of our sheep-shears! It is somewhat of a novel experience to feel sympathy for a horse, a cow and a sheep all within the space of two minutes! Clinical stories of bits of scalp torn off are apt to shake the nerve, but there is nothing really unusual except perhaps the noise which one customer likened to Waltzing Matilda! After the clipper, another operator finishes you off with scissors, the sheet is removed and you deposit your silver in the box. You rush out with a weird sensation of looking for a hurdle or two to hide in, but for all that feeling a better man. This service, which fills a real need, is carried on by volunteers in their own time. It is a good step up to Highfields and back in time to cut hair before the afternoon shift, but they keep it up. They deserve a big Thank You from many satisfied customers and from the War Services Fund.

By the autumn of 1944, the Combs and Cutters had shorn close on 1,350 pates. By the end of the war, Lister's efforts alone had raised £26,194; some 18,000 parcels of comforts sent out and 2½ million cigarettes, and £3,030 had been sent to the Red Cross 'Prisoners Fund'.

War ships were an unfamiliar concept to the Cotsaller; airfields had sprung up over farmland and introduced him to Spitfires and a whole range of other incredible aircraft, and tanks had rumbled through many towns and villages as troops settled their garrisons throughout the area, but ships belonged to the sea — which was at the very edge of the whole island. However, just to promote the idea more visually, as well as posters and newspaper illustrations, models were constructed to arouse public interest in the largest item of the war machine to which they were being asked to contribute. A model, mounted on a car, was collected from Filton Aeroplane Works in the aftermath of the daylight raid on the works and area, in which 147 people, most of them girls caught in their shelters, were killed. The model warship was driven around Dursley and stimulated the response to the tune of over £250,000.

The trout waters of the River Coln at Fairford added a bit of riverain reality to the town's appeal when a wooden model, floating on old oil drums, was launched on its maiden voyage by the town bridge. HMS *Pride of Fairford* carried the message on its prow 'Cost £425,000. Please Help Pay For Me'.

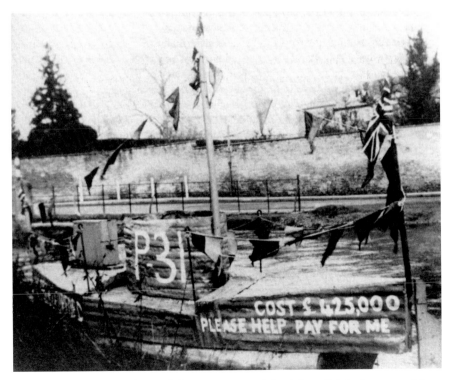

The model battleship built to sail the trout waters of the Coln at Fairford as part of the town's warship fund-raising.

The crew lost a little of its nautical composure and bravado as a real gun was fired through the model's barrel and Bertie Wane fell into the river, much to the annoyance of the peace-loving trout and the delight of the watching townsfolk.

Saving was not confined to salvage and scrap and pounds, shillings and pence alone. Apart from the shortages which made saving on petrol and fuel and light essential, so that in the early part of the war nearly every other vehicle had some quaint 'priority' on its windscreen, rail travellers questioned whether their journey was really necessary, and clergy changed their Sunday Evensong to gather in the flock by daylight to save lighting, there were the country's treasures to safeguard, too. Many art collections found their way to some of the stately homes of the Cotswolds, only to have to be found more secure and secret hiding places when troops and Ministries took them over, such as at Hatherop Castle which was housing some of the valuable paintings from art academies in London, only to find that SOE had been directed there for training. Fairford's world-famous medieval stained glass windows were removed from St Mary's Church for fear of bomb damage. Each window was carefully catalogued as the 600 individual panels of stained glass numbered for identification were packed into crates.

The pride of British monarchial history, the Coronation Chair was taken for safe keeping to Gloucester Cathedral and spent the war years in the crypt, sandbagged and with an electric heater on occasionally to keep it aired. While her husband, Dr Herbert Sumsion the eminent Cathedral organist, was carrying out his voluntary duties as aircraft spotter from the tower of St Michael's Church at The Cross, and wardening around the hospital, Mrs Alice Sumsion recalls taking overseas soldiers and aviators into the crypt to see the Coronation Chair bricked up in its wooden case. When Harry Pearce, one of the Cathedral masons, put the effigy of Robert, Duke of Normandy, on top for safe keeping, too, the architect, Bernard Ashwell, made the notable — and since oft-quoted — remark that the Duke got nearer to the throne of England in the twentieth century than in his own lifetime.

Intangible, but equally as valuable, was daylight. And that, too, was saved. Daylight saving, or Summer Time as it became more widely called, was first proposed in 1908; eleven bills were presented before it was made permanent in 1925. During the Second World War its duration was first extended from 25 February to 17 November 1940, and then made to last all the year round. In 1941, Double Summer Time from 3 May to 9 August was introduced. During all the war years the subject was in contention. The Scots, miners and farmers were generally hostile to the idea.

'The Good Old Summer Time' was the subject of an irate response from a Land Girl, writing in the *Wilts and Gloucestershire Standard* in 1941:

Think of our poor Land Girl, all you great powers who sit on office stools and rule the universe, turning Summer into Winter by a word. Do we favour this extra advanced hour? We do not. We get up at 4.30 a.m seven days a week, month after month, throughout the long winter and tramp across fields to work in pitch darkness, because batteries are scarce, and anyway 'it isn't done' to have a light. We stagger beneath the storm, bitten by frost and snow, soaked with rain, chilled to the marrow, sticking in mud, skidding on ice, and barking our shins in the darkness. In a month's time it will be light! Light! We shall be able to see! We shall creep forth from the dark, chill cow sheds to warm our stiff and aching limbs to drink in the morning light — but no! Mr Herbert Morrison says breakfast shall be at 6, and we must get up at 3.30 a.m. It will still be dark! Then in the evening o'er the sun has properly set and birds still carol in the trees we must go to bed because we have to be up the next morning at 3.30. Bother the war, and down with the Fuehrer — when we give, we give but another hour!

## TROOPS AND REFUGEES

Safe keeping of refugees was in addition to providing a safe lodging for evacuated British children. Lord Baldwin's fund for refugees prompted a 'Support Mother's Day for Refugee Children' in May 1939. The local papers gave space for advertising the appeal for those 'who if not rescued now must drag out their lives under conditions such as no human creature can be expected to endure'. Some of the French and Belgian refugee children and twenty mothers, who had fled before the German invasion, struggled along the roads of northern France, only to get caught up in the siege of Calais, found refuge temporarily in Calais Town Hall. From there, along with wounded soldiers from the British Expeditionary Forces, they were brought by battleship and fishing boats to Britain and settled at Pauntley Court — family home of the legendary Dick Whittington. Mollie Eley, a teacher employed by the British Council, recalls teaching at the hostel established by the International Commission for War Refugees. The British and Allied orphan children delighted in their new home, retracing Dick Whittington's steps of five centuries before when he left his home on the edge of the Cotswolds to seek his fortune and fame in London. The British children attended the local council school and the French-speaking refugees had school in an old mill house, kept by a Belgian

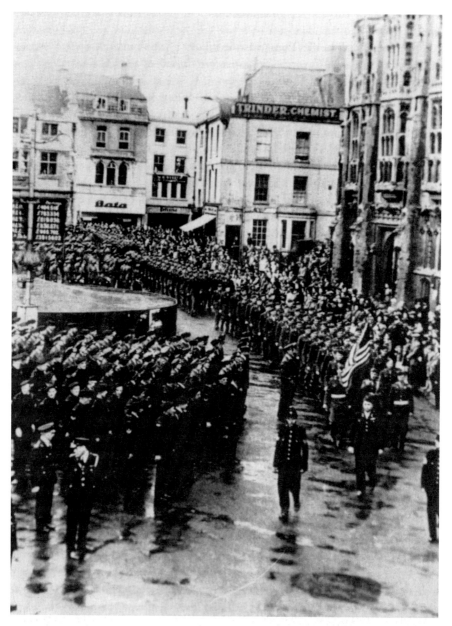

American troops parade in Cirencester Market Place. Note the emergency water supply and fund-raising target board (Courtesy, Corinium Museum).

woman, Madame Pollet. From their top-floor classroom the children had a grand view of the old waterwheel and learnt at first hand the wonders of generating electricity.

In one of her monthly reports which she compiled, in her dual capacity as teacher and secretary at Pauntley, Mollie Eley writes:

> It is rumoured that if one visits 'chez Pollet' at supper-time, one is served with delicious fried eel. The children walk across the fields to school — they all enjoy it enormously. We have had six newcomers this month. The bees are very content, as George has been seen doing strange things under a veil, with a cortege of small boys behind him, so we are assured that there will be pounds of honey for us soon, so all is well. We have been eating home-grown radishes, cress, spring onions and cabbage and we hope there will soon be some peas. Last night Madame Lefevre had a grand surprise when her son Jacques came on forty-eight hours' leave. He is now sixteen years old, but looks very grown up in his uniform of the Free French Forces.

The English Speaking Union Centre for overseas servicemen and women was started in Gloucester on the top floor of what was then Dentons Drapers off Northgate Street by Mrs Alice Sumsion. With the help of over

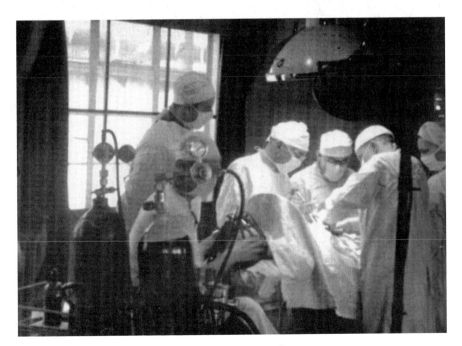

Inside one of the USAAF military hospital's operating theatres.

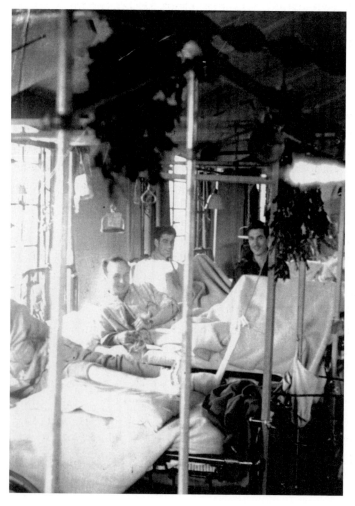

*Above:* Entrance to 110th USAAF General Hospital at Ullenwood.

*Left:* Christmas Day smiles in one of the wards at USAAF 110th General Hospital at Ullenwood.

200 volunteers, Mrs Sumsion ran the centre for the last two years of the war for service personnel from the American hospitals at Crickley Hill, Birdlip, Malvern and Fairford, the Canadian Air Force based at Barnwood, New Zealanders from Cirencester Park and Australians. An American centre was also formed in the Bon Marche. An Americans-only clubroom at Cirencester's Bingham Hall was named Doughnut Dugout by the locals.

Cirencester was the centre for the administration of over a dozen American hospitals spread over the Cotswolds. From the Bingham Hall and Shrubberies in Victoria Road where they were first billeted, the contingent of nearly 300 moved their headquarters to Stratton House Hotel, vacated by the 11th Forestry Company of the New Zealand Engineers. The 15th Hospital Centre arrived in Cirencester in 1942, according to an American secret document, to organise comprehensive war hospitals in anticipation of the huge number of casualties expected from D-Day and the invasion of Europe. The hospitals spread from Stroud and Ullenwood in the west across to Bicester and Oxford on the east side and opened on 13 May 1944.

The wounded arrived by the trainload on the then busy Cotswold railway lines. Witney saw huge numbers of the wounded and demoralized soldiers from Dunkirk lying in exhausted lines on Church Green before moving on to their next destination. In the latter half of the war years, Witney and the eastern edge of the Cotswolds had become an enormous arsenal for Allied troops with army and air training bases. Brize Norton and Broadwell aerodromes activated with bombers and service personnel from America, Australia, New Zealand and Eastern Europe crowding the single branch line from Witney to Fairford. Special military trains were put on to cope with the increased rail traffic and supply trucks chuntered along constantly laden with armoury and ammunition and mysterious crates. Second sidings had to be constructed at Lechlade and Fairford railway stations for goods traffic as it increased with the building of the aerodrome at Fairford — the last new one to be built in the eastern side of the Cotswolds.

Tetbury Hospital treated a total of 287 patients, which included a number of military patients, in the first year of the war which it was reported was a record in the hospital's seventy-two-year history. It had an active 'Linen League' of some 127 members who made up garments and did mending of the hospital linen as part of the war effort.

A revision of the Panel system, at least for the war years, was suggested by someone 'Somewhere in Gloucestershire' as part of the war effort in saving petrol and doctors' time. The letter appeared in the *Wilts and Gloucestershire Standard* and refers to the flu epidemic of January 1940:

USAAF medical officers of the 15th Hospital Centre at their headquarters, Stratton House.

Headquarters 186th enlisted medical staff. Left to Right: Robert Meyers, William Brown, William Sarver, Bryan Davis, Wilbert Schmidt, Richard Briley, Fred Winter (Courtesy, Richard Briley).

We house under this roof 120 evacuees, and one doctor serves the lot, my husband and myself. In addition, we have a private staff of eight maids who are on the panels of eight different doctors. This house is situated seven miles from any medical man, so that the wastage of doctor's time and petrol is obvious when all the panel patients are ill at once, as has been the case recently. Domestic servants in full work do not as a rule require anything more than common-sense medical advice. Why cannot we be rationed in doctors and revert in some measure to the old system of country practices? I dare not sign my name for fear of incurring the wrath of my own domestic staff and their medical attendants.

The 188th Hospital and 25th Hospital, later renumbered the 192nd, covered some ten acres of Cirencester Park — a massive tree-felling operation to provide timber to build the gliders needed for the invasion had already cleared the space needed. The townsfolk, represented by the old Urban District Council, officially adopted the 188th USA Hospital 'in admiration for the care, skill and attention given to the wounded and invalided men' according to a parchment dated 21 September 1944. The 192nd General Hospital (now the site of Deer Park School) was honoured by a visit by the legendary Glenn Miller. Captain Glenn Miller and his band arrived by air at the RAF Base at South Cerney and gave a memorable concert on a lovely summer's day on 7 August 1944.

The 186th General Hospital was built in Fairford Park as a 1,000 bed hospital and received nearly double that amount of patients within hours of the D-Day landings, to be treated by 45 doctors, 80 nurses and 200 other enlisted men. One nurse, Ariel Powers, found herself nursing her own brother after his aircraft was shot down. Richard Briley arrived just after his 19th birthday. 'I believe it was 9 May 1944 when we trucked to Fairford, it was raining cats and dogs. We dismounted in the pouring rain in front of rows of Nissen huts and were issued with two canvas sacks, one small one and one long one. First Sergeant John Stanton yelled, "There's piles of straw out behind them barracks, you'se can put it in them sacks for a pillow and a mattress". Naturally we all started complaining, because we knew the straw was soaking wet and the canvas was getting wetter by the minute. He told us to just dig down into the pile and we would find some dry stuff. He was right, but it smelled pretty bad and we all wondered if there were varmints in it. We ate very well at the Mess hall but never had any fresh eggs. We had powdered eggs, with a rather sulphurous smell and colour. The longing for fresh fried eggs, over easy, or sunny side up, was endemic amongst all the GI's. I had gotten sergeant's stripes and was made the sergeant of a barracks that was next to the fence that separated us from the big manor house. Some of my enterprising barracks mates had made

the acquaintance of the lady housekeeper and entered into a barter system of toilet paper, hand soap and whatever the guys could scrounge, for fresh eggs. I wasn't supposed to know this, but when they fried eggs on top of the hut's heating stove at night and that aroma wafted throughout, I came out of my little room to investigate that heavenly smell and after swearing I never would tell, ate eggs and toast with the rest of them. I learned later that we weren't the only barracks in her bartering system, and those hens were sure kept busy!

Many of the 186th GI's, including some of the ambulatory patients, went to dances held in Fairford's Palmer Hall and the Corn Hall in Cirencester. We all rode bicycles wherever we went, unless it was a sponsored event and there were trucks for transport, then we had to be back on time. But sometimes, in our amorous pursuits, we lost track of time and had to sneak back "under the wire" with our bicycles. The fellows of the 186th I knew were a very dedicated group. They would recite many stories of the amazing things the surgeons and medical doctors would do. Some terrible injuries were inflicted on those combat soldiers. I was often asked to be part of an honour guard to award purple hearts, as they lay in their beds, sometimes so grievously wounded they could not speak. The Medical Group performed a wonderful service, and was an essential part of the war, and I have never forgotten the patients we received, and those same guys that were discharged. Many received that "million dollar wound" and were sent home, some went back to combat!'

For John Mills of Quenington, wartime brought its own compensations and excitement. Breeding rabbits with Merv Law at the evacuee settlement, collecting sandwich lunches for teachers at the school and swapping the classroom for the open fields to help with the harvest and potato picking 'was a good skive'. Even the disruption of having the Quenington Road churned up and blocked by great dumpers when the 186th Hospital was being built in Fairford Park, making the road so muddy that you couldn't push a bike through, making it impassable from Rag Hill so that the bike ride to school meant going the long way round Pitham Bottom, John and his friends were rewarded by chewing gum and candies and became 'quite buddies' with the guards on the gate once the building was completed, and kept the secret of knowing where the old Austin 7 tourer, painted yellow and black with its buzz bomb picture on its side, was hidden under the trees in Lovers Walk. The same car was to be seen on occasion at the Keeper's Arms pub. Later, the whole of Farmor's School were invited to the hospital centre for a Christmas party, and many local families welcomed the Americans into their homes for an English meal.

Official figures state that a total of 99,220 patients were admitted to the American military hospitals.

USAAF serviceman Emmett of the 186th Hospital with a Fairford schoolboy friend.

Nissen huts of the 186th American Hospital built in Fairford Park: the Mess Hall is shown centre, behind the flagpole and the PX is on the right (Courtesy, Richard Briley).

Military hospitals were self-contained; it was the strange new world of the garrison town which affected the social life of the Cotswolds within a handful of years to an extent and at a speed unprecedented in history. To provide recreation for the troops, the Saturday night 'hop' became a regular feature in the village and town halls. There were always plenty of young servicemen in even that remote area: men from Dunkirk were stationed at Cot Abbey, Winstone and The Highwayman, Beech Pike and Miserden Searchlight Battery. An officers' convalescent home was centred on Edgeworth Manor, and one for members of London Gas Board was at Cotswold Park. Land girls were also in Miserden Park.

Complaints about behaviour of the American Forces after dances in the town prompted a letter to the Commanding Officer at the Fairford Base, and 'goings-on' were reported to have been going on outside The Pig and Whistle at Quenington. The jitterbug became an epidemic. Cirencester held the first Jitterbug Contest in May 1940, organized by the evacuated staff of Texas Oil Company. Everything from 'Truckin' to Boogie Woogie to Alec Mattock's augmented band reverberated the boards in the old Corn Hall, and the Memorial Hospital was £43 10s. better off for it.

Such a precious and rare object was a lemon to be given as a prize at one of Fairford's dances that it was auctioned and an incredible £40 was finally paid for it. Two live turkeys were taken to the Gloucester Tennis Club dance in 1939 and tripped the light fantastic with their donors while waiting to be won as top prize.

The Oxford and Bucks Light Infantry quartered in Boulton Mills had to make a hasty retreat to the new school at Highfields as Parnall's aircraft factory moved into Dursley, following the devastating raid on its works at Yate in February 1941. The Royal Horse Guards, fully mechanized in 1942, encamped in the equestrian enclave of the Cotswolds, at Badminton Park. At Hinnegar, a refugee camp community had already been set up for evacuated families from the blitzed cities, and was regularly visited by Queen Mary, who joked with them that she, too, had been evacuated to the Cotswolds.

It was the arrival of the Americans in August 1942 which caused the greatest stir; hardly a village or hamlet had not hosted one unit or other of the armed forces by then. Khaki blended in with the countryside and heavy armoured vehicles churned up country lanes. But the rapture for welcoming the heroes was reserved for the slickly uniformed Americans and they were greeted with the euphoria of a liberating force when they sailed into Avonmouth and into the West Country. Three long years of war,

Americans introduced square dancing and the jitterbug to the local 'hops'.

miserly pay and blitz weary, the Tommy in his coarse cloth uniform merged even further into the background with his Brylcream and Woodbines as the Yanks swept the local girls off their feet, literally, with the uninhibited jiving, the smooth cloth uniform that had not seen the dust of active duty on it and deodorized bodies unstained by the sweat of fight and fear. Lucky Strike cigarettes made the little Woodbine look weedy in comparison, and sharing two ounces of humbugs on the barrack room bench hauled into the village hall to watch a jerky film, transmitted through a beam of thick smoke from a gyrating projector which frequently broke down, was a primitive pastime when the Yanks had money to take the girls to 'the flicks'. Lavish with compliments and candie, nylons and other niceties of which the local people had been starved for three years, the American troops appeared as film stars from the land of plenty bringing manna in kind to a ration-riven country. 'Gum' and 'gas' became synonymous with GI's — from the Government Issue aura of benevolent bounty in which they moved amid the folks of 'the Old Country'. Not unnaturally, the local boys and English servicemen resented the invasion of their transatlantic cousins especially when they went poaching on their preserve. And girls who dated Yanks became known as 'Spam-bashers or Yankee-bashers and far more derogatory names.

Any initial resentment and suspicion between the English and American forces was of nought compared with the deep racial prejudice which existed between the white and black Americans. When this was manifested within the English social structure it was something which local people could not comprehend. For many, the 'blackie' was the first coloured person they had seen in the flesh: dark-skinned piccaninnies had appealed with large melting eyes in trusting faces from church missionary boxes, and benign aged negroes had attracted grand-dads to Anstiss baccy from tin posters tacked to the front of counters in village stores. In reality, they were a novelty at worst, but charming and courteous at best. And Cotswold girls found the racial tension between the whites and blacks both bewildering and distasteful. Coloured soldiers were given the most menial of the tasks and witnesses to some of the racial riots which broke out in Bristol and Cheltenham, particularly, were on a scale which frightened local people.

The preference for black Americans to white English heroes of some of the most daring and dangerous deeds of the battle zones was verified by Don Miles, a decorated naval man in the SOE based in the Cotswolds. 'Like all servicemen, we had asked what the local girls were like when we were posted to Hatherop Castle,' he recalls, 'and we were told — not a chance, they much prefer the black Yanks'. Complaints of the discrimination and often brutal treatment of the black soldiers were investigated at Cheltenham; the overwhelming evidence of the townspeople that there was

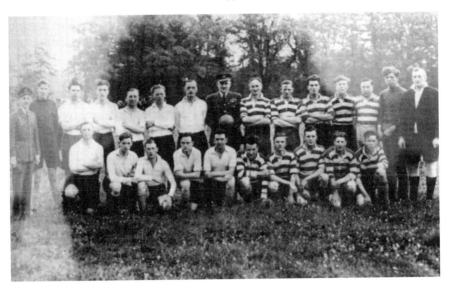

Taking time off to keep up skills at football, Eastleach v RAF, 1944.

a serious racial problem among the American forces there only brought forth a damning condemnation of Cheltonians — by the white officers — that they 'were nigger-lovers'. At Westonbirt some 1,000 coloured troops were billeted, but at Dursley the contingent of 1,200 was mixed, as they were at Wotton-under-Edge where another 600 assembled — all in preparation for the build-up for the Normandy invasion.

Stow-on-the-Wold Parish Council welcomed the US forces stationed in and around the North Cotswold market town with a Welcome Dance at Maugersbury Park Camp in March 1944, with the band from the RAF station at Moreton-in-Marsh. It was reported as a great success and much appreciated by the 773rd Tank Destroyer Battalion in whose honour it had been held. However, by August rumour was rife that 'the inhabitants of Stow do not desire the USA coloured troops in Maugersbury Park to come into the town'. The Clerk to the Council was directed to write to the Commanding Officer of Adlestrop Park to inform him that that was not so. 'If the coloured troops are allowed in moderate numbers to come into the town, the Parish Council will certainly raise no objection.' Many — black, white, Yank or British —never had the chance to return and became part of the statistics of over a quarter of a million men killed, wounded or missing in the fight to liberate western Europe.

Individually, rather than collectively, relationships between troops and local Cotswold people were much more accommodating. Officers were billeted in private homes where possible, and many familes opened

their doors to help 'the boys from some poor mother's home'. With local young men away in the fighting line, the security of others from elsewhere encamped in the vicinity brought a strange tenor of excitement to an otherwise drab and work-weary routine restricted by rationing and regulations. Older men, too, adjusted to the new fresh young faces in the village pub. Educating them in the intricacies of English currency usually ended up as a communal effort as they pondered over the cost of something at 5s. 11d.: 'five and eleven — okay, so you guys are saying that's sixteen. No? Five and eleven, but five what and eleven what?' And cricket, with the side going out when they were in, and coming in when they were out, let alone the short legs and silly mid-offs, was dismissed as another English eccentricity rather than struggle with its interpretation when there was a war to be fought and thought about.

Julia Paul's childhood memories of seeing their cavernous stone-smelling kitchen at Edge Farmhouse being filled with soldiers one morning, seated at their own trestle tables and cooking eggs and bacon on the cast-iron range opposite the old, long-disused cider-press, was nothing short of awesome wonder:

I had never seen so many people together before in my whole four years, and all in our kitchen. The sergeant, a burly cheerful man, called me his little robin. The others were all too busy eating, or drinking out of their tin mugs — and they disappeared as quickly as they had come, so perhaps they came for that one meal, although later we often had an RAF officer billeted with us. As a child one just accepted things, but I was disconcerted on VE night when my parents took me into Stroud to find George Street, King Street and Russell Street full to overflowing with people dancing and hugging and waving flags. There were sailors, very drunk and happy, dragging people into a wild unsteady dance, completely hemmed in by a solid crowd of celebrating grown-ups. I had never thought grown-ups could behave like this and was rather uneasy that they had all gone a bit mad. I also remember that we had two German POWs from Paul Camp at Edge to work in our very large garden at one time. I felt a bit let down that they looked so normal, even nice, young and quiet, tall and fair-haired, and not a bit like the gesticulating Hitler that had threatened us from the screen at the Ritz in Stroud, making our blood curdle and filling our young minds with absolute terror as he raved at the mass of Nazi saluting crowds. My mother used to feed them lavishly, cooking and baking and using up our precious stores. When I asked why she did that for the Germans when we had to scrimp and scrape she said, 'They mustn't know how hard things are for us, they mustn't know about the

shortages.' I learnt then a bit more of the English character and spirit of the wartime of hiding how near to disaster we all were.

Just as the poet is unsung in his own country, the home soldier is not always accorded the compassion as that shown to the enemy. When Mr E. Bridges made his way home to Chalford on leave from the RAF and found himself trapped in the corridor two coaches from the platform, he had no alternative than to go on to Stroud. The reception he received at the hands of a local ticket collector when he finally got off the train was anything but welcoming. However, despite the demands for excess fare, even after having been told what had happened, Mr Bridges refused to pay and shouldered his way out of the station only to find that the delay caused by the ensuing argument had meant the last bus that night was to be seen disappearing into the darkness. After walking about three miles, he was picked up by the village postman and deposited at the foot of Chalford Hill. Petrol being so scarce even a short distance more was beyond the realms of further help. Having had one strange experience of colliding chin to chin, and forehead to forehead with another serviceman in the black-out, he was wary of other footsteps in the dark. When he finally arrived home he found his mother had had a set-to with her nine-year-old evacuee boy who had caused absolute havoc when she refused to give him beer with his supper.

There is hardly a village, let alone a town, that has not at least one enduring friendship forged during the war years that has stood the test of half a century. Jimmy Greelish remembers his introduction to the Cotswolds with affection:

I came to Wotton-under-Edge with the 45th American Evacuation Hospital on 25 November 1943. Many of us had never been away from our homes before and we wondered what England would be like. I was with a friend in Lime Lane when Betty came down the hill to do some shopping and we asked her if she would show us a little of the town. She told us to wait while she went to get bread for the weekend. But when she returned without any we realized how you nice English people were short of food with everything tightly rationed.

We then asked her to wait a while and we got her a nice big loaf from our American stores. She was so grateful and asked us home to meet her parents. That started a friendship from which I learnt how to play darts and the game of 'Tippit', passing a sixpence along from hand to hand under the table and then when all the hands were placed on top, one had to guess who was holding it. I had my first fish and chips in Wotton-under-Edge and I got to know the baker, Mr Stokes, really well.

We couldn't understand what was going on when they put the fish and chips on paper and we started laughing. I guess the Cotswold folk had a laugh out of us, too, because we didn't know what they meant by 'Q-up', but we soon found out when we didn't stand in line and wait our turn. The Cotswold people were the first English most of us had seen and it took us a while to try and understand their ways. We would call them Limeys and they called us Yanks. We used to go up to the top of the hills at night to watch the searchlight operations. Betty was a nurse at Gloucester and one day we went there and she showed me the ruins from the bombing, we hadn't seen anything like it before. Then we had to leave the lovely Cotswolds for Normandy.

The hurried departure of the Americans for D-Day operations meant they had to travel light. The locals, aware that they had buried a lot of things and threw cans of food into the ponds, soon dug them up and retrieved what they could. Rosemary Guy recalls the return of different soldiers to the town, exhausted and dirty from D-Day. 'They came in army trucks and families went down to pick so many to offer them a wash or a bath, if you had one in the house, and whatever food one could muster. My parents brought home two soldiers. One was so grateful. He had immaculate manners, and said to my mother, "If I told you who I was you would be surprised, I could have gone straight in the top rank but I wanted to know what it was like to work up from the bottom. You can call me Bunny".'

The strange tailpiece to that episode was, as Rosemary recalls, 'Years later, we were sitting watching television, it was at the time when people were buying their first sets, when all of a sudden the back door opened and in walked an army officer. He sat down, watched the television for a brief moment, then got up and walked out the front door, as if he knew the house, and never spoke to any of us, to disappear as suddenly as he had arrived. We often wondered if it was the same man, rose up from the bottom!'

# Dig For Victory

## LAND USE

Every endeavour must be made to... produce the greatest volume of food
of which this fertile island land is capable...

Winston Churchill

The V-Boat and the Bomber versus the Farmer and the Gardener.
Torpedoes and Bombs against Wheat, the Potato and their many allies.
The Land is a vital war weapon—It's in your hands. You can defeat both
Submarine and Bomber. Every seed placed in the ground is a bullet sped
on its way to the black heart of Germany. The potato has come into its
own; every root of every kind, for winter storage, is a shell destined to
find its mark. Do your bit to provide these munitions of war. Plenty of
food and you can provide it easily to spell certain and complete victory.
Go To It — Dig, Sow, Plant and Cultivate for Victory.

The drive to dig for victory started immediately war was declared.
Following the Prime Minister's momentous broadcast on Sunday, 3
September 1939, the announcement was made that the Minister of
Agriculture had appointed a War Agricultural Executive Committee
(WAEC) for each county and made the Cultivation of Lands Order
1939. The aim was to increase an additional one and a half million
acres of tillage area in England and Wales compared with that of June
1939. Each county was allotted its share of that total, and the WAEC,
or War Ag as it became known, had the task of implementing the
order.

References in many Cotswold village school log books imply the help of
schoolchildren in the survey. Soldier labour was drafted on to the farms,
on application from farmers whose workers had been called up, to get in
the 1939 harvest without delay. The applications had to be assessed by the
War Ag, who then applied to the army for help from troops in the vicinity.

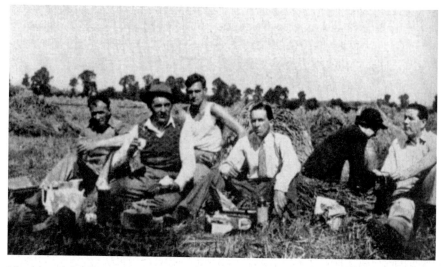

Members of the Gloucestershire War Agricultural Committee take part in the 1941 harvest.

Farmers were required to pay the appropriate rate in respect of soldiers who worked in the harvest fields.

'He who doth not plough is an enemie to his Kingdome', Walter Blyth's warning in his book, *The English Improver*, 1649, was translated across the centuries into severe penalties for any farmer not complying with the order. The WAEC also had control of government tractors for carrying out ploughing and other operations where farmers were unable to get them done.

Comparisons were made with the situation in the First World War and it was discovered that Germany was at that time producing enough food on every hundred acres to feed eighty-five people; Britain was feeding only forty people per hundred acres. Parks, playing fields, lawns and whole vistas of pasture land went under the plough. At Malmesbury the Act of Parliament of 1821 had to be referred to when the common was under surveillance: but it was enacted that Malmesbury Common be enclosed and upwards of 400 acres be divided into 280 allotments to be held individually by commoners under a system of life tenure, with 50 acres — Shade Hill Pieces — to be let by the Trustees; within the first year some 200 acres were being cultivated. Failing to complete the order to plough a total of 182 acres in the required time, a Coln St Denys farmer was fined at Northleach petty sessions in August 1940; evidence against the farmer said that 'he was not in sympathy with the idea of ploughing land'.

Personal and deep-rooted traditional policies in farming were often discounted as obdurate opposition.

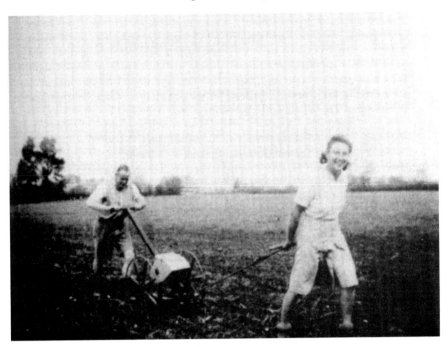

Land girl Wendy Tregale, and Bunny Arkell mangold planting at Butler's Court, Boddington 1943.

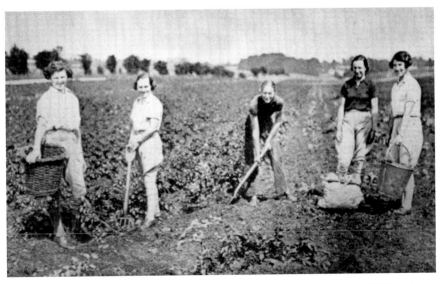

Land girls at work on the Royal Agricultural College Farms at Cirencester (W. Dennis Moss).

Will Garne of Aldsworth, the grand old man of the Cotswolds, who saved the ancient breed of Cotswold sheep from total extinction, should be accorded the highest accolade for his tenacious hold on our Cotswold heritage. He kept his Shorthorn herd with the oldest pedigree of any British herd, and the only flock remaining of the heavy and lustre fleeced Cotswold sheep despite pressure to turn his precious pasture to more profitable arable yields. The Garnes held farms at Taynton, Cam and Aldsworth when war broke out, but it was at Aldsworth that Will Garne made his heroic stand to conserve the Cotswold sheep on whose back the wealth of medieval England was carried to become the staple revenue for the kingdom to the extent that the Chancellor plumped himself down on a woolsack — and has done so ever since. The saying in the Middle Ages was:

> The finest wool in Europe is English
> The finest wool in England is Cotswold.

   The entire wool clip was taken over by the government, through the Ministry of Supply from 1941, but as pasture went under the plough there was a resultant drop in sheep-keeping; the figures for England and Wales were reduced from 17,986,000 in 1939 to 12,602,000 by 1943. Cattle increased only slightly in numbers during the war years, and pigs — although kept in small numbers by householders — fell from 3,515,000 in 1939 to 1,463,000 in 1943. The head of poultry almost halved in the same period, despite, again, the individual clutch of hens kept by individuals. It was not the road to supplementing the rations as Brian Carter recalls their family egg coupons had to be given up in exchange for the units allowed for poultry meal which he collected in his schoolboy truck from Smith's in Cirencester. 'The secret of getting any eggs seemed to be in the tuppenny-hapenny packets of Karswood spice which peppered up the mash made from the household scraps. It was made from ground insects.' Real horse power was revitalized and by the end of the war there were still some 485,000 horses working in agriculture.
   Ted Smith of Cirencester was the last ox man in Britain to be still working with a team of oxen which proved invaluable during the war years. Ted gained exemption to leave Powell's School at the tender age of 12 years to work on Cirencester Park Farm in the first year of the 1914-18 war for 7d. a day. As an apprentice ox lad he had to undergo the ritual 'christening' by having a bottle of cattle medicine tipped over his head by the older ox men 'it was a black mixture prepared by the vet, Mr Blunsom,' he recalled. In later years it was his last pair of working oxen — Jim and Joey which he had bred himself — that had to undergo a colour change

when they were given film star status and painted gold to appear in the film, King Solomon's Mines. Ted worked with oxen all his life, but adapted as and when necessary to drive a tractor which had replaced the horses on the farm, but he maintained that oxen were always more reliable — they never broke down. Ted's son, Ralph and daughter Gwen were born in the Round House in Cirencester Park, and the shepherd lived in the Square House. Ralph followed his father to work on the Bathurst estate and recalled the days when the Gloucester Regiment had their training at The Barracks close to the Park entrance. 'We loved to watch their Tattoo with all the soldiers smartly marching to their band. Old Sergeant Smith with his red sash on would be outside trying to get new recruits. His wife was a midwife. My Dad had the greatest respect for the Bathurst family – as we all did. It was a wonderful tribute to the old Earl's love of country life and traditions that when he died my Dad took him to the church from the Mansion House on the bier drawn by his favourite oxen.'

Girl power was used for drilling mangolds at Butler's Court, Boddington, when Bunny Arkell found a willing land girl in Wendy Tregale to haul the drill over the two acres which they turned over to root crop for winter feed. Jack Wharton of Minster Lovell had his 'Super Lion', one of only four of that type of traction engines to be made, commandeered by the government in 1941 for war duty. Stripped of its gleaming chrome and barleystick twist splendour, the 25 ton work horse had its front cut off

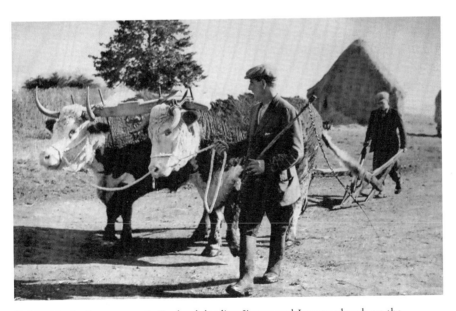

Ted Smith, the last ox man in England, leading Jimmy and Joey to plough on the Bathurst estate farm, Cirencester. Note the thatched rick in the background.

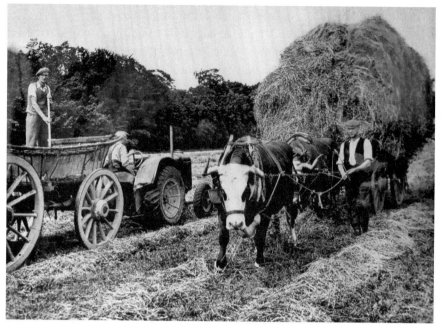

Ox power passes the modern tractor power at harvest time.

and a crane tacked on its back for service at the docks and hauling down bomb-damaged buildings. It took Jack some 25,000 hours of loving and painstaking restoration over twelve years to bring it back to its former glory, and take its rightful place in the Cotswold fairgrounds.

The call to Cotswold farmers to take immediate steps to plough up 10 per cent of their grassland, without waiting for directive from the WAEC, was answered by the Duke of Beaufort starting on Badminton Great Park and putting 150 acres under the plough for spring oats and 14 acres to wheat. A further Home-grown Wheat Control Order of 1941 prohibited the feeding of millable wheat to any livestock. All was required by law for human consumption. Details of threshing had to be returned to the WAEC within seven days, whether it was done by the farmers or by contractors.

Farmers were urged to increase the milk supply by top dressing the pastures with sulphate of ammonia to get a flush of grass a fortnight earlier; a restriction of the sales of liquid milk was made in 1941 in an endeavour to have larger supplies for cheese — an increase in the ration to mining and industrial areas reduced the general ration by half in the spring months of that year. The calls on the land and its produce were immense. Growers were ordered to reduce crops of rhubarb to grow more necessary crops, and all orchard fruits and soft fruits decreased in output, except pears and cherries, over the six years. Threshed peas, for human consumption,

were increased; the acreage of barley doubled; wheat crops trebled; potatoes doubled, as did mixed corn. The resultant straw yield doubled — hops for the traditional British pint remained stable. In July 1941 two Cotswold farmers E. V. Sainsbury of Lyegrove, Badminton, and S.J. Phillips of Fosse Hill Farm, Coates were among a handful from the West Country to spearhead a whole new process of turning straw into winter feed. By treating the straw with caustic soda and water it was converted into a starchy food which was like a concentrate overcoming the indigestibility of untreated straw. Ricks had to be thatched by law, and the WAEC gave warning that unless ricks were thatched by October in 1940 immediate action would be taken. A thatch was also a good disguise of what was beneath it when seen from the air: a wonderful rick was built around an observer post at Tewkesbury, complete with neatly thatched top.

Reviving the practice of flax-growing was important to provide the linen fibres for aeroplanes and other service purposes as production increased and the sources from Russia and Belgium became more difficult, if not impossible, to obtain. The normal imports of flax fibre amounted to some £6,000,000 per annum. The drive towards growing flax in Gloucestershire was made in 1940; together with the counties of Hereford and Worcester, the National Farmers' Union aimed at producing some 2,000 acres out of the country's potential 40,000 acres. In 1940, 15,000 acres produced 23,000 tons; in 1944 50,000 acres had been turned over to the crop and produced 88,000 tons.

As with any official administrative body set up to oversee, control and re-organize such a traditional industry as farming, with individuals entrenched in generations of old ways, the War Ag became the 'war aggrevation' to many farmers, especially as they were then seen as the saviours of the country's food after years of decline and indifference by government for agriculture as a whole, resulting in a massive drift from the countryside to the industrial towns and higher wage packets. But it had to be done and Mr H. Lawrence, an agricultural valuer and senior partner of Bruton Knowles, recalls his role in the Gloucestershire WAEC being concerned with some 8,000 acres taken over by the County Committee:

There was some opposition to ploughing up grasslands in the early days, but this changed as the urgency of the situation was made obvious as the war progressed. One thing which we did was to organize a visit of a number of farmers to the docks in the aftermath of a blitz to see the damage done to goods being imported. This made a great impression on them and they renewed their efforts to increase food production after that. In a number of cases, farmers found financial and labour difficulties so great that they asked the WAEC to take over their holdings.
I know of no sanctions or cases of physical eviction in the Cotswolds;

the general principle was of requisitioning. Amongst my cases, The Shuthanger and Brockeridge Commons near Tewkesbury, of some 324 acres, and part of Selsey Common near Stroud, of 50 acres, were managed by the WAEC and ploughed up to be cropped with bread grains. At the end of the war, in keeping with the general policy, they were handed back to the Common Holders Committees and reverted to pasture, after cleaning and reseeding.

One of the most dramatic achievements of Bobbie Boutflour, Principal of the Royal Agricultural College which was closed for the war, was his idea of ploughing up the wetlands of the Severn meadows at Slimbridge. Some 310 acres were drained, ploughed and cropped with potatoes most successfully from 1942. He even got a railway in for transport as an alternative to the poor road over the Severn-Berkeley canal. At the end of the war, it was re-seeded and handed back to the Berkeley Estate and re-let, some to the Wildfowl Trust. Serving in the Food and Agricultural Branch of the Military Government at Kiel, and afterwards in Hannover as Lieutenant Colonel in command of the F and A team for the provinces, I was able to compare at first-hand the virtually nil performance of the German farmer compared with the British. I consider it was a great privilege to have been involved with the magnificent contribution of the Cotswold farmer towards a British victory.

Allotments were offered of ten rods each by Cirencester Municipal Offices in December 1939 under the Dig for Victory campaign. After a poor response initially, 95 out of the 120 plots at Chesterton were taken up by April, and an Allotment Society was formed. Northleach Rural District Council offered a half acre free to be shared between four Bibury Council house tenants on the condition that they cultivated the land and did not use it for poultry keeping. Gloucestershire Education Committee launched a vigorous and highly successful schools garden scheme. Gardening had appeared on the curriculum much earlier, but the contribution made by schoolboy gardeners towards providing vegetables for evacuee settlements was quite considerable. Self-sufficiency on the Home Front extended to air bases, as shown in the Log Book for RAF Fairford. Despite the frenetic work of getting the airfield ready for D-Day operations, records show that Pilot Officer Williams was appointed Gardening Officer on 19 April 1944 when an initial five acres of land were ploughed and 17 tons of seed pota-toes planted. In July a further three acres were cultivated and planted with some 15,000 assorted cabbage and greenstuff plants.

The enthusiasm to put every bit of available land under the plough fired local resentment when footpaths were ploughed up 'under orders' — it was not the direct policy of the WAEC to plough up footpaths as a means

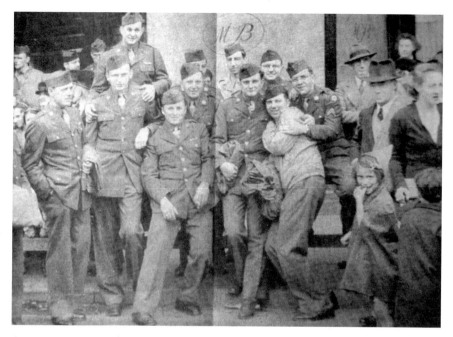

American GIs posing for a celebratory picture on VE Day in Cirencester Market Place while local people look rather bewildered.

of securing more land, only when the path ran across an arable field when it was then the duty of the farmer to create a diverted path.

If the countryman doggedly preserved his ancient rights of way, despite the world being torn apart around him, the passion for his country game was even more deep rooted. War intervened as Wally Hammond scored his seventh century, and an Emergency Committee was set up to watch the interests of Gloucestershire County Cricket as Hammond and Charlie Barnett hung up their white flannels for the duration — Herr Hitler was warned, through the local press, that these were formidable chaps with a bat so he had better look out when they turned their attentions to his unsporting activities. No county cricket was possible for Gloucestershire during 1940 as the players were in the forces, but Charlie Barnett, as Flying Officer, returned to the pitch while on leave in 1941 to captain a match in aid of Tetbury Hospital funds. In 1941 Cirencester Cricket Club held a meeting at Viners in February and decided to carry on as long as possible although so many of their team were away serving in the forces. The opposition was rather limited as it was reported that only two teams were known to be playing: Cheltenham and Swindon GWR. The question of the outfield not being cut was raised and they decided it would not make that much difference; Mr Berkeley Stephens, chairing the meeting,

said that was the game fifty years ago, they would just have to hit that much harder. It would have been a brave body to ever cast a ploughing eye on the sacred runs of Cotswold cricket fields!

## LAND ARMY

To put into practice the policy of digging for victory, with men called from the land for fighting and support services it was left to the womenfolk of the country to fill the men's places. The Women's Land Army training started in Gloucestershire in June 1939 with a fortnight's intensive course at the Royal Agricultural College. By the end of the first year of the war, Gloucestershire was the fourth largest employing county for the Women's Land Army in the whole country; 252 girls were on farms, 27 in market gardens and 35 in the Forestry Commission as foresters and timber measurers.

Land work ranged from dairying, driving tractors, digging ditches, sowing, hoeing, harvesting and threshing, to rat-catching and dung-spreading. Fred Russell of Winchcombe looks back to those days and the sheer grit of the girls with whom he worked:

I started work on the Great Barrington Estate at the age of fourteen during the Thirties — a very depressed time for farming. My wages were 9s. for a 56 hour week; the men had 30s. and that fell at one time to 28s. Hay-making meant a lot of overtime, very welcome at 6d. an hour, 9d. for the men. I was very proud to be able to drive the very old and worn Fordson, as it was otherwise all horses on the outlying farm called Westcote Heath. It was very high up and the wind was always blowing up there, then we were told to sell up and move off as the land was being turned into the Central Flying School, Little Rissington. Unemployment disappeared. Men came from far and wide to work for Wimpeys who were building the aerodrome. We on the farm were envious of the high wages being paid to them; but as we were in tied cottages we were also tied to the job.

Then I was at Tangley Hall farm on the Burford to Stow road, that became a training place for the Land Army and the girls were housed at a hostel at Ducklington. We felt sorry for them. They had come from London; some were from hairdressers, fashion shops and beauty parlours; none had got their hands dirty before. Neither had they ever got really wet or cold before. They would plough all day in any weather. They had poor dinners, some had flasks, others had nothing to drink all day.

One of the worst jobs was potato picking, we had so much harvest to do that it was always late in the year, November to Christmas, when it was cold and wet and the potatoes like icy mud lumps. I often wondered what happened to those girls, after training they were sent off to other farms. I remember Minnie Knapton from Huddersfield; one day a wave from the tractor and 'see you tomorrow'; but tomorrow came and she was posted somewhere else and I never saw her again — I wonder if she ever remembers Tangle Farm.

The minimum rates of pay for the Women's Land Army, fixed by the Ministry of Agriculture in 1939 were 28s. for a forty-eight-hour week, with 7d. an hour overtime for over eighteen year olds; those under eighteen received 22s. 6d. for a forty-eight hour week with 6d. an hour overtime. Where board and lodging were provided the recommended charge was 14s. a week for over eighteen years; under eighteen years 12s. 6d. In 1940 the rates were increased by 2s. a week for carters, stockmen and shepherds, 1s. for the rest; female workers 1d. per hour increase. A land worker, signing himself 'Democrat', asked Mrs Allison Morrison, Chairman of the Women's Land Army in Gloucestershire, how much longer had the land workers — the lowest paid in the country — 'to work to get food for everyone and starve himself because he has not the money to buy it'.

The county's move to release men from road work for war work, and fill their places by women in 1941 with a wage of 1s. an hour, brought a nervous response from the Highways Committee as it was far in excess of the women land workers who were paid only 8d. an hour; the effect being that there would be a move from the essential land work they were doing. They tentatively agreed on 10d. an hour, with an increase of a half-penny after three months and the incentive of another half penny after a further three months, deciding that 'because a woman was employed on the land at a starvation wage, it did not mean that all the others should be the same'.

There was much discontent over the disparity of wages paid to roadmen and farm workers, and the Dumbleton farmers criticized the War Ag that the increase in roadmen's wages — of 2s. a week at the outbreak of war, and a late morning start if they claimed voluntary duties during the evening to compensate — as 'a curse to the country at a time when the farmers were under pressure to produce more with little help from the government'.

The degree of discrimination between serving forces and the land army extended to being deprived of canteen privileges for obtaining chocolate and cigarettes; a complete embargo on metal for the land girls' badges from 1942, although brass was still used in all other uniforms, and

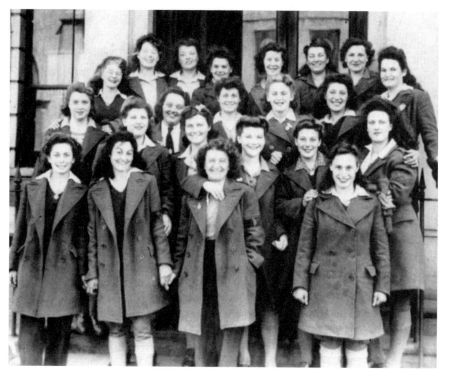

Land girls demonstrating at Cheltenham Town Hall, in protest at not being included in the Government gratuity scheme for their part in the war effort.

the final inference of inferiority when, at the end of the war, they were excluded from demobilization benefits and a service gratuity. The girls at the land army camp at Southam Priory in 1945 formed themselves into an attacking force at this news. Joyce Large (nee Blake) was among them as they marched on Cheltenham Town Hall to put their case. 'But all we got after all the years' service to the country providing the essential food, was one pair of breeches, a poor aertex blouse and the heavy overcoat which you wouldn't wear anywhere else but on the land.' The public face of the Women's Land Army was of attractive young women smiling happily among the corn sheaves; the picture of health and vitality enjoying a spring gambol with the young lambs, or playfully tinkering with an old Fordson tractor to the obvious admiration of benign and aged farmers; a line of dairymaids coyly cheek by udder in the milking shed, or a lithsome beauty outlined against the ever-blue skyline, as she tossed a wisp of hay artlessly above her brimmed hat atop a rick — an endearing image often painfully remote from the reality. The drive to recruit a land army 25,000 strong to replace some 10,000 twenty to twenty-two-year-old men within the first few weeks of war was intense. The valuable contribution made by the

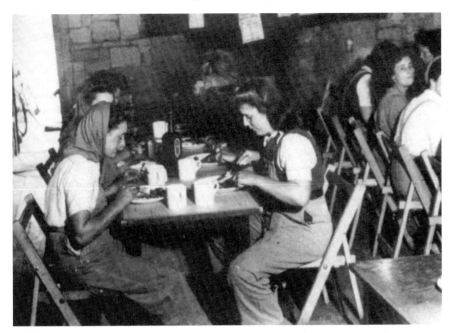

To the barn for breakfast for Land girls at Southam Priory (Courtesy, Joyce Large).

former generation of women was well within living memory of Cotswold farmers, and one was reported in The *Gloucestershire Countryside* as saying, 'Send me the 'oman. I'd rather 'ave one 'oman about the place than a couple of bwoys fer they be more plague than profit.'

As well as the final total land army of 47,861 in England and Wales, there were many volunteers who answered the call to do their bit for the war effort on the land. Mrs Margaret Mooney was at a teacher training college in Yorkshire 1941–43 and, as was expected of those with long vacations, found herself with a small group of friends with some three dozen other students in the Cotswolds after volunteering for fruit-picking:

The girls took over a village hall, with straw mattresses on the floor, one toilet and one washbasin, with cold water only, and no kitchen. The male students were billeted in a huge barn nearby in even more primitive conditions. A domestic science student was recruited as cook with one assistant to manage on a field kitchen — they always, somehow, achieved a good hot meal for us at night. We had to hand over our ration books to the cook and there were a few basic supplies there for us as well. We had to take a snack lunch and a drink with us as we were working at distant fruit farms, transported by open lorries, then having to toil up the steep hills to the fields and orchards. We picked raspberries, currants and

gooseberries, then plums, and peas when it was wet. Many of us were 'townies' and we found it hard work.

We were very glad of our men students, apart from practically re-designing the troublesome plumbing in the hall — many of them training to be engineers—they stood guard outside the village hall on the night of our arrival as an American Army camp about half a mile away descended on us. Seeing a large number of young women arrive, they thought that a brothel was being set up for their benefit. It took our fellow students hours trying to explain the real state of affairs and eventually the Commanding Officer had to come and sort it all out. After that the Americans were helpful and generous. They would take away sacks full of potatoes and bring them back peeled, they supplied us with ice cream and sugar and all the things we could not get — just to cheer us up. There was no contact with local people who were all too busy with their own war work, no one to take any interest in us at all except to turn up in a lorry to take us to work and tally it up at the end of the week to pay a miserly sum. Our weekly treat was to go by bus to Cheltenham for a bath! We were too tired after the hard work to go sightseeing and I still have no idea where I spent those five weeks on the Cotswolds. We had got off the train and were taken by lorry to the village hall, there were no signposts — but I do remember enjoying the beautiful scenery and the fresh air and the companionship of our own group. It is only now when I look back at our naivety and youth, with no older person to help us, let alone 'counselling', to sink or swim, that I marvel at our being able to reduce those GIs into peeling potatoes for us — of course, they did try it on, but as they say, it's up to the boys to scout and the girls 'to be prepared'.

'Lend a hand on the land' was a slogan which was answered by local people on the farms, too. The titled and talented, gentry and gipsies, plodded over the rich red soil of the Cotswolds bonded together for the common weal. Dame Henriette Abel Smith recalls working at Tinney's farm at Leafield with Nadia Ustinov and gipsies camped nearby:

We picked up and sorted potatoes, and got quite quick and skilled at hooking up swedes and mangolds with one hand and banging the earth off with the other. We were given a couple of swedes now and again to bring home to cook and jolly good they were, too. My sister-in-law, Angela Palmer, was in the Land Army during the war, and my sister, Rachel, looked after the Land Girls at Eastleach Downs. I was just a volunteer, and worked at Willes Farm, too, at Ladbarrow — I used to marvel at the hard work that Mrs Willes managed, but felt quite proud

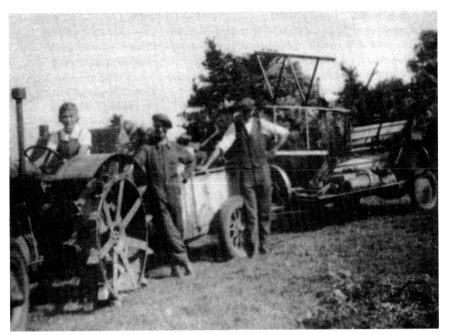

Harvesting on Inglestone Common.

when I mastered the skill of rick-making. I think that was about the hardest work: standing on a bouncy rick, sinking into the hay while try-ing to catch a great pitchforkful then tossing it, which was surprisingly heavy, to make the rick flat. I remember standing alone in a huge field of roots, recently widowed — my husband and brother both killed in the war. There were no support bodies in those days, one just had to get on with it, and working alone in the fields with my thoughts was the only way forward. I remember how kind to me the gravedigger from Fairford was, he was helping on the farm and was very touched that my second child was born posthumously, he made me a lovely walk-ing stick — it was as a sort of token of his concern. Petrol was very short, and Rachel and I drove miles in the pony cart and one got wise to keep to the middle of the road because the big army lorries would get you into the ditch otherwise. I worked half days on the farm and every week bicycled to Coln Stores to drive their butchers van, in addition to my Red Cross duties which often didn't finish until 1 o'clock the next morning.

Local Education Authorities were pressurized into arranging school holidays to allow as much time as possible for agricultural purposes. In 1943 Gloucestershire was requested to compromise between 'educational

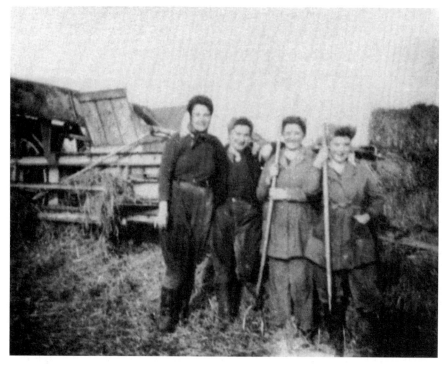

A bevy of Land girls baling: Joyce, Betty, Connie and Edith in 1944 (Courtesy, Joyce Large).

and other inconveniences' in having holidays at different times in different areas, and due regard to the urgency of harvesting when the crops were ready and the weather conditions favourable. For town boys, like Fred Waygood and his brother evacuated to the Acocks in Fairford, and their friend Eddie Walpole allocated to Kathleen and Peter Pitts, learning about the countryside was at first hand on John Whiteman's farm at Totterdown. 'Together, with Ray Jordan and Dennis Higgs we would follow the horse binder as the corn was being cut and tried to catch rabbits with big sticks as they ran out. We used to help guide the big farm horses, Captain, Sergeant, Jolly, Trooper, Colonel and Duke for Mr Geach at Milton Farm, too. Everyone had a title: the farmer's son was Master Ted and there was a correct form for the key workers: Shepherd Hayward and Carter Swinford. John Whiteman tried to teach me to milk a cow — I still owe him for that eyeful!'

Town Boys on the Farms Scheme was instituted in 1941 with School Camps. The War Ag asked farmers to ensure that the boys were employed for a minimum of forty hours a week so that they 'would not be out of pocket'. The wages were set at 6d. an hour for those over sixteen years; 5d. for under sixteen years; with a cost for living at the camp of £1.

Bringing in the harvest are schoolboys from Cheltenham College, at one of the several harvest camps.

It was decided that the camp at Meysey Hampton should have eighteen male and six female students and not schoolboys.

The idea of harvest camps had been introduced the previous year by Cheltenham Boys' College. On their own initiative, two or three college masters set up the camps in the Andoversford, and Brockhampton areas, with one for younger boys at the Toddington Fruit Factory. Initially, the camps started at the start of the summer holiday and the boys had to muck out cowsheds, saw and stack timber and do other jobs around the farm until the harvest was ready. Accommodation, although in a barn, afforded more home comforts than many camp schemes, but due in no small part to the inventiveness of the masters who, at one camp, had provided a bath by stretching a large tarpaulin over a pile of straw in which a sizeable hollow had been moulded. Water, heated on a portable stove, was then tipped into the lined hollow. Bell tents, blankets, cooking stoves and utensils were provided by the government who sponsored the scheme for public schoolboys to work on the farms during part of their holidays.

Wycliffe College boys maintained their Cotswold ties through the public schools' harvest camps. Although exiled to Lampeter for the duration of the war as their Stonehouse school was requisitioned by the Air Ministry's Meteorological Branch, the senior boys, aged eleven and upwards, who had been moved to Wales, returned each year for six weeks at a harvest camp at Barnsley. A workforce of forty masters and boys clocked up some 7,000 hours farm work each summer. The camp was visited one harvest time

by King George VI, and the Young Farmers' Club which the boys started during the war continued when the school returned to Stonehouse.

As the war progressed and more women were needed in the munitions factories to keep apace with the urgency of production, the government were forced to curtail their recruitment for the land army. Prisoners of War were difficult to get shipped back from the Mediterranean, and it was not until the harvest of 1941 that England had the first batch of Italians. Working in gangs, under armed guard, the Italians were initially in camps then gradually were accommodated in farm cottages if they had proved to be trustworthy. Their Latin temperament was often anathema to the local farm workers, who considered them lazy and morose and too volatile to work with comfortably. There was also some resentment at the POWs being better provided for in bad weather with government-issued boots and waterproofs whereas Hodge had to make do with a potato sack round his shoulders as his meagre wage would not run to mackintosh protection. The drafting in of German POWs caused even more unease in 1944, especially where farms were employing conscientious objectors — on direction from the tribunals who had the power to determine where they should be placed. Some 25,273 POWs were working on the farms of England and Wales in 1944. The largest German POW camp in the United Kingdom was in the Cotswold parish of Blockley, on one of the coldest spots of the wolds.

PESTS

War became an advertiser's lynchpin: war was waged in persuasive terms against dingy teeth, indigestion and pimples with proprietory paste, powder and pills; the various ministries of information urged the public to declare war on waste, squandering, and careless talk. No sooner had the war with Germany been declared than it was announced 'Government Declares Total War on Public Pest Number One — the rat'. National Rat Week was declared for the first week in November when the statisticians had worked out that during the First World War rats ate and destroyed more food than was sunk in the four years by German U-boats. In monetary terms it was estimated that rats cost the country some £60 million a year, or more than a quarter of the interest of the National Debt. 'Another War Must Be Won — Fight Rats With Rodine, 7½d. and 1/3 sizes; Don't Let Rats Share Your Rations' appeared in all the newspapers and the Ministry of Agriculture and Food issued leaflets 'to put an end to this pest'. The loss of the traditional Cotwold staddle stone, which was devised to keep ricks dry and free from rats, was deplored publicly — 'especially', the report went

on, as 'more are seen as ornaments of tea rooms than under ricks'. A year later the problem was still as bad, with 111 rat-infested premises reported as serious in the county. Tips at Dursley and Preston were inspected by the War Ag and a joint rat-catcher appointed. In the first three months of his appointment he reported a catch of some 337 rats by means of dogs and traps. Despite the all-out war waged against the rodent, the rat was still ravaging his way into the news in 1944, when it was destroying some 2 million tons of the country's food in a year. Gloucestershire appealed 'that every man, woman and child to become a rat reporter'.

Pests did not always come in the guise of vermin. In the spring of 1940 it was the white butterfly which bedevilled gardeners who had planted extensive cabbage crops, as bid for the national good. G.F. Kiddle of Coln St Aldwyns wrote in the *Wilts and Gloucestershire Standard*, 'I should like the schoolchildren to start a butterfly club, called the White Butterfly Club. I think someone should be responsible in procuring butterfly nets and giving them to the children and make arrangements to pay them so much a dozen. I am sure this could be obtained by a very small subscription from people who have a garden or allotment, or a large field of greenstuff. I am sure they would take an interest if they understood it was for helping the people's food.' Mr Kiddle's idea must have been taken up, at least in part, judging by a subsequent letter in May. 'Regarding the cabbage butterfly plague, now that children are hot on their track, is it not advisable that in their own interests they should be taught that these pretty creatures should be destroyed humanely: and not kept alive for hours in jars crushed together. Also boys should not catch them by flapping them down with coats, etc.' Signed 'Fair Play, Cirencester'. The Ministry issued yet another leaflet on the control of the butterfly — leaflet number 19.

After the rats and the butterflies and injurious weeds — for which 543 occupiers in the region had 'been communicated with resulting in statutory notices being served on 30 for the Ministry to enter the land and destroy the weeds' — came the rabbits to wreak havoc and cause destruction on such a scale that a Damage of Rabbits Act was passed. Brer Rabbit has never been far from controversy in the countryman's conscience, and confounded the law into a paradox of pest control on one hand and poaching on the other.

As war was declared on the English rabbit in 1939, Goering made German rabbits game under the Four Years' Plan. And as the Cotswold coney was officially and legally declared a pest and orders were served on farmers and landowners to control the number on their property, an Act was passed protecting the rabbit from spring traps 'except in rabbit holes'. But when is a hole just a hole and not a rabbit hole? That was the question which had to be decided by the magistrates debating a case of trapping at Rendcomb.

It was agreed that 'a fence through which a rabbit gained access from one field to another was the same as a rabbit hole — and therefore no offence had been committed'.

Gloucestershire farmers were urged to keep down rabbits to two per acre, warning that where there were eight to an acre, sheep farming would have to be given up. In 1939 the County Council advertised for a rabbit trapper 'for a man over military age', with his own transport, salary £156 per year with 2*d.* a mile travelling expenses. Applications to be made to the County Rabbit Officer. The War Agricultural Executive Committee employed 'panel rabbit trappers' and these could be sent to any farm or estate on which an order had been served as having excessive numbers of rabbits — which were destroying crops on plague proportions.

Mr Horace Gough of South Cerney followed in his father's footsteps as a professional trapper. Isaac Gough was likened to George V for being a crack shot, and delivered an eloquent treatise on trapping in the lobby of the House of Lords as the new Rabbit Act came in. The arrangements for the lobby speech had been made by Lord Knutsford who wrote of him 'your integrity and charm of manner'. Attired in country tweeds and driving a Ford T model, Isaac Gough set a standard for his family of trappers.

A framed photograph of Isaac Gough, looking for all the world like a country squire, is a family heirloom. Around the magnificent car is draped a necklace of some 467 rabbits, like a South Sea welcome garland, a trophy of one night's catch at the end of the First World War, when he was contracted as a trapper for Pest Control. Horace records his comparable achievement at Mrs Fielding Johnson's farm at Compton Bassett where he caught nearly 9,000 rabbits in one month in mid-summer. Being a countryman, Horace had studied the ways of the rabbit and saw at first hand the destructive force of it:

> Just before dusk, you clapped your hands and the whole field would be alive with half-grown rabbits, they would devastate a cornfield, a number like that would destroy the young corn for about 150 yards from the hedge in less than a week. But it was a job that you had to be on the spot for. I had a couple of trappers contracted with me, and we would sleep in a deserted cottage on the farm, or take a caravan, because we always visited the traps at least twice during the night. My father taught us to be as humane as possible. I remember having to sleep on an elevator at Lechlade Manor, just with a layer of straw for some form of mattress, when I was sent there by the Ministry. The Butts family at Coleshill wanted me to trap a fox once, I had to do it but I bound the trap with string so as not to injure its legs. Three of my brothers were professional footballers. When we were children we used to take rabbits round to

the villagers, but during the Second World War they were mainly for the markets at Smithfield and the Midlands. We sent them in hampers by the train and it was said it was the rabbit that kept the English from starving during the war when meat was so scarce.

So although it was a pest in the crop, the rabbit which was introduced to the Cotswolds by the Romans, was the saviour of the cook pot, and became the little hero of one of the wartime ditties:

> Run rabbit, run rabbit, run, run, run
> Here comes the farmer with his gun, gun, gun.
> He'll get by without his rabbit pie
> So run rabbit, run rabbit, run, run, run.

'We nearly all bred rabbits,' recalls Dame Henriette Abel Smith:

The Quenington Rabbit Club was quite famous in its day, I helped the three Burge brothers run it. I remember the screams one day coming from the kitchen when Mark and Antonia discovered their pet white rabbits all laid out ready for the pot, but it wasn't long before they turned into quite professional little rabbit-skinners themselves under Reg Moaby. Country-bred children are very practical, as indeed we all had to be.

Lady Howard of Dean Farm smiles when she looks back on trying to cope with a new social era:

I can still picture myself with a knife in one hand, a chicken in the other, and my nose glued to Mrs Beaton to find out how to get the one to the other. Before the war everything was done for us, one could read a novel before lunch then suddenly we were struggling to learn how to live. It was a jolly good thing for us, too. We became real people with a real job to do.

The contribution of country folk to the total war effort was boosted by helping hands from evacuated town children delighting in the pursuits of gathering rose hips for the manufacture of rose hip syrup to replace the Vitamin C, and horse chestnuts for munitions. In 1942 Gloucestershire's total of rose hips was the highest of any county in England. Over 14 tons (14.1 tonne) had been sent by schools by the beginning of October. The target was 2,000 tons (2,020 tonne) for the whole of the country. Germany imported two million tons of hips from Bulgaria alone, for the same purpose, as citrus fruits became impossible to get into either country.

The acres of khaki cloth and other fabrics for service uniforms took priority in the clothing industry and clothes became rationed by coupons.

> When Dad has worn his pants too long
> They're passed to brother John,
> Then Mother trims 'em with the shears
> And William put 'em on.
> When Bill's thin legs too long have grown,
> His trousers fail to hide 'em.
> So Freddy claims them for his own
> And stows himself inside 'em.
> Next, Ted's fat legs they do invest
> And when they won't stretch tighter,
> They're washed and turned and then re-pressed,
> And fixed on me — the writer.
> Ma makes 'em into rugs and mats
> When I have bust the stitches.
> I wonder, shall we ever see
> The last of Dad's old breeches?

This little poem, written by Gladys Withers for her family during the war years, sums up the inititative and extent of the making do and mending which became the cornerstone of surviving the restrictions of clothing. Even the calico and fine hessian sacks in which the sugar and flour came to her father's bakery were utilized by the family. Unpicked, and washed, the sacks became pillow slips and even undergarments.

Mrs Nancy Cawthorne remembers her mother brightening up the curtains by dyeing them in a Camp coffee solution. 'If you saw a queue you joined it,' she said, 'and then found out some time later what it was!' Joining a mysterious and slow-moving queue outside Dicks of Cheltenham one dinnertime break, Mrs Muriel Cutts was delighted to discover from those in front that a supply of rugs had arrived. Having recently married and acquired the basic furniture through saving hard and 'dockets', Mrs Cutts shuffled slowly along over a period of one and a half hours dreaming of the rug that she so badly needed to go on the lino in front of the fire. The colour wouldn't matter so much as actually having one at last. 'Breathless with excitement it came to my turn and I asked what colour they had in the rugs. Rugs turned out to be pieces of brown underfelt. However, even though not the grand and cosy rug I had envisaged, I was still thrilled. Neither my pride nor "rug" lasted long, an enthusiastic dog scratched a hole in the middle of it. But it was good while it lasted and I thought more of that rug than any I have ever had since.'

The *Chronicle* ran regular columns of helpful ways for Cotswold ladies to keep abreast of fashion while making do and mending. Frocks can be made to fit by clever shrinking, was one such piece of advice in November 1939, and the Board of Trade issued leaflets on how by turning two old dresses, which were too small, into one dress 'a member of one of the many classes had made a smart frock and saved seven coupons'. In fact, the footnote divulged that this nimble-fingered seamstress had 'saved another two coupons by making a pair of knickers out of the leftover printed material'. Frederick Boulton's of Cirencester offered a free cutting-out service with their material to help the war effort, and Rosemary Guy remembers being requested to stay in during school playtime to stitch lazy daisy flowers all over a hat her teacher had made from lisle stockings which she wanted to wear to something special that evening.

The *Citizen* advertised 'Harrods Famous Knickers' at a reduced price of 3s. 11d. a pair, in the latest colours of khaki, sunrise and air force blue. Fashion followed a military trend, but most people could not afford new clothes and often sold their clothing coupons or exchanged them for a friend's left-offs. Points and coupons and dockets were powerful bargaining and bartering currency — all illegal, but as in any time of shortage the black market flourished.

Covering the hair became a trend; headscarves, turbans and snoods became fashionable substitutes for hats, which often as in the case of felt became something else—felt hats were cut into long strips and plaited or cut into shapes and stitched together as slippers. Posters advising women in factory work to cover their hair 'as your Russian sister does' were aimed at safety when dealing with machines in which long hair could become entangled, but the reference to identity with Russia was at the time when Britain declared admiration for her stand against Germany's aggression.

As 1944 heralded in 1945 the fashion in hair styles as well as hats echoed the V for Victory theme, in the victory roll with the hair dipping to a point at the base of the neck.

### THE KITCHEN FRONT
Dearly beloved Brethren
Don't you consider it a sin
To peel a potato
And throw away the skin
The skin feeds the pig
And the pig feeds us
To keep that potato skin
Really is a must

The war years generated more ditties and rhymes and jingles and riddle-me-rees than any other period in history. All had a message. And that is why it is said the Japanese Intelligence was at its wit's end to unscramble the popular sing-song that trilled along the radio wavelengths:

> Maresy dotes and dozy dotes and little lamsy tivy
> A-kiddleitivytu... woodntu

Probably it was the only little jingle that did not have a meaning other than expressed as

> Mares eat oats and does eat oats and little lambs eat ivy
> A kid will eat ivy too, wouldn't you

which really added to the fun when it was discovered what a lot of Japanese brain power went into trying to interpret an innocent little tongue twister. At the outbreak of war there was a code name given to certain commodities. Nutmeg was the code name for soap when the shortage needed to be broadcast without enemy listeners being aware of the real situation. The BBC broadcast regular hints and advice on its *Kitchen Front* programmes and the Ministry of Food reminded everyone that it was a national duty to keep fit and the healthy eating patterns established through restricted rations of fats and sugar, with the emphasis on wholesome home-grown vegetables resulted, to everyone's amazement, in a nation which proved to be healthier and fitter despite the long hours of hard work and the physical and emotional stresses endured.

> Potatoes new, potatoes old,
> Potatoes in a salad, cold.
> Potatoes mashed, or baked, or fried,
> Potatoes whole, potatoes pied.
> Enjoy them all, including chips,
> Remember spuds don't come on ships

was one of the songs of Potato Pete, a jolly potato character who, with his friend, Doctor Carrot, chipped in their helpful hints and messages, backed up by the Radio Doctor. Locally, the Gloucestershire Education Committee published recipe leaflets 'suitable for wartime' at a penny, and Wessex Electricity ran a Home Management Corner in the *Wilts and Gloucestershire Standard*, in which Our Miss Switch gave ways and means of stretching the rations by adding a little soda to honey for sweetening to

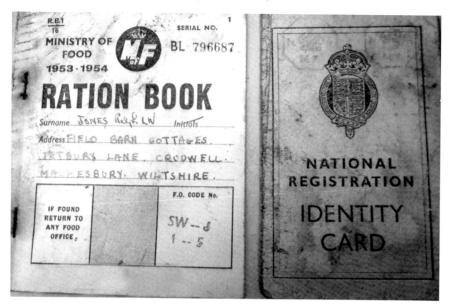

Ration book and Identity Card — essential documents of wartime.

save on sugar, and frizzling rinds of bacon first to extract the fat and then to save them to add flavour to stews.

In the First World War rationing was introduced only in the last year; in the Second, ration cards were prepared a year before war broke out and rationing was implemented within the first four months. Winston Churchill was opposed to rationing; but public opinion on the whole was in favour of it as the well off started to stockpile on a scale that the poorer families could not. The local papers appealed to housewives 'to play fair' and not shop around in several places in order to hoard foodstuffs. Ration books were posted to each household, who then had to register with a shopkeeper by 23 November 1939.

Bacon and butter were the first two items to be rationed, but sugar quickly joined them. 'Bacon for breakfast is a vice', declared Mr Robert Boutflour, Principal of the Royal Agricultural College, Cirencester, as he became chief executive officer of the Gloucestershire War Agricultural Executive Committee. No other man in the world, he wrote, asks for a breakfast like the Englishman religiously demands, and rationing bacon should change his habits to a healthier start to the day. Pig-keeping on a small scale had been practised by Cotswold cottagers for generations and Mr Sid Jacques of Coln St Aldwyns remembers that if two pigs were sent each year to Gilletts Bacon Factory, the householder was entitled to keep one for his own use and a Co-op butcher would kill it on the owner's premises. Pig and Food Production Clubs had started in the First World

37.

WEDNESDAY DECEMBER 23ᴿᴰ.

XMAS DINNER.

Roast Pork with Sage & Onion Stuffing. 400

Apple Sauce

Roast Potatoes, & Greens

— " —

Xmas Pudding + Custard. 400

— " —

| | | | | |
|---|---|---|---|---|
| PORK. | 85 lbs @ 1/6 | | 6 - 7 - 6. |
| GRAVY | 60 Pts @ 1ᵈ | | 5 - 0. |
| APPLE SAUCE | 50 LBS @ 7ᵈ | | 1 - 9 - 2. |
| STUFFING | 30 lbs bread @ 2ᵈ | | 5 - 0. |
| | 30 " Onions @ 5ᵈ | | 12 - 6 |
| | Sage, Salt, Pepper. | | 3 - 2 |
| GREENS | 160 lbs @ 3ᵈ | | 1 - 5 - 0 |
| POTATOS. | 2 cwt @ 9/- | | 18 - 0 |
| XMAS PUDDINGS | 30. | | 3 - 15 - 0 |
| CUSTARD. | 52 pts milk + water | | 9 - 4 |
| | 3¼ lbs Custard Powder. | | 3 - 3. |
| | 3¼ " Sugar | | 1 : 1. |
| CARRY FORWARD | | £ | 15 : 14 : 5 |

Page from catering notebook of a feeding station showing quantities estimated to supply 400 Christmas Dinners in 1942, costed out to 1s. 3d. per head. A note at the end of the costing states: Tickets cost 1s 4d and included tea or coffee. All tickets sold on the two preceding days. All pork was not available and some topside of beef was served. 450 meals were served altogether. A great success.

War and were revived rapidly at the outset of the Second. The Small Pig Keepers' Council, established in 1939 to assist small-scale pig-keeping and administration of registered Pig Clubs, was the watchdog council for enabling pig owners to get coupons for meal; rationing of national pig food or national poultry food was strictly controlled, and it fell to the Club secretaries to distribute the coupons, which were valid for only one month at a time, and to assure registration with a supplier.

The first Communal Pig Club in Gloucestershire was formed in Cirencester in 1940. Mrs Chester-Master spearheaded the canvassing of the whole town, through the WVS, for kitchen waste of which it was estimated that some three tons could be collected each week.

Marjorie Townsend was twenty-one years old when war broke out and her brother William Le Mons — named by his parents to commemorate that famous battle of the First World War — was twenty-five. Their father's two cattle trucks were requisitioned, one by the Ministry of Food, the other by the Ministry of Aviation. Both were involved in collecting pigs from all over the Cotswolds, then Marjorie decided to volunteer as an ambulance driver. No sooner had she reported to her base than she was face to face with Winston Churchill. He shook hands with Marjorie and asked what job she was doing before joining up; she told him that she and William collected pigs from every village of the Cotswolds. 'Then that is the most important job you should be doing,' he told her, 'now you get back and carry on with that'. Poor Marjorie had no choice but to return to the pigs instead of the clean clinical smells of the ambulance unit for which she had just got a smart uniform. Marjorie was left to do the pig-collecting until the end of the rationing, while William was directed to driving the other cattle truck heavily camouflaged to carry building materials for Brockworth aerodrome and then transporting parts of the aircraft from all over the country as directed. 'We knew every pigsty in the Cotswolds during the war years,' he said.

The rumour that the English pint of beer was to be weaker in order to free barley for pig feeding had to be scotched in 1940. A spokesman for the breweries said 'this is wishful thinking on the part of the pig-keepers who find it difficult to obtain their full requirements of feeding stuffs, but I can't see the Minister of Agriculture commandeering grain which is of good malting quality fetching 70s. a quarter to make it available for feedstuffs which is only paid for at the rate of 25s. However, in June 1941 Broadway in the north Cotswolds got in the news for having 'the pubs with no beer'. The shortage of beer in some parts of the rural areas was a combination of increased population from evacuated families, servicemen from bases throughout the country and 'the tendency these days of young women frequenting licensed premises, about which a few licensees refer to the

SUGGESTION FOR SPENDING
2000 POINTS

| Item | Points |
|---|---|
| 4 6lb: Tins Luncheon meat @ 86. | 344. |
| 2 Tins Grade III Salmon @ 16 | 192. |
| 6 " Tomatos @ 9. | 108. |
| 3 doz: Tins of Peas @ 4 | 144 |
| 8 lbs Rice @ 4 | 112. |
| 8 " Sago - " | 112. |
| 6 " Lentils @ 2 | 112. |
| 8 " Haricot Beans. @ 1. | 28. |
| " Syrup. @ 8. | 224. |
| " Dates. @ 12. | 336. |
| " Figs. @ 6. | 168. |
| " Prunes @ 4 | 120. |
| | 2000. |

An exercise from a catering establishment training centre on how to spend 2,000 points, from a notebook of the Hamilton Smythe family who lived at Meysey Hampton.

growing practice with concern'. The additional summertime meant that so many men working the extra daylight on farms and allotments could not reach their favoured inn by the closing time of 10 p.m. Broadway decided to look after the interests of its own sons of the soil and by mutual consent all the licensees closed at certain parts of the day in order to conserve supplies for their own locals at night. One landlord penned his concern at having to close his tavern when the beer ran out:

> We do not close this pub for fun
> But only when our stocks are done
> And when we've nothing left to sell
> Remember we're fed up as well.
> Also, please remember, too,
> That though it may be hard on you
> It's mighty harder still on us
> To see our business going bust
> But if, when all is said and done,
> This shortage helps to beat the Hun
> Let's count everything we've lost
> As but a very little cost

But, John Lewis, the landlord, asked, does the shortage help to beat the Hun? A good deal of avoidable industrial unrest was caused during the last war by too severe reduction of the beer available. Deprive the worker of his beer and the war effort will suffer. In July 1941 the plan for issuing coupons to bring in beer rationing was rejected 'in the public interest'.

The basic commodities of the countryman's diet were rigidly controlled on quantity, quality and price. In February 1940 a maximum prices order, number 4, was introduced and a trader was fined £5 for the overcharge of one farthing. A Burford farmer was fined similarly for watering his milk.

1940 introduced rationing. The ration book became the most vital item from 8 January in the household. In March, meat was rationed by value rather than weight; offal was not rationed because of its limited keeping value, but was often very difficult to get. In July, tea joined the list, which was to become even more extended after the heavy losses of shipping in the Atlantic battle and subsequent Far East involvement. In May 1941 cheese was rationed at an initial mousetrap bite of one ounce per week. Shell eggs came under Government restrictions in June and a mere two and a half dozen fresh eggs, per year, were allowed per person. A points system was then instituted to ensure a fair distribution for all: in November 1941 the allocation was twenty points per person every four weeks, and by the end of December 1942 pulses, dried fruit, cereals, condensed milk, oats, rice,

tinned fruits and vegetables, syrup, treacle and biscuits, sweets, cooking fats and preserves were strictly rationed.

The actual quantities of the rationed goods did vary slightly according to availability, but generally the following guide was the average for one adult for one week.

| | |
|---|---|
| Bacon and ham | 4 oz (113 g) Meat to the value of 1s. 2d. — 1s. 10d. sometimes offal formed part of this allowance |
| Butter | 2 oz (57 g) |
| Margarine | 4 oz (113g) |
| Lard | varied 2–4 oz (57–113 g) |
| Milk | 3 pints, often 2 |
| Cheese | varied from an initial 1 oz–2 oz (28–57 g), then 4–8 oz (113–226 g) |
| Sugar | 8 oz (226 g) |
| Tea | 2 oz (57g) |
| Eggs | 1 per week when plentiful, otherwise per 2 weeks |
| Sweets | 12 oz (340 g) per 4 weeks |

Household milk and dried eggs were powder forms which could be reconstituted with water, but also formed part of the rations to become a new type of food along with strange varieties with compound names, such as soyaghetti and farinoca. Substitutes and omissions and disguise exercised the imagination of cookery experts and housewives alike; vinegar cake and eggless sponge, fadge and mock cream, duck, and goose, champ and hash, padded pudding and pathfinder pudding, turnip top salad, bread soup, savoury oatmeal bakes, English monkey, and wheatmealies were just a few of the ingenious dishes to join the local dunch and feggy dumps and Cotswold clangers. An ATS unit in the Cotswolds was reported as having rations with a difference due to the culinary brains of their Czech cook who was 'able to disguise the everlasting army sausage' with flair and imagination.

Country children munched beech nuts and hawthorn leaves, locally called bread and cheese although they tasted slightly peppery and not at all like cheese; hedgerow fruits and a scrubbed carrot from the garden helped stave

off a few hunger pangs between meals. 'We always seemed to have good stews from such unlikely things as pigs' tails and trotters, pork bones and vegetables, and sometimes tripe and onions, we thought it all quite delicious,' reminisces Mrs Ceinwen Smith. 'We used to make up a little paper cone from a triangle and wrap it round our finger and screw up the bottom to make a small bag, then mother would put a spoonful of sweetened cocoa in it. We took it out to play and would lick our finger then dip it into this mixture to suck off — it was lovely.' Phil King remembers the night a line of American lorries skidded into a ditch on the Cirencester to Swindon road from a combination of icy conditions, black-out and unfamiliarity with the district:

My father went out to see what had happened. It was a bitterly cold winter's night and the sight of those shivering soldiers set my mother and a neighbour to put on kettles and mix up powdered milk and raid the meagre rations to provide them with a hot drink while they tried to get the vehicles back on the road. My mother made a big jug of Ovaltine and Mrs Baker made a big jug of Bovril and they refilled the jugs a couple of times until they were satisfied that all the soldiers had received a drink. A tiny coloured American carted the jugs back and forth and poured the drink into their own mugs. Eventually he knocked on the door to return the empty jugs and brought an orange for me and a packet of biscuits in gratitude. 'Ma'am that was sure good tea, we've only just come into this country, heard a great deal about the English cup of tea and I reckon I must have just mixed the right amount from both jugs, cos it sure was good.'

Mrs Pauline Fairclough recalls her nursing during the war often meant an odd orange came the way of the hospital; so precious were imported citrus fruits that once the orange had been eaten by the patient, Pauline would carefully pare off the peel and store it to bring home to her mother to add to the marmalade making. Her father, Lt. Col. Donald Macleay, although grateful for the equally salvaged and scarce razor blades, would not reciprocate his daughter's treats by letting her have a few eggs to take back as they had to go to the Board, and he would not bend the rules. Extra vegetables grown at Eastington House helped to feed the evacuees, then later the British Restaurant in Cirencester — the communal feeding centre.

Robert Ely remembers two summer holidays in the Cotswolds 1942-3, cycling with his mother from their home in Warfield in Berkshire to Swindon to go by train to Stroud, then cycling on to Nailsworth to stay at Dunkirk House in Amberley. Mrs Walker, widow of a Doctor of Engineering, was very proud of the fact that her paying guests were served home produce. 'But,' Robert reflects, 'the portions were desperately meagre and my mother would take me to the British Restaurant in Nailsworth

to "top up". There one could eat cheaply without handing in any food rationing coupons. To the best of my memory, soup was 3*d*. (1*p*), main course 7*d*. or 9*d*. (3*p* or 4*p*) and pudding 4*d*. (2*p*).

As preserves became rationed the move towards making them at home increased to cottage industry proportions, and points for preserves could be taken in equivalent rationed amounts of sugar. A ready market for the home-made jams and marmalades and pickles extended the initiative to village preserving centres at the request of the Ministry of Food. Initially, as at Crudwell, the preserves were sold to local tradesmen, the public preferring it to factory-made varieties. The Malmesbury Group of Women's Institutes centred their preservation of fruit activities at Crudwell Court and had made over one ton of jam by early September in 1940. A Jam Club was formed by Beverstone and Chavenage Mothers Union in 1940; within the first two months the ladies had produced 600 lb (270 kg) of jam, all sold at Park Farm, and were working on achieving an even bigger output with the 40 cwt (2 tonne) of sugar allocated to them.

Many small villages set up their individual clubs: Eastleach formed a committee to oversee their activities and produced in the year of 1942, 1,076lb (484 kg) of jam and bottled 101 lb (45 kg) of fruit and vegetables. They moved that the baker's oven should be repaired under the direction of the Local Defence Committee as it was designated the village lifeline in the event of an emergency. Flour was also to be stored at the bakery as the village stock.

The full extent of the production of the ladies of the county can be judged by the following table of fruit preservation through the Gloucestershire Federation of Women's Institutes during the war years.

| Year | No of centres | Jam (lb) | Cans | Bottles | Pickles | Other |
|---|---|---|---|---|---|---|
| 1940 | 80 | 112,000 (50 tonne) | 4,000 | 3,000 | | 11 cwt (559 kg) |
| 1941 | 162 | 82,000 (37 tonne) plus unstated 'large quantity bottled fruit' | | | | |
| 1942 | 82 | 70,000 (32 tonne) | 5,124 | 2,856 | 2,400 | |
| 1943 | 46 | 46,000 (21 tonne) | 3,426 | 3,869 | 2,618 | 934lb (420 kg) |
| 1944* | 26 | 23,000 (10 tonne) | 1,165 | 1,681 | 2,200 | |
| 1945 | 8 | 3,060 (1.4 tonne) | 22 | 202 | | 48 lb (22 kg) |

* A very bad year for fruit

Little wonder the WI earned the label 'Jam and Jerusalem'.
Mrs Edie Adams of Cirencester recalls:

> We shared everything, you see. I had £3 a week to keep my seven children
> on. We would bring the sweet ration home and line every sweet up and
> share them out. At Christmas I would wrap a penny in shiny paper to
> make it look more special in the toe of each stocking. Once I gave the chil-
> dren a few pennies to buy their own sweets which they then brought home
> and I hid them until Christmas. It was dreadful to find that I had hidden
> Anne's so well that I couldn't find it, and I had absolutely no money left
> to buy even a handful, but the others all shared theirs with her. No matter
> how scarce foodstuff was, our mother, Ethel, Victoria Bowly, Annie Fowler
> and myself would scrimp up a few bits and make cakes and sandwiches
> for the dances to raise funds for the hospital. Not only were the rations
> scant, but they were about as much as we could afford anyway. Often I
> only had 6d. at the end of the week to feed the lot of us. My husband was
> in the Navy and used to write home about how well they were fed — but it
> was all blown up really just to stop us worrying about him. Often we had
> a meal of bread and white sauce as there was just nothing else. However
> Ethel and I found enough from the houses in Bowling Green to give the
> children a street party when war was over is a miracle.

The sight of overflowing swill bins at military camps, with bread bobbing
about on the top, brought an angry response from local householders at
the height of the shortages and at a time when one had been hauled before
the Bench for giving a dog a crust. The *Bristol Evening Post* reported the
case of one woman being fined £10, with two guineas cost, for 'permitting
bread to be wasted'; her servant 'who was seen throwing crumbs of bread
into the garden for the birds twice in one day' was fined 5s. for actually
commiting the offence.

Controlling food in wartime was a mammoth undertaking of
administration according to the figures publicized by the Cirencester UDC
in the first year of the war. A total of nearly four million coupons had been
handled for bacon, fats, tea and sugar alone. The large floating population
had created the issue of 7,000 emergency cards; the arrival of 150 new
born babies had caused a like number of registrations, and miscellaneous
work involved: special issue of sugar for preserve making; canteens for
troops requiring urgent arrangement for rationed goods; special permits
for 'office tea' for ARP and Home Guard personnel; tea and sugar and
cheese supplements to farmers for harvest workers; sugar permits for bee
keepers; re-registration between traders, and the dealing with irate people
complaining of strong butter, tainted meat, dirty sugar and fat bacon.

Typical of street parties up and down the country is this one in Cirencester at Kingsmead to celebrate the Victory in Europe.

If the in-trays of the offices were overflowing, and the housewife's cook pot underfilled, there was also the weight borne the other side of the counter on the shoulders of the baker and grocer who had to juggle the administration of the one with the admonition of the other. Mrs Gladys Withers recalls the immediate inspection of her father's bakery when war was declared by officials from the Ministry of Food:

> in case bread became rationed straight away. They checked his stocks of flour and a proportion of wheat flour, to which peas and other pulses were added, had to be used in baking what became known as the 'standard' bread. In fact, it made a very acceptable loaf and customers preferred it to the fine white flour bread. There was very little choice of the few sweets allowed on the rations, but many children liked to chew liquorice root and the imported locust beans when we could get them. These were similar to our runner beans, but dried. We could buy about four for a half penny and they were as sweet as honey. We used to think we were like John the Baptist feeding on them when he was in the wilderness.

Highfields Post Office in Rosebery Road, Dursley was home to the Whittard family during the war. Mrs Josephine Davey recalls her childhood on the other side of the counter as one fraught with worry about what would happen to her parents' business if she lost the envelopes containing the

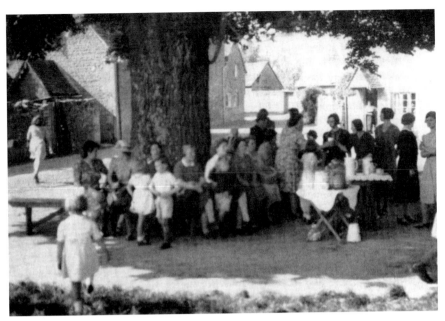

On a smaller scale, VE Day was celebrated by tea on the village green at Temple Guiting (Courtesy, Gloucestershire Record Office).

precious coupons which she had to take to Kingshill House:

> I also had to make sure that the envelopes were not opened by anyone but the right person at the Food Office. Many times we had to forfeit some of our own meagre rations because there was a shortage caused from inaccurate cutting up of ounces of cheese and bacon; that was certainly a good training for any would-be provision assistant. I well remember how we used to hold our breath at the end of each month when the sitting room table was covered with these small pieces of paper called points and coupons. We dared not breathe in case they scattered to the floor and got lost. It was quite a headache on red letter days when bananas arrived as to who should have them and how many.

Mr Tudor Williams of Prestbury also had childhood Sundays punctuated with points:

> My father was the manager of a busy grocery store and what started off as a kind of game involving the whole family in sorting out the scraps of paper, some of which were no more than half an inch square, into their right tins, soon lost its novelty. We would make excuses, but eventually had to accept that it was all part of Sunday. After dinner, the tins would

be emptied on to the huge kitchen table and we would scramble for our preserve, putting the points and coupons in their rightful tins because in a busy grocer's shop they often got muddled. It was impressed upon us the importance of our task, because the Ministry of Food would only supply the equivalent rations for the amount of points collected. Often, though, he would relieve us and let us listen to 'Hi Gang' on the wireless. I can imagine him and a fellow grocer working out the prices for the next batch of supplies in the odd moments they could catch as Special Constables. On his one half day off a week, he would be digging for victory, supplying us and visitors with good home-grown food. Probably the only relaxation he had was reading The Grocer, a dull-looking weekly magazine full of facts and figures from which he had to check the ever fluctuating prices and ration quotas. I used to be offered a lot of lifts from our village into town. The conversation would be very lighthearted until we reached our destination, then the question I would be asked was 'has your father's whisky ration come in yet?' Fortunately, I never knew the answer; but I saved a lot of bus fares.

The cost of the rationing system was astronomical. Figures published after the first year of the war resulted in a rationing of the ration books and a rationalization of the scheme itself. From January 1941 ration books were issued for a whole year instead of every six months; customers could buy two weeks' rations at a time, and they did not have to re-register every time new books were issued, but they had the right to change their retailer every month where necessary. The saving for one year was estimated as some 360 million counterfoils, 14,500 million coupons and 15 million coupon envelopes. The economy of one ration book instead of two in a year meant a saving of 1,000 tons of paper. The cost of producing 50 million ration books worked out to £70,000 plus another £90,000 for postal delivery charges.

Paring close to the bone, literally, was the skilled job of Fred Haddrell at Jessie Smith's, the main slaughterhouse in Cirencester. It was a long week of long hours, working until 2 p.m. on Sundays. Cattle trucks were requisitioned by the Ministry and transported the meat to the old livery stables in Dyer Street to be rationed out to the butchers in the town. Cattle were often walked down led by oxen. The average ration was by price at 1s. 10d., but Fred remembers the lowest being 10d. worth per person per week in acute shortage. A 12 oz (340 g) tin of corned beef, costing 10d. was often the only meat some families had for the week. As offal was not rationed long queues would form if customers thought a lorry was delivering some. A lot of liver was frozen. It came in 6 lb (2.7 kg) tins and had to be thawed out before it could be cut up and eked out.

One dinner-time two men delivering to the old cottage at the back of the shop for safe keeping were trapped inside for over an hour by the Haddrell's dog, who had been taught to 'guard the rations'.

Foot and Mouth disease struck in 1941 at the height of the serious food shortage. Fred was directed by the Ministry to Moreton-in-Marsh to slaughter over a hundred pigs; he had to stay on the farm to complete the job of segregating the infected animals, which had to be destroyed then burnt, and killing the unaffected animals to be kept in frozen condition for a month. 'My hardest bed was the concrete floor of Moreton Station,' he recalls. 'The Manager, Frank Chapman, had to collect bread from Cirencester to feed our small gang as we had to go round all the farms in the neighbourhood with the Ministry's inspectors. Moreton shops only had enough food for their own registered customers. We worked at Moreton from dawn to dusk, we just had to contain the disease.'

The old Cotswold saying that you can use every part of a pig but its squeak, was more than a homespun homily in the crucial dark days of self-sufficiency for self-preservation. 'Sheep gut was worth far more than meat for eating,' Fred explained:

The gut was vital in surgical stitching. Medical supplies were reliant on the slaughterman's skill. We had to cleave the bullock's head behind the brain at just the right spot and extract a gland with tweezers. It was a delicate job and you needed the steady hand of a surgeon not to bust it. It was worth 4*d.* to the slaughterman but worth its weight in gold to medical science — I think it was used in arthritic diseases. I understood the spinal columns of the animals were used in cosmetics, the foundation for face powder and hair cream. We had to save the gall bladders from the cattle in five-gallon drums, and they were used in the manufacture of indigestion tablets. The glands each side of the kidney for insulin, and the female ovaries of beasts were transformed into a chemical injection against haemorrhage in childbirth. The inspectors were very strict on saving. Sheep gut had to be washed in hot water and bundled up in fives. Every bit had to be cleaned before it could go on for medical purposes. It was heavy work. I think I can say that it was only Joe Mustoe who could bend down while carrying a quarter of beef on his shoulder, weighing anything up to 200 lb [90 kg].

The expertise of the slaughterman was the salvation of wartime medicine.

Heroism of the food front has been filed away in the archives of the Ministry of Food, but one incident was reported in the *Wilts and Gloucestershire Standard* in 1940: 'when a time bomb came crashing into a slaughterhouse during a recent raid, the men were persuaded to stay and

get on with the work of dressing the carcasses and getting the meat into a safe place while the manager sat on the bomb and smoked his pipe in order to instil a feeling of cool calm'.

The stoicism of the Englishman can also be summed up by the way John Hoskins dealt with a bomb that had crashed through the roof of his house and landed on the kitchen table. Mrs Hoskins had just placed a plate of bacon and egg in front of him. With quiet contempt, John picked up the bomb, opened the window and hurled it outside — it landed a little way off and went off, the explosion smashing the window. Calmly announcing that he would deal with the damage later as he had more important things to do — he was working at the Stirling aircraft factory, and then there were his all important bee hives to tend to — 'I'm not letting any German come between me and my breakfast', he said.

# Seventy Years On

Th' Recording Angel at our last parade,
Well noted countless thoughts of us who paid
Our one last time in rank with comrades good.
Sad thoughts and glad, the phantom mem'ries passed,
Of seven full years of service duly past.
The early days of class and exercise,
The Munich 'knell', the sudden enterprise
Of census, gas mask, urgent action, for
Our World was plunged in all-pervading war.

This extract of a lengthy poem penned by ARW in the *Stroud News* at the end of June 1945, commemorating the Farewell Parade of all Civil Defence Services in that area, sums up the feeling of the thousands involved in the defence of their home patch. A stand down of the emergency services started with relaxed control about March. The Government decreed that 2 May 1945 was the day on which the Civil Defence organization was no longer needed for the purposes of war, and a general winding up of the services started immediately.

Coincidentally, the 'appointed day' of stand down was the date on which the *Daily Express* published Hitler's obituary:

> The *Daily Express* rejoices to announce the death of Adolf Hitler. It prints today every line of news obtainable about the manner of his death. It wastes no inch of space upon his career. The evil of his deeds is all too well known. It gives no picture of the world's most hated face. It records that Hitler was born Schickelgruber at Braunau, Austria, on 20th April, 1889, and that his days upon the earth he sought to conquer were too long.

Hitler was burned in effigy on bonfires throughout the land and house-wives scraped an almost bare cupboard to make a mountain of jam sandwiches and cakes for the street parties to celebrate the end of war.

A quiet pint by Quenington locals outside the Pig and Whistle pub, which The Inklings (C.S. Lewis and J.R.R. Tolkien) discovered when they came to the Cotswolds to celebrate the end of the war in December 1945 (Courtesy, Lucy Abel Smith).

A look back to the past, a group of schoolchildren are led by Peter Grace, founder member of the Living Memory Historical Association, on their way to see the air raid shelter in the Memorial Hospital grounds at Cirencester. The imposing building in the background, redesigned from an earlier non-conformist chapel, was the annexe and X-ray department, built as a memorial to the town's 209 servicemen lost in the 1914-18 war.

The Inklings, as the academic trio, C.S. Lewis, J.R.R. Tolkien and Charles Williams became known, planned to delay their victory celebrations until the end of the year 'To take a whole inn in the countryside for at least a week, and spend it entirely in beer and talk'. But Charles Williams had died before the plans materialized; Warnie Lewis joined his brother and Tolkien — none of them could spare as much as a week away from their commitments, so they came by train from Oxford to the end of the line and stayed a few days at the Bull Hotel in Fairford, and found 'down on the river a perfect mill-house where we amused ourselves by dreaming of it as a home for the Inklings'. They found a pub called the Pig and Whistle at Quenington. They walked and argued and admired the countryside in the subtle light of winter and then they went home to Oxford.

Before Wally Glavor went home to the United States, after serving at the 186th General Hospital in Fairford, he 'liberated' a Union Jack flag that was flying in the Market Place at the VE celebrations to take back as a souvenir. Wally, after half a century and gentle, good humoured banter with Ralph Wilkins, a retired detective and Cirencester Old Grammarian who was on a visit to the States, gave up the flag and Ralph returned it to Fairford.

Preservation of wartime memorabilia has fallen to a dedicated few in order that future generations can see for themselves the artifacts and get some sense of life during that time, and the Living Memory Historical Association at Cirencester has set an excellent example by basing their exhibitions at the old Memorial Hospital air raid shelter. Over 40,000 visitors from all over the country and overseas have been attracted to it over the last two decades.

Nationally, recognition of those who played such a crucial part in this period in our history has been slow in coming — some seventy years on medals are still filtering through for such services as the ATA and the Land Army; and only now, in 2009, has a UK's Armed Forces Day been inaugurated.

But the capitulation of Germany on 8 May did not mark a sudden return to pre-war life. Far from it. Food shortages were realized in an austere diet in 1946, when bread and cakes and flour were rationed for the next two years having not previously been during the whole of the war years. Rationing continued until the 1950s, although some foods gradually 'came off' as supplies became more available.

The last of the evacuees returned to their city homes in June 1945; many stayed and made their home in the Cotswolds — some had no home left to return to, others stayed by choice. A new community of people settled in the Cotswold villages: 'squatters' were housed in the abandoned army and air bases and 'pre-fabs' mushroomed on the periphery of many parishes.

The Scott Report of 1942 had highlighted the inadequacy of housing, sanitation and lighting particularly in the rural areas in village halls and schools as well as the family home; the role of the farm worker was being appreciated for its worth and some attempt was made to increase wages, and holidays with pay were introduced, but the drift from the countryside increased as better pay and conditions were offered in the post-war industries in the towns. Prisoners of war continued to work the land and the Land Army continued until November 1950.

The firm of A.W. Hawkesley of Hucclecote switched its production from aircraft to aluminium bungalows in June 1945 and was turning them out at four an hour. Gloucester had its first twelve post-war houses built in Finlay Road by December 1945 and street shelters were demolished, providing employment and a real sense of a return to peace. In 1948 the Ministry of Aircraft Production disposed of their interests in Smiths Aerospace and Defence Systems to the company and Cheltenham Rural District Council co-operated in a housing association development which formed the nucleus of the post-war estate of Bishops Cleeve.

POLISH HOSTELS

Resettlement had an entirely different cultural connotation for the Polish people displaced through the last war. The forgotten odyssey, as a recent documentary, produced by Lest We Forget Productions, has called the forgotten tragedy of some 1.7 million Polish people of various faiths who were forcibly removed from their homes and deported to special labour camps in Siberia, Kazakhstan and Soviet Asia. The film is but one of the publications to start appearing as the search for the truth delves deep into the history and politics and painful memories of the survivors. Recently published statistics show that Polish people are the sixth largest national group in Europe; the UK has the seventh largest Polish diaspora with around 500,000 established Poles in Britain today. Following the end of the war in which many Polish servicemen had fought with the Allies, the British government reluctantly allowed some of them to come to Britain with those of their family who had survived the Siberian and Nazi labour camps, rather than return to the communist regime in Poland. A Polish Resettlement Corps was raised in 1946 as a corps of the British Army into which Polish servicemen enlisted for the period of their demobilization in 1948. Accommodating the refugees, who were considered as a 'special case' because they had fought alongside the British against Hitler's forces, was in the vacated military camps and field hospitals as a temporary measure.

Fairford was the largest of a number of Polish Families Hostels set up in the Cotswolds, utilising the barracks that had been built for the American 186th General Hospital. Administered by the National Assistance Board, with a warden and a Residents' Association, Fairford became home to some 1,200 Polish people from 1947 until the termination of its lease in 1959. Like most of the Polish camps, Fairford had just basic utilities: initially families shared barracks, there was no regard to privacy, but eventually they were re-distributed so that family groups could be together; tarpaulin, blankets or some form of curtaining partitioned off a sleeping area, but the majority had to use communal washing and toilet facilities. Furniture was little more than wooden fold-up chairs and iron-framed beds, with a solid-fuel stove for heating and cooking.

Resolute and resilient, as the Polish people are, the austere corrugated iron barracks *beczki* meaning barrels, from their rounded shape, became more homely and comfortable as the women softened them with net curtains and cushions and embroidered wall hangings, buying the materials with the little money they could earn and turning their sewing skills to good use. Cultivating the plots around the barracks where they could grow their own vegetables and sometimes a few chickens brought some form of security and settlement into their lives, as well as supplementing the meagre rations to which everyone was subjected.

Alicja Swiatek Christofides, who was born at Fairford, the largest Polish family camp of the eight in Gloucestershire, posing in her Sunday best outfit made by her mother contrasting with the ramshackle barrack of a neighbour's Nissen hut.

Life was hard, but they were free and determined to make the best of what they had and were capable of. Devoutedly Roman Catholic, religious services and festivities were celebrated at the small brick built chapel close to the entrance of the hostel. Weddings and funerals were conducted at St Thomas of Canterbury RC Church at Horcott; more than half the churchyard there is now filled with Polish graves, visited by relatives every year on All Souls' and All Saints' Days when they leave lighted candles in decorative holders to burn all night.

Integration into English community was initially hampered by the language barrier, and the camp's translator, Boleslaw Wojciechowski, and the administrator, Mr Cymberkiewicz were significant figures in the smooth running of the hostel — the official name given to it, but the Polish people referred to it as *oboz*, meaning camp, which became as close as possible to a self-contained Polish village with its own medical centre, kindergarten and junior school. Dennis Bridges opened up a branch of his family grocer's shop in one of the nissen huts with as much of the Polish foods as he could get, in response to the residents' requests for such delicacies as salted herrings and the camp became part of the local milkman's round. When Fairford staged a post-war revival of its famous carnival, the Polish entry in the decorated floats was a tableau of St George and the Dragon, depicting Freedom — an appropriate choice as St George is the patron

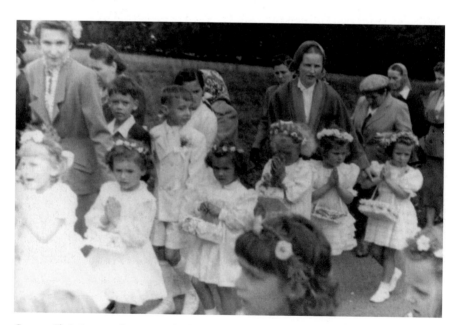

Corpus Christi procession at Fairford Polish Hostel.

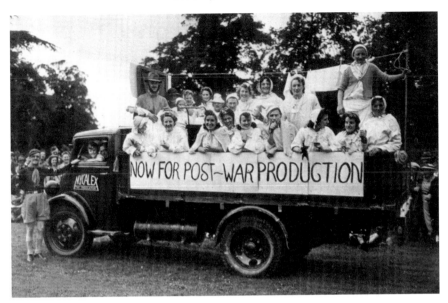

A look forward to the future with this 'Now for Post-war Production' float entered by Mycalex of Cirencester in the revived carnival.

The Walecki family were re-housed at Lechlade after the Fairford Polish Hostel closed. (Left to right) Maria Walecki holds baby Edwin, Richard Ziotkowski, 'Simpie' Trew, Marian Walecki with Trixie the dog, Ewa Walecki and Zygmunt Walecki in the garden of their Gassons Way home.

saint of both England and Poland. Tenacity to their culture and customs
meant many a school and church fete were enlivened by the colourful and
exuberant folk dancing of the Polish youth in their traditional costumes,
and Mary Vizor recalls the musical talent of the Poles when the Fairford
Silver Band were invited to take part in their social evenings — with one
bandsman missing his notes completely at the end of one Christmas party
on the strength of the Polish hospitality.

By 1954 the English Fairfordian was in a three-to-one minority with
1,200 Polish people in the Park and over 2,000 American servicemen at
the RAF Base at Horcott. Although the Base and post-war construction
and engineering works were providing extra work in the area, there was
real competition for jobs especially as demobbed local men had returned
to a different social structure and economy from which they left to serve
in the war. Poles were known to be hard workers and were keen to work
to feed and clothe their families and save as much as they could towards
an independent life once the camp was disbanded. Many skilled and
highly trained Poles ended up working in the most menial jobs, simply
to be employed: Mr Kanas, for instance, had been a judge in Poland but
could only find a job as road sweeper at the camp; Polish qualifications
were not always accepted by English employers, Unions fiercely protected
British jobs for British people, and the inability to communicate in English
were major problems to overcome. Education in the English system was
recognized as essential and parents supported and encouraged their
children to dedicate themselves to do well at the local schools — which
they certainly did, working hard at their lessons, with a creditable number
going on to grammar school, college and university, and giving local teams
a run for their money on the sports field.

Marian Walecki lived at the camp until he was nine years old and the
family was rehoused at Lechlade. He says: 'I remember us all harvesting
cabbages and using a washboard, which had been adapted with cutting
edges, so we could shred the cabbage to put into barrels to make
sauerkraut. The barrels to me were enormous and wonderfully made out
of wood with metal banding. Before the new Farmor's School was built
in the Park we had to trudge through the town to Coln House School at
Horcott to use their playing field, going barefoot because the leather studs
were the ones which were nailed in, and my parents couldn't afford for
me to wear the boots out on the pavement. I had to make them last and I
thought Chris Mattingley must be very rich because he had nice new ones
and always clean laces. We all had to share spikes for sprints, regardless
of whether they were too large or too small for us. Brian Cooper was the
best sprinter, so he saw more of them than anyone else. I was the only boy
in the Fifth grade in the shorthand and typing classes as I thought I might

A family friend holds baby Alicja while Alicja's parents, Sabina and Ignacy Swiatek with Sabina's mother (centre) Wladyslawa Marczewscy look on proudly.

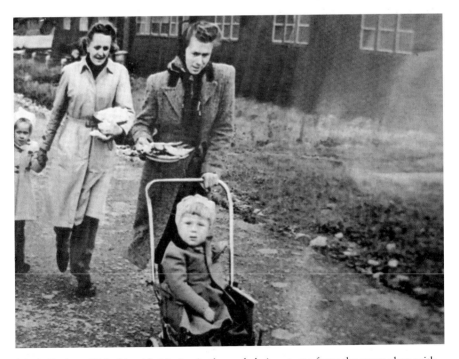

Maria Barbara Walecki, with Marian in the pushchair, returns from the camp shop with a plate of salted herrings, followed by Klima Osinska and Krysia.

have become a reporter. I later went to The College at Swindon and then on to London University. I loved being food monitor at school dinners as I chose the table directly opposite the serving hatch, because my table being the closest got any seconds that were going! I often wonder what it was like for the last of our family when we had to use the same water in the zinc bath once a week. When we moved to a council house we only had a few bits of furniture which we had through the State vouchers, plus a radiogram which was our pride and joy. The joy for his younger sister, Ewa, was having a bedroom to herself, instead of being partitioned by a curtain in her brothers' space in the nissen hut, and the initial novelty of going upstairs to sleep. 'I must have driven them all crazy,' she recalls, 'as I would get out of bed several times during the night simply to run down and back up the stairs.'

The highlight for the Polish residents was the day General Wladyslaw Anders visited in 1953. Accorded full celebrity status, General Anders was greeted with ceremonial honours as a national hero and saviour of the hundreds of thousands who had marched his army out of the prison camps in Siberia and the Gulag Archipelago through the Middle East, fighting for the Allies and eventually to Europe and freedom.

Alicja Swiatek was also born at Fairford Hostel to where her parents and grandparents came by way of transit camps in India after their exile in Siberia. She grew up with snippets of their ordeals and suffering floating through her young mind like bad dreams, and accepted the ritual of her grandmother kissing any small piece of stale bread to be thrown away after mentioning how, like thousands of other starving families in the labour camps, they somehow survived on a ration of half a loaf of hard black bread a week. In the inhospitable landscape of a Siberian winter there were not even grasses to pick and stew, and certainly no animals for food. Not even half of the estimated one and a half million Poles who had been forced out of their home at gun point to be herded on to cattle trucks, thrown on to sledges, but mainly marched to Siberia survived. During her time in a transit camp in India, Alicja's mother, Sabina Marczewska, had learnt dressmaking and pattern making; she managed to bring her Singer treadle sewing machine to England as the family was one of the 245 displaced Polish people picked up in India to come by sea on SS *Ormonde*. Using her skills she was able to make clothes for the family, and cut their hair, her father mended their shoes, and Alicja's father turned his artistic skills to painting and 'graining' orange boxes to make extra pieces of furniture such as cupboards so that they could live as economically as possible, saving and dreaming of the time when they could have a real house of their own again. The ethos of poverty and uniformity of the camp's environment made a striking and incongruous environment

against, and in which the Polish people dressed smartly and fashionable in their home-made clothes which gave them identity and independence and dignity in their free life to make a new future.

Northwick Park in the north Cotswolds has recently erected a monument listing all the camps for the displaced Polish people in Gloucestershire — each with its story to tell.

## EPILOGUE

Comparisons are always invidious and misleading, so related to the country as a whole it might appear that the official status of the Cotswolds as 'a safe area' was fair; but they did not escape unscathed and many survivors of those war years may still be amazed to know the extent to which they and their contemporaries were involved. Official figures reveal that in one period of thirty-one days in 1940 alone, one area of the Cotswolds bore

General Anders (centre), who was responsible for getting thousands of Polish people from labour camps in Siberia to freedom through the 2nd Polish Corps, was given a hero's welcome when he visited Fairford Hostel in 1953 (Courtesy, Urszula Wasilkowska).

the strain of some 345 hours of air-raid warnings, covering the whole of almost every night and part of the days. Between June 1940 and February 1944 some 237 people were killed and 696 injured. There were nearly 1,000 incidents which were the result of the dropping of 4,000 high explosive and 20,000 incendiary bombs and 10 parachute mines; they damaged four churches, two chapels, a babies' home, twenty-one farm buildings, six schools and 2,400 houses. Behind those statistics are as many stories, of those who lived and died in those times: this book tells of a few of them; I offer it to them as a kind of literary litany, and a fervent prayer that never again will there be *The Cotswolds at War*.

# Index

Ablington 88, 89
AFS (Auxiliary Fire Service) 62-66, 68
Aldsworth 88, 95, 133, 202, 204
Amberley 231
Ampney Crucis 24, 89, 91, 93, 102
Ampney St Peter 90, 92
Andoversford 54, 88, 92, 217
Arkell, Reginald 131
ARP (Air Raid Precautions) 50-57, 59, 61, 62, 68, 69, 75, 77, 80, 81, 84, 86, 129, 233
Ashton Keynes 127, 141
Aston Blank see Cold Aston
Aston Down 41, 67, 87, 108, 110, 116, 158
ATA (Air Transport Auxiliary) 41, 118-123, 241
ATC (Air Training Corps) 26, 176
Avening 127

Babdown 95, 105, 108, 180
Bagendon 29
Badminton 47, 48, 49, 87, 90, 195, 206, 207
Barnsley 91, 108, 116, 217
Barnwood 53, 72, 95, 189
Bath 66, 81, 89, 167
Batsford 73, 90
Beaufort, Duchess of 49, 180
Berkeley 61, 208

Beverstone 91, 232
Bibury 33, 34, 43, 63, 64, 71, 88, 90, 91, 95, 108, 109, 132, 133, 134, 144, 178, 208
Birdlip 95, 106, 189
Bishops Cleeve 85, 99, 165, 166, 179, 242
Bisley 85
Blakehill 109, 112
Blockley 90, 92, 218
Boddington 203, 205
Bourton-on-the-Hill 45, 90
Bourton-on-the-Water 100, 102, 132, 176
Brimpsfield 92
Bristol 47, 67, 71, 81, 86, 90, 92, 94, 167, 196
British Legion 37
Brize Norton 29, 88, 94, 96, 108, 189
Broadway 45, 174, 227, 229
Broadwell 189
Brockhampton 92, 217
Brockworth 67, 90, 91, 93, 95, 96, 99, 102, 109, 163, 164, 227
Buckland 90
Burford 14, 64, 178, 229

Calcot 87
Castle Combe 109
Chalford 93, 117, 199

Chamberlain, Neville 134, 139
Charlton Kings 93
Charmy Down 123, 124
Chavenage 88, 95, 232
Chedworth 63, 87, 90, 91, 92, 95,
    110, 130, 135
Cheltenham 10, 26, 35, 37, 42,
    43, 57, 59, 65, 67, 69, 77, 82,
    83, 85, 89, 90, 91, 92, 93, 94,
    95, 100, 109, 129, 131, 135,
    163, 165, 166, 170, 173, 175,
    196, 197, 209, 212, 214, 217,
    222
Cherrington 90
Chipping Campden 89, 93
Chipping Norton 15, 110
Chipping Sodbury 88, 89, 90
Churchdown 82, 90, 91
Churchill, Winston 42, 49, 73,
    150, 152, 201, 225, 227
Cirencester 13, 14, 19, 21, 23, 24,
    41, 43, 51, 52, 56, 57, 63, 66,
    73, 75, 76, 81, 82, 83, 84, 85,
    89, 90, 92, 93, 96, 99, 100,
    102, 105, 106, 119, 128, 129,
    130, 131, 136, 137, 167, 170,
    175, 176, 177, 178, 179, 180,
    182, 186, 189, 190, 191, 192,
    194, 203, 204, 205, 208, 209,
    219, 223, 225, 227, 231, 233,
    234, 236, 237, 240, 241, 245
Civil Defence 51, 54, 67, 68, 239
Clapton 61
Coates 89, 92, 93, 207
Cobham, Sir Alan 117
Cold Aston 31, 94, 95, 100
Coln St Aldwyns 90, 215, 219,
    225
Coln St Denys 87, 202
Compton Abdale 87, 91
Compton Bassett 220
Compton Cassey 87

Condicote 95
Cotswold Bruderhof 141, 142
Coventry 45, 57, 86, 91
Cranham 106
Cricklade 54
Crudwell 232

Daglingworth 91, 92
Day-Lewis, Cecil 174
Defence Committee see Civil
Defence
Dorn 90
Down Ampney 23, 109, 110, 111,
    113
Dowdeswell 54, 91, 93
Driffield 58
Dumbleton 211
Dursley 83, 84, 89, 93, 95, 134,
    157, 158, 167, 180, 182, 183,
    195, 197, 219, 234

Eastleach 43, 75, 77, 90, 92, 140,
    178, 197, 214, 232
Edge 198
Edgeworth 96, 167, 194
Elkstone 93, 96
Enstone 112
Evesham 64, 166

Fairford 18, 19, 25, 26, 27, 28, 43,
    51, 63, 93, 95, 96, 109, 112,
    113, 114, 123, 131, 139, 146,
    147, 150, 172, 174, 176, 177,
    178, 180, 183, 184, 189, 190,
    191, 192, 193, 194, 208, 215,
    216, 241, 243, 244, 245, 246,
    248, 249
Farmington 96
Filton 86, 167, 183
Fire Guard see AFS
Ford 44, 45
Forest of Dean 158, 171

Frampton-on-Severn 93

George VI 47, 218
Gloucester 14, 53, 54, 55, 59, 66,
   67, 72, 73, 77, 78, 80, 81, 82,
   90, 91, 94, 95, 109, 158, 160,
   170, 171, 177, 184, 187, 194,
   200, 242
Gloucestershire Regiment 40, 45,
   113, 158, 205
Gotherington 61, 90, 92, 99
Great Barrington 91, 210
Great Witcombe 91
Guiting Power 44, 45, 96

Hampnett 96
Hannington 154, 155
Hardwicke 92
Harescombe 90, 100
Haresfield 87, 116
Hartpury 95
Hatherop 43, 90, 92, 99, 144, 145,
   184, 196
Hawkesbury 70, 84, 90, 96, 99
Hawling 88, 92
Hazleton 92
Highbridge 71
Highworth 150, 151, 152, 153,
   154, 155
Hillesley 69, 70, 92, 96
Home Guard 37-50, 54, 55, 58,
   68, 69, 70, 87, 93, 106, 130,
   133, 233
Honeybourne 45, 170
Horsley 61, 108
Horton 87
Hucclecote 90, 109, 242

Idbury 17
Inglestone Common 215

Johnson, Amy 122, 123

Kelmscot 112
Kemble 13, 21, 23, 87, 90, 92, 94,
   102, 113, 115, 170, 180
Kempsford 23, 24, 25, 42, 131,
   173
Kingham 128
Kings Stanley 41

Lamb, Charles 174
Latton-cum-Eysey 72, 82, 128
Laverton 44, 92
LDV (Local Defence Volunteers)
   *see* Home Guard
Leafield 94
Lechlade 26, 29, 91, 95, 99, 181,
   182, 189, 220, 245, 246
Leckhampton 91, 92, 93
Lee, Laurie 173
Leighterton 108
Lewis, C.S. 173, 240, 241
Long Marston 115
Long Newnton 109, 115
Lower Slaughter 87

Malmesbury 21, 72, 129, 143,
   161, 162, 163, 178, 202, 232
Marshfield 90, 96
Marston Meysey 87
Mass Observation 162, 163
Meysey Hampton 178, 217, 228
Mickleton 91, 96
Midsomer Norton 43
Miller, Glenn 191
Milton-under-Wychwood 17, 30
Minchinhampton 94, 108
Minster Lovell 205
Miserden 87, 91, 106, 122, 194
Mitford, Unity 38, 94
Montgomery, Field Marshal BL
   154

Moreton-in-Marsh 45, 85, 89, 91,
     96, 100, 112, 115, 116, 197,
     237
Moreton Valance 67, 116

Nailsworth 51, 62, 68, 89, 231
NARPAC (Animal ARP) 56, 57
Naunton 90, 96
Nether Swell 31
Nether Westcote 86
North Cerney 29, 91, 92, 95
Northleach 13, 51, 58, 60, 63, 64,
     88, 91, 92, 94, 95, 96, 104,
     108, 116, 181, 202, 208
North Nibley 70, 95
Northwick Park 249
Notgrove 90, 92
Nympsfield 158

Oakridge 87, 104, 106
Observer Corps 52, 59-60, 142
Overley 105, 116
Oxford 40, 64, 173, 189, 241

Painswick 61, 90, 91, 96, 97, 98,
     99
Pauntley 185
Poulton 88, 95, 176, 178
Prestbury 90, 91, 92, 93, 99, 235

Queen Mary 47, 48, 49, 50, 133,
     157, 160, 180, 195
Quenington 9, 145, 161, 192, 194,
     221, 240, 241

Red Cross 20, 32, 37, 57, 173,
     176, 177, 183, 215
Rendcomb 29, 116, 220
Rissingtons, The 45, 78, 90, 96,
     101, 112, 113, 116, 118, 121,
     210
Rodmarton 35, 91

Royal Family (Families), The 47,
     49, 113, 134, 158, 164
RSPCA 21
Ruscombe 105, 116

Salperton 96
Sapperton 22, 132, 134, 170
Shaw, George Bernard 127
Sherborne 91, 130, 181
Shipton-under-Wychwood 17, 30,
     99, 175
Snowshill 40, 44, 45, 91, 92
Somerford Keynes 23
Southam 212, 213
South Cerney 52, 55, 82, 86, 87,
     91, 92, 95, 100, 102, 108,
     115, 116, 117, 123, 141, 191,
     220
Southrop 77, 117
Special Constabulary 52, 55, 58,
     59-61, 68, 145, 236
Springhill 40, 44, 45
Standish 96
Stanton 45, 131
Stanway 44, 45
Staverton 67, 89, 90, 99, 116, 117
Stinchcombe 90, 167
Stoke Orchard 116, 118, 122
Stonehouse 138, 142, 217, 218
Stow-on-the-Wold 44, 55, 132,
     197
Stroud 21, 41, 55, 57, 62, 67, 68,
     77, 79, 85, 91, 96, 105, 177,
     179, 180, 189, 198, 199, 208,
231
Sudeley 92
Swinbrook 38, 94
Syde 105

Taynton 90, 92, 93, 204
Temple Guiting 29, 30, 35, 235

Tetbury 13, 22, 75, 85, 90, 101, 105, 108, 112, 178, 181, 189, 209

Tewkesbury 73, 90, 158, 159, 207, 208

Tibberton 93

Toddington 93, 217

Tolkien, J.R.R. 173, 240, 241

Tormarton 90

Tortworth 180

Turkdean 91

Tunley 94

Ullenwood 188, 189

Upper Framilode 71

Upper Oddington 92

Upper Slaughter 28, 33, 66, 100, 101, 118

Upton St Leonards 91, 93

Ustinov family 139-140, 214

WAEC (War Agriculture Executive Committee) 34, 130, 201, 202, 206, 207, 208, 211, 216, 219, 220, 225

War Artists 20, 27

Waterley Bottom 87

West Littleton 90, 96

Westonbirt 22, 112, 197

Weston-sub-Edge 39, 93

Whelford 24

WI (Women's Institutes) 21, 170, 232, 233

Wickwar 90

Winchcombe 94, 96, 210

Windrush 88, 89, 90, 95, 96, 103, 104, 118, 121, 130

Winstone 105, 106, 107, 194

Withington 110

Witney 16, 64, 92, 189

Women's Land Army 26, 87, 185, 194, 210-216, 241, 242

Woodmancote 93, 96

Wortley 70

Wotton-under-Edge 61, 69, 70, 71, 89, 90, 92, 96, 158, 167, 180, 197, 199

WVS (Women's Voluntary Service) 13, 19, 21, 37, 49, 139, 227

Wycliffe College 35, 134, 142, 143, 144, 217

Yate 88, 90, 95, 166, 167, 195